Paradise Transformed

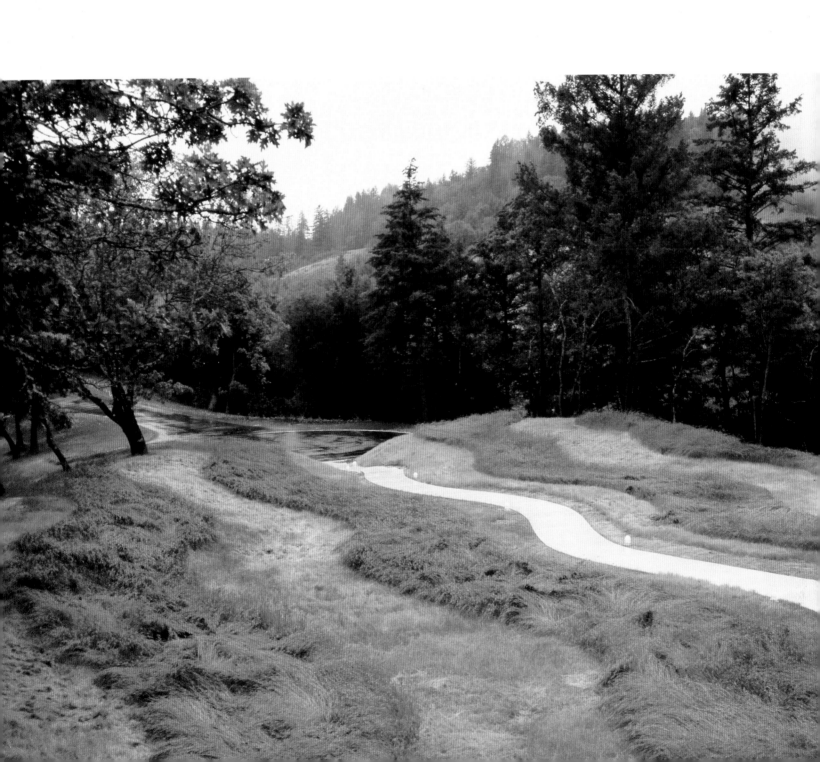

Paradise Transformed

THE PRIVATE GARDEN
FOR THE TWENTY-FIRST CENTURY

Guy Cooper and Gordon Taylor

THE MONACELLI PRESS

First published in the United States of America in 1996 by
THE MONACELLI PRESS, INC.,
10 East 92nd Street, New York, New York 10128.

LIBRARY OF CONGRESS CATALOGING-IN-PUBLICATION DATA
Cooper, Guy.
Paradise transformed : the private garden for the twenty-first century /
Guy Cooper and Gordon Taylor.
p. cm.
Includes bibliographical references.
ISBN 1-885254-35-0 (hc)
1. Landscape architecture. 2. Gardens—Design. 3. Gardens—Pictorial works.
I. Taylor, Gordon (Gordon I.) II. Title.
SB472.45.C66 1996
712'.6—dc20 *96-24485*

Printed and bound in Hong Kong
Designed by Lorraine Wild Studio

Page 2–3: George Hargreaves, Villa Zapu, Napa, California.
Page 6: Yotoo Yoshimura, Fukuda Garden, Kyoto, Japan.

ILLUSTRATION CREDITS
Numbers refer to page numbers.

Aerodata: 162–63
Courtesy Dean Cardasis: 9 left, 90, 92, 93
© *Child Associates: 52, 53, 54, 55, 57 top, 58*
Courtesy Gilles Clement: 148, 149, 150, 151, 152, 153
Peter Davenport: 30, 36, 37
Courtesy Delaney & Cochran: 166, 168, 169, 170, 171,
172, 173, 174, 175
Courtesy Garrett Eckbo: 9 right
Pieter Estersohn: 70, 71, 72, 73 top, 74, 75
Tom Fox: 140, 142, 143
© *Felice Frankel 1987, courtesy Child Associates: 56,*
57 bottom
Courtesy Ludwig Gerns: 84, 85, 86, 87, 88, 89
© *Martyn Greenhalgh 1989: 24, 34*
Courtesy Grissim/Metz: 144, 145, 146, 147
Courtesy Kathryn Gustafson: 196, 198, 199

Courtesy Richard Haag: 38, 39, 40, 41, 42, 43
Courtesy George Hargreaves: 2–3, 200, 202–3, 204
Haruo Hirota: 6, 62, 64, 65
Courtesy Charles Jencks: 66, 68, 69, 73 bottom, 76, 77
Courtesy Office of Dan Kiley: 10, 124, 125 (photograph
Richard Pete), 126, 127, 130, 131
Courtesy Myra Lehr: 128, 129
Courtesy Tom Oslund: 108, 110, 111, 112, 113
© *David Paterson: 28–29, 31, 35*
© *Cymie Payne 1988, courtesy Child Associates: 59,*
60–61
Courtesy Regina Pizzinini & Léon Luxemburg: 176,
178–79, 180, 181
Antonia Reeve Photography: 27, 32, 33
Martha Schwartz: 114, 115, 116, 117, 118, 120, 121,
192 top

Courtesy Vladimir Sitta: 98, 99, 100, 101, 102, 103,
104, 105, 106, 107
Courtesy Achva Benzinberg Stein: 185
Courtesy Chip Sullivan: 94, 96, 97
Gordon Taylor: 13
Courtesy Shodo Suzuki: 44, 45, 46, 47, 48, 49, 50, 51
L. Toussaint: 132, 134, 135, 136, 137, 138, 139
Courtesy Peter Walker: 195
Courtesy V. J. Walker: 80, 82, 83
© *Paul Warchol: 182, 184*
Alan Ward: 119, 192 bottom, 195
Courtesy Ron Wigginton & Land Studio: 186, 188, 189,
190, 191
Courtesy Jacques Wirtz: 154, 155, 156, 157, 158, 159,
160, 161

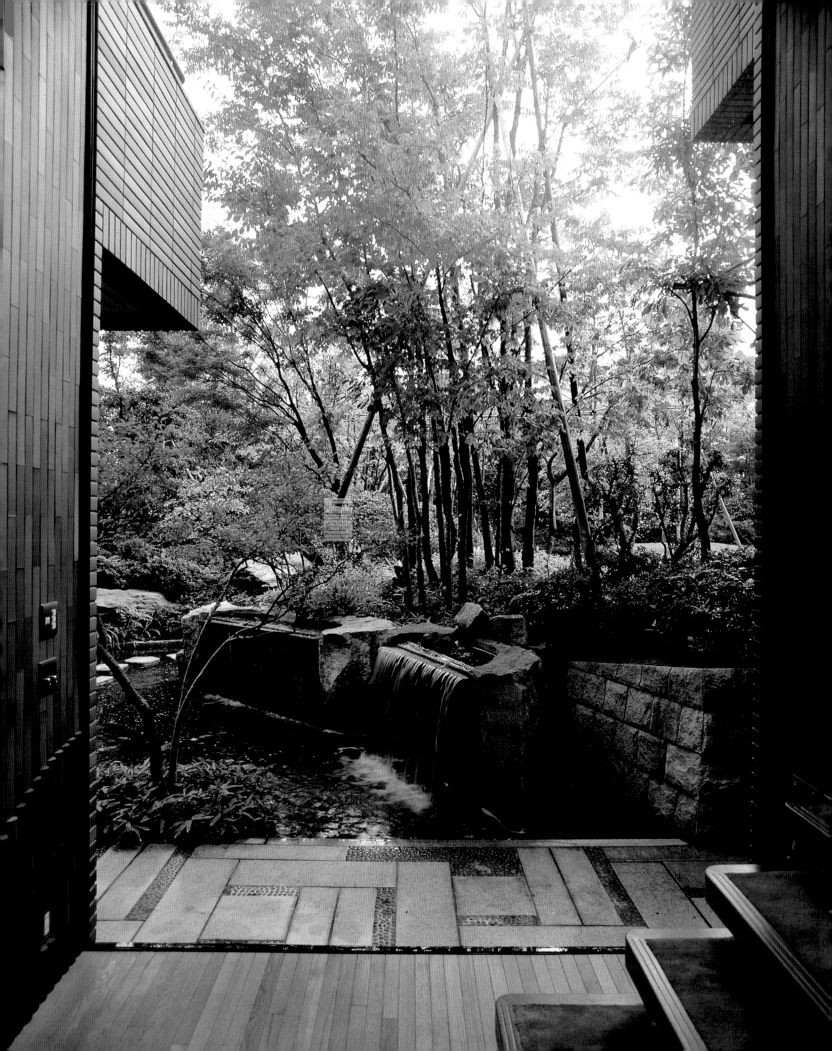

Acknowledgments

Any project of this scope requires the aid of many parties, and we are extremely grateful for the help and hospitality extended by the many landscape architects and designers we contacted in our researches.

In Great Britain we would like to especially thank Gerry Lord; Robert Holden; Simon Nicol; Pat White of the Rogers Coleridge and White Literary Agency; Professor Michael Ellison; Kate Campbell; Julie and Peter McBride; Sally Rena; Martina Nicolls; David Williams; Elaine Barry; Joseph Kent; Paul and Valerie Sykes; Victoria Lane Fox; Sir Roy Strong; James Hope; Laurence Boulting; Fiona Freed; Iain Michael Brunt; Jill and Andrew Zarzycki; Gregory Gossayn; Adrian Gill and Nicola Formby; Alfred Cochrane-Ireland; Robert and Alexandra Lacey; Anne M. W. Manson; Moo and John Nowell-Smith; Shailesh Patel; Deanna Petherbridge; Anthony Smith; Stephen Colgan; Penny and Jeremy Simpson; Guy Stevenson of Imagination; Sean Wyse-Jackson; Mark Boyce; Lionel Guyett; Lisa Evans; Graham Williams; Richard Hood; Peter Docherty; Gloria, the Dowager Lady Cottesloe; Sara Miller; Dominic Palfreyman; Frances de la Tour; Yat Malmgren; Christopher Fettes; Michael Abrahams; Cherry Fraser; John Dalton. In Germany, Jan Dieter Bruns and Hans Draht of Bruns Plants; Irmgard Schwaetzer; and Udo Phillips. In Japan, Shunsaku Miyagi. In France, Jean Paul Pigeat, Director of the International Garden and Landscape Festival. In Denmark, Anna Castberg, Director of the Museum of Modern Art, Copenhagen. In Spain, Enrique Molina, Director of the Museum of Contemporary Art, Barcelona; and Hugo Mony-Coutts. In the United States, our publisher, Gianfranco Monacelli; our editors, Andrea E. Monfried and David Brown; the book designer, Lorraine Wild; Dodie Kazanjian Tomkins; Laurence Freundlich; Michael Mushak; Mac Griswold; Hope Alswang; Henry Joyce; Gene Fairly; Frances Alswang; Joseph di Mattea; Fanny Howe; Robbie Kendall; Jane O'Keefe; Sally Ann Howes; Douglas Rae; Elizabeth Smith, Los Angeles Museum of Contemporary Art; Aaron Betsky, San Francisco Museum of Modern Art; and J. William Thompson and Michael Leccese at *Landscape Architecture* magazine.

The main research in America for this book was done in the summer of 1995 by Guy Cooper, who would like to thank all the friends he visited and who helped him maintain his sanity and good humor while visiting thirty-eight gurus of American landscape architecture and design. Thanks are also due to Tom Todd for the home away from home in New York City; Maurice Kennedy and the Walther family; Geoffrey Soulges; Henry Thaggert III; J. C. Raulston; Peter Strickland; Bonny and David Martin; Lee and Carole Jaynes and also Dede Rose, Dallas; Bruce Donnell; Tommy and Darlena Goetz; Fred Hill and Peter Lloyd Gilliam; Richard Paulin; Philip Smith and John Buffinton; Raymond Lunney; Jeffrey Macpherson; Jack Tarpley and Paul Dorman; and Regis and Karen Breem. Special gratitude is in order for the little red Chevy Cavalier from Avis, which did not complain once during the journey of 14,106 miles.

Introduction

What is a contemporary private garden?

This question has been asked many times. We have asked it. Friends have posed it. Clients have asked for it to be designed.

The landscape architects and designers presented in this book have *achieved* it. This book is a survey of garden designs since about 1980 that signal what the private garden might be in the twenty-first century. The built and unbuilt projects here show the many and varied ways landscape architects and designers have responded to the multiplicity of cultural phenomena and contemporary realities of the last two decades, and hint at how they will respond in the coming years.

In these past twenty years, landscape architects, particularly in America, have asked ever more searching questions about the nature of the gardens they design—of whatever size—and how they can be integrated into the community and the local ecology. During this period, landscape architects have been able to experiment with extremely controversial ideas for corporate and municipal clients. Plazas, university campuses, corporate headquarters, and multi-dwelling developments have on occasion been surrounded by and integrated into landscapes that sometimes show amazing creativity and sometimes amazing arrogance, but are almost always made with minimal personal involvement. Neither the landscape architect nor the chairman of the board nor the parks commissioner nor the developer has to live in the landscape which they have commissioned. (Nor do some leading architects of the modern or postmodern live in white walls and glass.)

Private gardens reveal the other end of the spectrum of contemporary landscape design. The executive may want to make a bold statement in the landscaping of his or her company's headquarters, suggesting that the leading edge of its design exemplifies the contemporary thrust of its corporate strategy, but individuals usually want the surrounding of their own homes to contain elements which give privacy, shade, serenity, and contentment. The designs in this book reveal approaches that can encompass both views, that of the contemporary and that of the domestic, in all their many interpretations.

There is no quality so universal as difference

—*Montaigne*

The one element unifying contemporary private garden design is diversity. It is diversity on many, many levels: it is diversity of geography (the gardens shown here are in the United States, the United Kingdom, Europe, Japan, and Australia), and it is diversity of inspiration. Landscape architects and designers active today draw inspiration from modern art, from the work of Luis Barragán, Roberto Burle Marx, and Isamu Noguchi, from the formal garden, from the postindustrial age, from ecological concern, and from the primitive.

MODERN ART

We think of the twentieth century as the modern age, for it is our own definition of the time in which we live. But the concept of modern in art, and in gardens, is not unique to this century. The modern in art, in all its aspects, applies to a period where there is both a sense of separation from the past and an attempt to substitute another set of forms, models, and means of communication for those of the prior generation(s). In early-sixteenth-century Italy there was a modern style, *il stylo moderno,* and gardens were made using formal designs. In late-eighteenth-century Georgian England, Horace Walpole's book, *The History of the Modern Taste in Gardening,* treated gardens and landscapes made in an informal design as modern.

This cycle of the "modern" returned in the twentieth century, beginning with the explosion of modern art in the century's first years, and continuing in various manifestations in architecture, design, and art for almost a hundred years. Now, landscape architects and designers are finding great inspiration and influence in the contemporary world and the great creative works of modern art and architecture.

Landscape architecture has often trailed behind the innovations of painters, sculptors, and architects. In fact, it is only recently that many of the ideas of modern art have begun to be seen in the landscape, first in public projects, and now, at last, in the private garden. Isolated examples do, of course, exist; in 1923, the Vicomte de Noailles had an

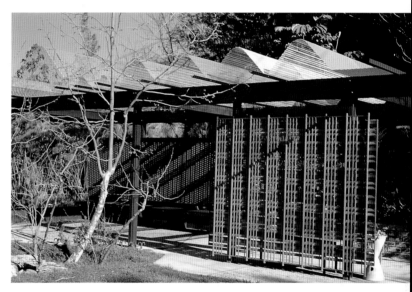

James C. Rose, Landscape Research and Study Center, Ridgewood, New Jersey.

Right upper and lower: Garrett Eckbo, Laurel Canyon Garden, Hollywood Hills, 1950–65.

Art Deco–inspired garden installed at his house in the south of France. But such designs were usually dictated by architects, who traditionally have had little interest in the landscape except as a background to their own creative efforts.

One architect, however, has been very important in changing the whole ethos of landscape architecture. In 1938, Walter Gropius became professor of architecture at Harvard University, having fled Nazi Germany, where he had been the director of the Bauhaus. The ideas and views of architecture and design he brought were to make Harvard the most influential international center of the modernist aesthetic.

The ideals of teamwork, standardization, prefabrication, and the rational and intelligent use of contemporary materials were the keystones of Gropius's teachings. From these teachings emerged not only brilliant young architects trained in what became known as the International Style but also a trio of landscape architects who were fired by the Bauhaus concept. Garrett Eckbo, Dan Kiley, and James Rose all studied landscape architecture in the traditional Beaux-Arts-based Harvard

Graduate School of Design, but spent more time in Gropius's Department of Architecture. His Bauhaus principles became the background and backbone of their redefinition of the twentieth-century landscape.

Eckbo, in his 1950 book *Landscape for Living,* strongly and succinctly presented his case for a new approach to landscape architecture that rejected historical models:

> *To treat history as an accumulation of garden features is to leave us here in the middle of the twentieth century with a horrible pot-pourri of Egyptian pyramids, Babylonian hanging gardens, Roman atriums, and Spanish patios, Medieval cloisters, Renaissance terraces and parterres, English landscape gardens, Chinese pagodas, Japanese lanterns and rocks and American alpine beds.*

> *What do we do with it? What principles of organization must we establish to wade through this eclectic hash and determine a clear, clean and beautiful way of solving our own problems on their own terms with the materials we have at hand?*

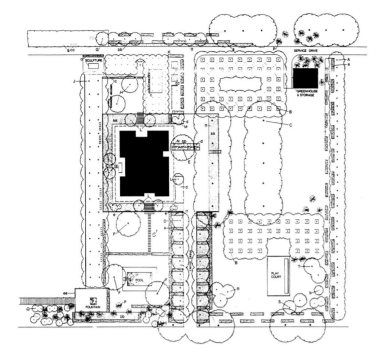

Left and below: Dan Kiley, Miller Garden, Columbus, Indiana, 1955.

These principles amounted to Eckbo's definition of the art of landscape architecture and design, which, he said, has four main elements: a three-dimensional space, a respect for the materials used, a cognizance of human needs, and a favoritism to native plants.

Eckbo is an iconoclast, the landscape designer who is most profoundly identified with modern American landscape architecture, as well as a writer, educator, and environmental planner. Along with Kiley and Rose in the 1930s and 1940s, and with Lawrence Halprin, Hideo Sasaki, Peter Walker, and Ian McHarg in the 1950s and 1960s, Eckbo has determined the direction of modern landscape architecture practice. Laurie Olin, a leading American landscape architect, has said, "Followers have made whole careers out of fragments of his ideas."

Eckbo is credited with two primary innovations: the freeing of landscape design from the axial nature of traditional Beaux-Arts formalism, and his use of the diagonal or asymmetric. He also advocated the consideration of the uniqueness of each site and its regional variations. Eckbo's work has been wide-ranging; he has helped design camps for migrant workers in California, made private gardens on Bel Air estates, and was a partner in the large interdisciplinary corporate design firm Edaw, Inc. In his book *The Landscape We See* (1969), he stresses the complexity of private garden design: "Residential design is the most intricate, specialized, demanding, responsible, and frustrating field for designers."

Dan Kiley was also an integral part of the "Harvard revolution" in landscape architecture. He began his career with Louis Kahn, who introduced him to a young architect, Eero Saarinen, a meeting that was to be very important for Kiley. It was with Saarinen that Kiley collaborated on the Miller House in Columbus, Indiana, in the 1950s. Mies van der Rohe's Barcelona Pavilion, designed in 1929, influenced both the house and the garden; the grid, the horizontal, and the reference to de Stijl that informed the Pavilion are all evident in Columbus, as well as a neoclassical order in both the architecture of the house and the landscape. Discussing his use of these formalist devices, Kiley has said:

> *I find direct and simple expressions of function and site to be the most potent. In many cases, though not all, this has led me to design using classic geometries to order spaces that relate in a continuous spatial system that indicates connections beyond itself, ultimately with the universe.*

André Le Nôtre and the formality of seventeenth-century gardens are important to Kiley's designs, and in the Miller Garden he has used allées, bosquets, clipped hedges, and tapis vert in juxtaposition to the modern architecture of the Saarinen house.

Kiley is also known for his ability to assay the relationships between buildings on large sites and the scale needed for the surrounding landscapes. "Landscape is not mere adornment," he has said, "but an inte-

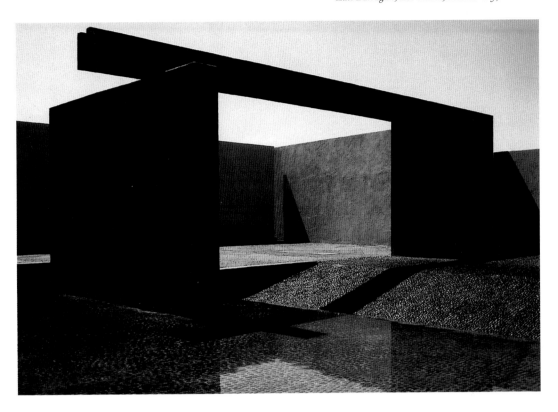

gral part of the disposition of space, plane, line, and structure with which it is associated."

Thomas Church also played a large role in changing the nature of landscape architecture at mid-century. Somewhat older than Eckbo, Kiley, and Rose, he had been designing from similar modern concepts in California. This work, along with that of Eckbo, would evolve into some of the designs that have had a primary influence from the 1950s onward, in the United States and internationally.

Church is known for devising the California Style, which was his response to hillside plots and small, irregular backyards. Wooden decking, bridges, paving, and planting beds and walls—both raised for sitting—were the main elements of his private garden designs, where he emphasized pleasurable family use and low maintenance. The Church Garden truly became the outdoor living room in its adaptation to the splendid California climate.

Cubist and Art Deco shapes can be seen in Church's earliest gardens. He used the zigzag and the diagonal axis to achieve illusions of greater space on restricted San Francisco lots. In 1937 he traveled to France to see the work of Le Corbusier and then continued on to Finland, where he met Alvar Aalto, whose architecture and designs for domestic objects inspired him to assume also an easier, organic curvilinearity. These influences, grounded in varied modern art movements, helped make Church's designs more asymmetrical and based on multiple viewpoints, which seemed to increase the garden space.

BARRAGAN, BURLE MARX, NOGUCHI

The landscape architects included in this book have each incorporated the influences, both large and small, of many designers—their teachers, their colleagues, and past and present masters. Three designers, however, have cast a particularly wide and important shadow over contemporary landscape work: Luis Barragán, Roberto Burle Marx, and Isamu Noguchi.

Luis Barragán's work as an architect has influenced not only modernist architects in his native Mexico but also three generations of architects and landscape designers all over the world. The traits evidenced in his first houses—the influence of Mexican architecture, formal Islamic design from Spain and the Near East, coupled with the prevailing International Style, mainly from the work of Le Corbusier—were all primary to the rigorous simplicity of Barragán's later work—the relation between house and landscape.

Beginning in 1940, Barragán initiated his life-long investigation of the conjunctions between ground planes and walls. Water was almost always integrated into his designs—pools, channels, and waterfalls; he always thought that water brought streams of light into any garden. One of his masterpieces, Plaza del Bebedero de los Caballos at Los

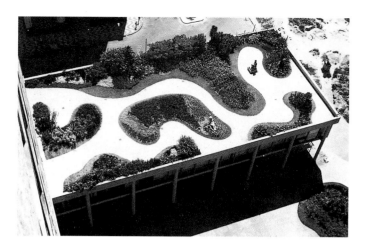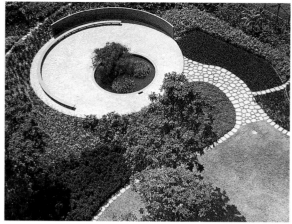

Roberto Burle Marx, roof gardens, Rio de Janeiro, 1936–38 (left) and 1955.

Arboledas near Mexico City, created in 1961, was made from the most simple and basic elements: water in a long raised horse trough, two plastered walls—one white and one blue—and a grove of eucalyptus trees with their forms reflected in the water and their shadows thrown onto the two walls. The design is practical and noble and surreal. Even the horses of Cortez would have been grateful to drink from it.

Roberto Burle Marx has been credited with being the originator of the modern garden. He was studying painting in Berlin in the late 1920s when he discovered, in the Dahlem Botanical Garden, a selection of the vast range of plants from his native Brazil. His landscape designs were to come from indigenous Brazilian sources, from his vision as a painter, and from modern art. His work in Brazil included important collaborations with such architects as Oscar Niemeyer, Lucio Costa, and Le Corbusier.

Large drifts, swathes, and massings of native plants in bold curves and free-form biomorphic shapes make great visual impact in his designs, often in contrast to the precise geometric plan and paths of the gardens, as well as with the modern architecture invariably nearby. "A garden is the result of an arrangement of natural materials according to aesthetic laws," Burle Marx has said. "Interwoven throughout are the artist's outlook on life, his past experiences, his affections, his attempts, his mistakes, and his successes."

Isamu Noguchi's father was from Japan and his mother was from the United States, of Irish descent. In 1924 in Paris he began working as a stone-cutter in the studio of Constantin Brancusi; this started Noguchi's life in sculpture. His other artistic passions were for the theater and for the landscape: designing plazas, memorials, bridges, playgrounds, and several of the most important public and corporate gardens in the latter part of the twentieth century. Some of Noguchi's masterworks in the 1960s were the gardens for UNESCO in Paris, the Beinecke Rare Book and Manuscript Library at Yale University, the Chase Manhattan Bank Plaza near Wall Street, and IBM Headquarters in Armonk, New York, where he created the Garden of the Future. To many, Noguchi's most significant garden design was "California Scenario" in the South Coast Plaza in Costa Mesa, south of Los Angeles, completed in 1984.

In his Kyoto Prize Memorial Lecture in 1986, Noguchi summed up his artistic philosophy: "The past is ourselves; going inside ourselves, we go into the past, because there is a memory inside. Going out, we go to the future. There is no memory there, so it's very questionable. We do not know what is out there, but inside of us, we know what is there . . . We know by instinct. If we study the past, we study ourselves."

The influences of these three masters are as diverse as they are widespread. The brightly colored planes used by Barragán are echoed in designs by Regina Pizzinini and Topher Delaney; the simplicity of Kathryn Gustafson's materials recalls Noguchi's spare work; and the exuberance and originality of Burle Marx's plantings find expression in

Below and right: Isamu Noguchi, California Scenario, South Coast Plaza, Costa Mesa, California, 1984.

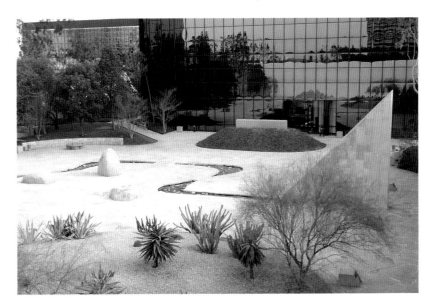

Ludwig Gerns and Vladimir Sitta's landscapes. More important than these individual elements, however, are the overall lessons learned, those of dealing with space *sculpturally,* creating flows *through* the space, not simply making a garden to look at.

FORMALISM

There is a strong use of the formal mode in contemporary landscape architecture and design. Le Nôtre lives on, as does the formalism of Islam and the Renaissance, in the work of Kiley in the United States, Jacques Wirtz in Belgium, and Fernando Caruncho in Spain, among others. But these designers are not simply using the great French designer's gardens, or the patterns of Islamic and Renaissance architecture, as pattern books. Rather, they are using elements from the alphabet of formality—clipped hedges, sheets of water, grids of cut stone—to create their own language of formal design that is expressive of the late twentieth century.

The appeal of symmetry has been studied recently by several scientists, including Anthony Arak of Halifax, England, and Magnus Enquist, of Stockholm University. Their studies of neuron interaction in the human brain show that the neural network has a dislike for the haphazard and irregular and loves symmetry. Such things as butterfly wings or a beautiful face, and perhaps Palladian architecture or the formal gar-

den, might be biologically favored, rather than simply pleasurable. "The existence of sensory biases for symmetry may be exploited independently by natural selection acting on biological signals and human artistic innovation," Enquist and Arak wrote in their 1994 article "Symmetry, Beauty, and Evolution," published in *Nature.* "This may account for the observed convergence on symmetrical forms in nature and decorative art."

ECOLOGICAL CONCERN

The ecological aspects of twentieth-century landscape architecture and design are very complex; indeed, they are a major primary study in themselves. An awareness of their importance has become a part of every landscape architect's battery of professional skills. One extremely important figure in landscape architecture was the first to make his students and the public cognizant of the primary significance of ecology: Ian McHarg. McHarg has been teaching landscape architecture at the University of Pennsylvania since 1954. His course "Human Ecological Planning" has been the basis for the ecological planning movement of the second half of the century.

McHarg described ecological planning and its methods in his book *Design with Nature,* published in 1972, which has become a manifesto for the planning and design professions as well as for urban ecol-

13

ogists. It was the correct book at the correct moment. Ecological awareness began to emerge in the late 1960s and 1970s, and McHarg was there to rally against "scabrous towns and pathetic subdivisions" just as ecology became a primary issue on many levels of our culture. He attacked, in the book and on the lecture circuit, "the neon shill" where human beings lived in a "termitary" along highways that were nothing more than "blue gas corridors." The message was well received by the profession.

However, a widespread perception arose that some landscape architecture practices and university departments overemphasized his vision and became more about planning and ecology than about the aesthetics of the landscape. McHarg responded: "I can't believe that design can proceed without knowledge of the natural environment and the social environment . . . [Design and planning] are complementary . . . I don't think [they are] adversarial at all . . . It is absolutely fundamental."

THE PRIMITIVE

One of the most exciting and fascinating influences in contemporary landscape design is that of primitive decorative markings. The most widely seen are the spiral, the serpentine, the zigzag, and the circle, forms that first appeared on carved bones as long as seventeen thousand years ago. Anthropologists have suggested that these marks may have been made to help with the hunt, to protect from some evil, real or imagined, or to propitiate some spirit. Their original inspiration does not really matter; their importance is that these more-than-ancient symbols have a potency, a simplicity, and a transformative power for landscape architecture and design now.

These elemental shapes have been used throughout human history, singly or in combination, but they became more visible in the work of a group of artists that formed in the 1960s and 1970s. Theirs was a new form of sculpture in and of the landscape, called variously Environmental Art or Earth Art or Land Art, but often subsumed under the category Earthworks. The artists involved were working from two major ideas: the repudiation of the commercialization of art as a small-scale commodity in the marketplace of galleries, and their interest and respect for the landscape, extending to a spiritual relationship between person and planet.

Robert Smithson created one of the most important pieces of land art, *Spiral Jetty*, a project realized in 1970 on the shore of the Great Salt

Lake in Utah. A spiral of black basalt, limestone, and earth 1,500 feet long extended out into the lake. Smithson's inspiration for *Spiral Jetty* was both microscopic, for he discovered a spiral formation in the lake's salt crystals when they adhere to rocks, and macroscopic, for there is a local legend that the Great Salt Lake was once connected to a (mythological) ocean by an underground river that arose as a giant whirlpool in the middle of the lake. Smithson has written that his spiral was coming from nowhere, going nowhere, and that it was matter collapsing into the lake mirrored in the shape of a spiral.

When Smithson found the *Spiral Jetty* site, it contained industrial junk and derelict vehicles from a failed oil extraction project. He was later to become more concerned with large-scale land art projects to do with reclamation of mine sites in Ohio and Colorado. Smithson wrote of this: "Art can become a physical resource that mediates between the ecologist and the industrialist."

THE ECOLOGICAL AND THE PRIMITIVE

The work of George Hargreaves, one of the influential landscape architects working in the United States today, embodies the leading edge of some of the most important new landscape design currently being made. Hargreaves and his team are not asked to do the landscaping around luxurious corporate villas set in idyllic green valleys. Rather, they are approached to deal with sites that have been industrial dumping grounds, with forty feet of garbage on which nothing will grow except perhaps native grasses, but only if a skim of topsoil is applied. The ecological, geological, and topographical analyses (among others) of both the immediate site and any other natural or human-made landmarks within view of it all become factors in the process from which a design emerges from the team's efforts.

Alexander Pope's truism about landscape architecture, from a poem to Lord Burlington, about being aware of "the genius of the place," applies to Hargreaves's approach, and to some other designers in this book. He is not looking for the "genius" as it existed for eighteenth-century designers, with their idealized picturesque landscapes set down in the British countryside. Hargreaves is instead searching for genius in the realities of the postindustrial, consumerist society of late-twentieth-century America. In 1983 he wrote:

> With this society's shift from the belief in the new to its recognition of limits in what exists, the stylistic explorations in Post-Modernist landscape architecture have just begun. Time, nature, sky, rain, plants, dirt, debris, people of all types, and man-made elements that

intensify and abstract what is already here will become the focus of simpler, more receptive compositions and non-compositions.

The garden designs in this book have been classified in four broad, sometimes overlapping, categories: Exploration, Innovation, Tradition, and Abstraction. These categories cannot, of course, describe all of what the landscape architects represented here do. There is a fine line, for example, between innovation and exploration, and formalized and abstract elements show up in a majority of these landscapes. But the categories can provide a good framework upon which one can look at, think about, and appreciate these creations.

Exploration is a necessarily vague category. It is clear that all landscape architects at the leading edge of their profession are exploring various aspects of the garden, from materials to traditional forms to minimalism; but the explorations of some are easier to see, even if these explorations are exceedingly diverse. Charles Jencks and Ian Hamilton Finlay, for example, have embarked on explorations of their personal philosophies, while Robert Murase and Motoo Yoshimura push their cultural gardening traditions in new directions. The forms of other traditions, including the primitive and the minimal, also become the basis for other designers' investigations into the nature and the limits of their discipline.

All of the landscape architects and designers in this book innovate; if they did not, there would be little reason to include them. The designers we put under the Innovation label, though, seem to specialize in the new—new materials, new shapes, and new combinations. The use of new materials is the element that these designers have most in common. Plastic, fiber-optic lighting, artificial fog, pink flamingoes, and metals are a few of the modern materials that have been used recently but are not usually associated with gardens. Other designers innovate instead with form, using new shapes for old ideas.

There will always be a somewhat limited vocabulary of forms, shapes, materials, and processes available to landscape architects, so all designs must to some degree bow to previous examples. However, several significant contemporary landscape architects knowingly incorporate many of the profession's old forms and materials. These traditionalists— a word that cannot fully describe their work, and a label that does not encompass their innovative and exploratory qualities—have exploited, expanded, and shaped these traditional forms into wholly modern land-scapes. Allées, hedges, formalized water treatments including fountains and watercourses, and conservatively treated paths are the primary elements that appear in their designs, elements that have been used since the beginning of the profession, but are seen anew in these designers' hands.

Finally, this vocabulary of design elements also informs a body of work that we call abstract. Landscape architects achieved this "abstraction" in several ways. Some, influenced by the tenets and forms of minimalism, pare down the number and type of elements in their landscapes. Others, such as George Hargreaves, engage in a series of analyses of particular sites, investigating the features and properties of the site and the natural and human-made landmarks of the surrounding landscape. These elements are then reflected, as both influences and specific elements, in their final designs.

In certain areas we have come to accept very different ways of living—

Exploration

no one today wears clothes, drives cars, or writes journalism like they did a hundred years ago . . .
The shock of the new has always been with us and it's high time we all got used to it.

—Sir Richard Rogers

Robert Murase

GARDEN, BLOOMFIELD HILLS, MICHIGAN

Robert Murase is of Japanese and American origin. He was educated in both Japan and the United States, and began his career in Kyoto, home to some of the most important traditional Japanese gardens. While there, he designed and worked for nine years on a Buddhist temple complex, the Myodo Kyo Kai, in the Shiga Prefecture. His Japanese background and experience are reflected not only in the sparse surroundings of his office but also in the simplicity and restraint of his designs for private gardens.

It may seem strange that a landscape architect imbued with Japanese tradition should be asked to design a small garden for a 1920s Tudor-style house in a prosperous suburb of Detroit. But the client's wife had lived in Japan for four years, and she had been impressed by the exquisite use of very small courtyard garden spaces meant to be enjoyed from one viewing point.

The main design problem in this project was that the house's old garages had been converted into a family room–type living space, and the new parking area and garage needed to be screened. This was done with a nine-foot-high wall along the house with entrances at either end, which created a twelve-by-fifty-foot ribbon of space for the garden. In this garden, completed in 1990, Murase has combined his two

Stone, gravel, water, maples, and azaleas furnish
this Japanese-inspired courtyard garden near Detroit.

cultural heritages: from Japan he took the small courtyard, textures of great delicacy, and most of all, the relationship between the interior and exterior of the house; and from the midwestern United States he incorporated elements of the architecture of Frank Lloyd Wright, especially the horizontal line intrinsic to his Prairie houses.

Murase's vision for the garden was one of water dripping down to a small pond, surrounded by a shrouded landscape, bathed in filtered light and quietness. The main feature is a seminaturalistic waterfall made from thin layers of local honey-colored sandstone rising almost to the top of the wall. The water falls from a pool at the top and gently cascades down the rock face into an irregularly shaped pool at the bottom. The waterfall is the focal point of the garden when viewed from the family room, and the moving water is always visually interesting; when the windows are open, the sound of water gives additional pleasure.

To give more height and interest to the design, four Japanese maples, *Acer palmatum,* were planted. Other shrubs set asymmetrically along this ribbon garden include one *Pieris japonica,* a *Viburnum opulus* "compactum," some brilliant red azaleas, and rhododendrons. The underplanting is astilbe, hostas, trillium, and ferns. Through the whole garden runs a path of irregular honey-colored sandstone pavers, the same material as the waterfall wall.

This thin secret garden makes an enormous impression in a very enclosed space. From the garage court it is invisible until it is glimpsed through one of the end openings, when suddenly there appears a small oasis of water, restrained plantings, and color. The waterfall can be heard but not seen, and one is tempted to explore the half-hidden stone path, for it must lead somewhere. From inside the house, the tops of the trees are just visible. They distort the sense of space and make the garden appear deeper than it is and create a vertical contrast to the lower underplanting.

So much care has been taken in this five-hundred-square-foot garden, next to a house that sits in an eight-acre landscape. But the comparatively few elements that Murase has employed here teach a significant lesson in how small and difficult spaces can be made into dynamic and attractive gardens.

The Dennis Garden, near Woodside, California, features Zen-influenced stone and gravel sculptural forms.

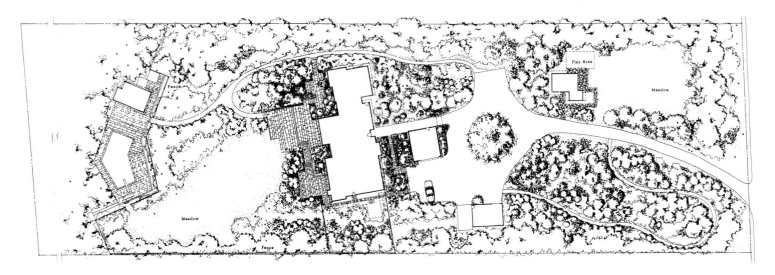

Plan of the Dennis Garden.

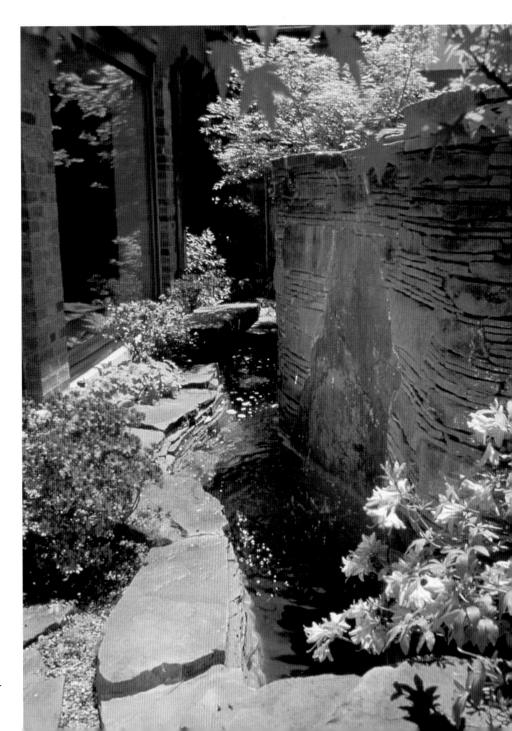

The sandstone waterfall and pool in the Bloomfield Hills garden.

This page and opposite:
For a solar-powered ski lodge in Sun Valley, Murase
has planted rosemary, potentilla, and other drought-resistant
ornamental species; in the meadow he encouraged native grasses
and flowers within the indigenous sagebrush plant cover.

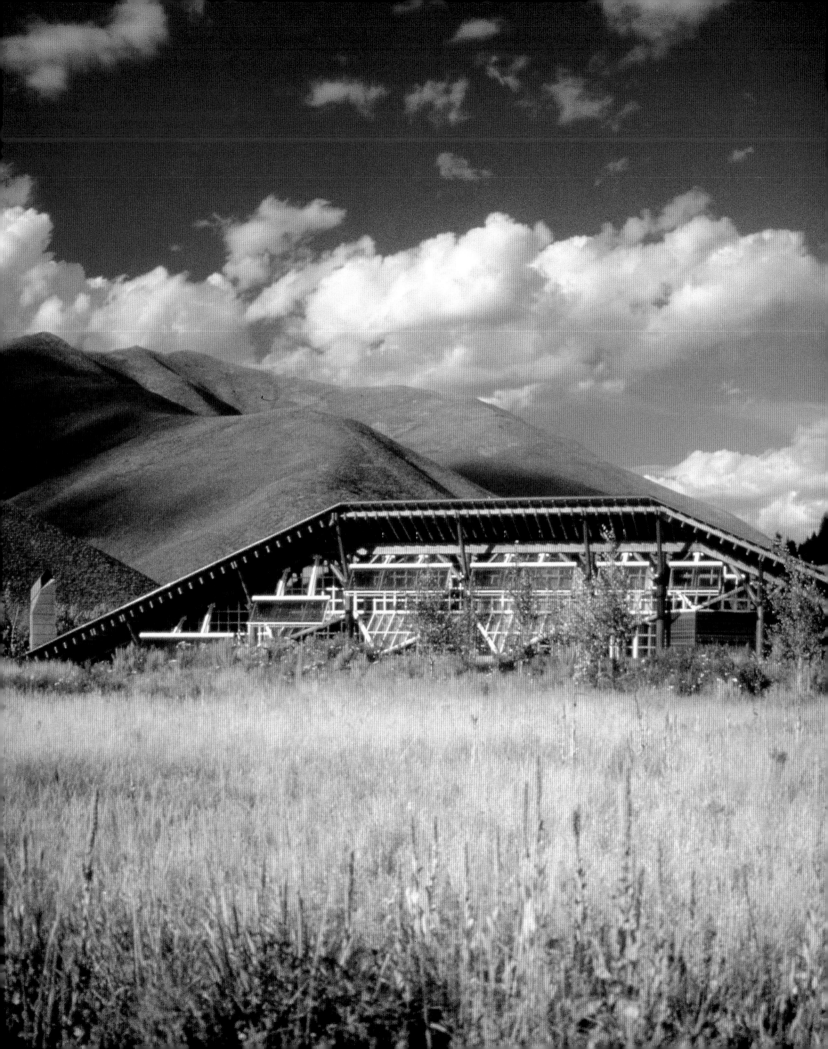

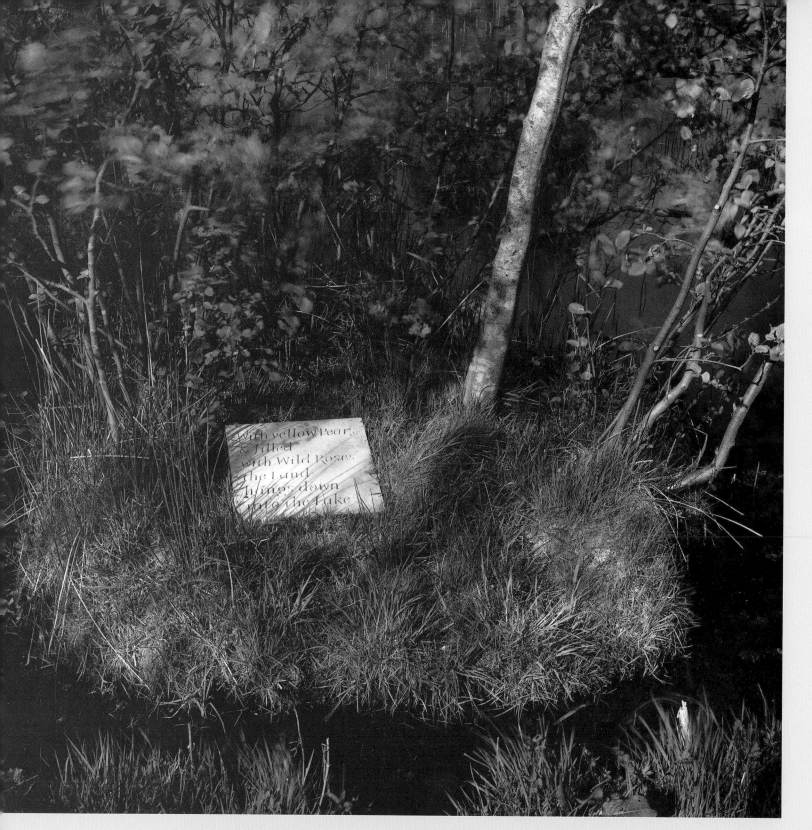

Finlay engraved part of the poem "Hälfte des Lebens,"
by Johann Hölderlin, an eighteenth-century German lyric poet, on a stone in his garden
(Finlay and Keith Bailey, 1985).

Ian Hamilton Finlay

To build, to plant, whatever you intend,
To rear the Column, or the Arch to bend,
To swell the Terras, or to sink the Grot,
In all, let Nature never be forgot.

— Alexander Pope

LITTLE SPARTA, STONYPATH, DUNSYRE, LANARKSHIRE, SCOTLAND

A weathered wooden sign announces Little Sparta from the road in the Pentland Hills, southwest of Edinburgh.

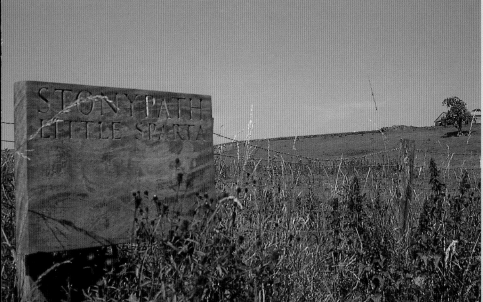

Alexander Pope would have approved of Little Sparta, the masterly garden created by the poet, sculptor, and gardener Ian Hamilton Finlay. Many of the elements of Finlay's landscape have a historical provenance in the piece of rhymed flattery the eighteenth-century poet wrote to Lord Burlington, which contains the famous epigram, "Consult the Genius of the Place in All."

Sue and Ian Finlay bought Stonypath, in the southern uplands of Scotland, in 1966, when it was an abandoned four-acre hillside farm with a small stone house and some outbuildings. Over the years this once forlorn site has become world-famous and has evoked great respect, like

The pilasters on the Garden Temple are painted stucco.
Column-capital seats surround the Temple Pool; in the pool
is the sculpture "Marble Boat."

this comment by Sir Roy Strong: "[This] garden is one of the few made post-1945 which must *not* be lost. It remains to me still the only really original garden made in this country since that date."

In 1978, during various battles with the Scottish Arts Council and the Strathclyde Regional Council, the name of Stonypath was changed to Little Sparta. What had been Finlay's gallery became a temple, although the region refused to give him the tax exemption granted by law to religious buildings. The upshot of the confusion — the "Little Spartan Wars" — was that the sheriff seized many works of art from Finlay's property. (Only the Wadsworth Athenaeum in Hartford, Connecticut, using the power of the U.S. State Department, has been able to retrieve its property.)

Little Sparta is indeed "a Work to wonder at," to use Pope's words. In creating the landscape, Finlay was interested in the emblematic and symbolic, not just in the flower-growing aspects of a garden; he has said that he was driven by *culture,* not just *horticulture.* The mythological and the contemporary are also given their due. The spatial relationships between the various "sacred groves," with their witty reworkings of the classical and neoclassical, both verbally and architecturally, are virtuosic in concept and realization.

Many of the features Pope alludes to in his poem are central to Finlay's garden, including the columns, arches, and grottoes in the passage above. There are, for example, many classical columns at Little Sparta, either freestanding or engaged on the fronts of farm outbuildings.

Finlay's Lararium honors Lares, the spirits of the house, which guard the household when propitiated. The example at Little Sparta houses a statue of Apollo, after Bernini, carrying not a lyre but an automatic weapon (bronze by Finlay with Andrew Townsend and Alexander Stoddart, 1986). Russian vine grows all around.

Overleaf: One of Little Sparta's many columns looks over Lochan Eck and the Pentland Hills.

Finlay has transformed the landscape in a classical mode. The Garden Temple and the Temple of Philemon and Baucis are two examples of this work. The Garden Temple has painted stucco, double-height pilaster columns with Corinthian capitals. The window and door lintels have carved legends embellished with gold leaf reading, "To Apollo • His Music • His Missiles • His Muses." (The missile reference is to Finlay's "Little Spartan Wars" with the regional council.) In front of the Garden Temple, at the edge of the Temple Pool, is a small reddish-stone scallop shell, on which is carved, "Caddis Shell • Goddess Shell," with a minute waterfall; from it a memorable, exquisitely quiet trickle of water falls into the pool.

A large freestanding column on the edge of a small lake, Lochan Eck (which Finlay made in 1969 by damming a small stream), is a memorial, Saint-Just's Column. The inscription on the base, "The world has been empty since the Romans," is from the eighteenth-century French revolutionary, Louis-Antoine Léon de Saint-Just. On a rise overlooking the lake, another quote from Saint-Just, "The Present Order is the Disorder of the Future," is carved on eleven large stones.

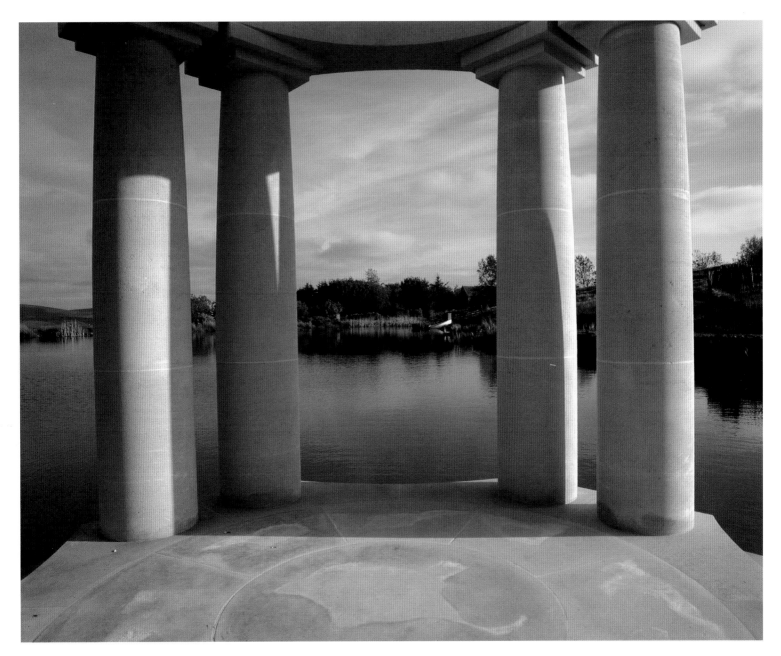

The Temple of Saint-Just, at the head of Lochan Eck, was built in 1994.

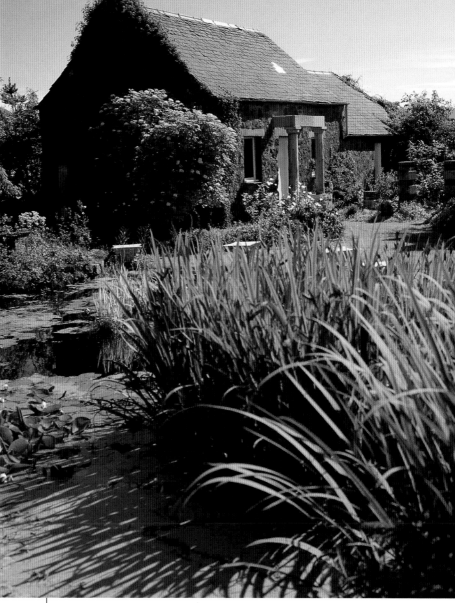

Alexander Pope also wrote, "Let not each beauty ev'ry where be spy'd, / Where half the skill is decently to hide." Finlay possesses much more than half this skill. Within his "sacred groves" and in the gently hilly landscape beyond are stunning discoveries at turns in a path, at focal points, attached to trees, and written in concrete pavers: carved stone classical memorials, columns, solar and seasonal sundials, and bronze emblems with poetic and witty wordplay and quotations from philosophers. One such inscription reads, "See Poussin / Hear Lorrain."

The approach to Little Sparta is up a steepish hill past three or four livestock and property gates. The perimeter is heavily planted with small trees and hedgerow shrubs, concealing the garden from the outside, and the outside from within. Once inside, Finlay's superb use of spatial contrast emerges through the occasional breaks in the tree and shrub boundary, giving wonderful long views out across the Pentland Hills as counterpoint to the garden's controlled beauty.

The basic orchestration of the garden spaces, in relation to each other and to the open rolling country, is the masterstroke of this garden. The enjoyment, serious cogitation, and amusement are intensified by the striking references and quotations and by the evocative names throughout Little Sparta: the Roman Garden, Henry Vaughan Walk, Sunk Garden, Mare Nostrum, and Raspberry Camouflage.

Temple Pool is the open link between the first grove and the subsequent ones. The most dramatic is the view out to Lochan Eck and the mountain beyond. On the edge of the loch is the inspired slate sculpture *Nuclear Sail*. With this work, Finlay added contemporary martial imagery to the classical, neoclassical, and revolutionary references in the garden. One bird table is a sculpture of an aircraft carrier; handsome gate piers are topped with splendid hand grenade finials, which from a distance may be read as eighteenth-century urns. Water is experienced throughout the garden in many imaginative configurations; at one point the stream is raised into a miniature Roman aqueduct.

Near the Temple Pool is the Temple of Philemon and Baucis,
a farm building transformed in honor
of the ancient Greek hero and heroine of hospitality.
Behind the temple is a neat vegetable garden.

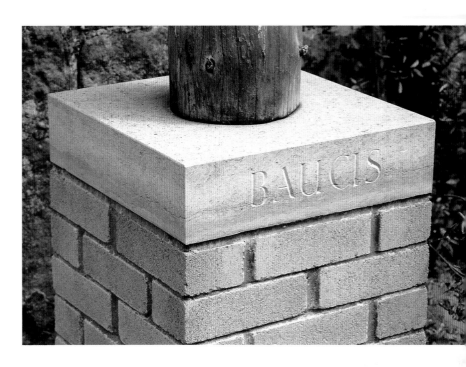

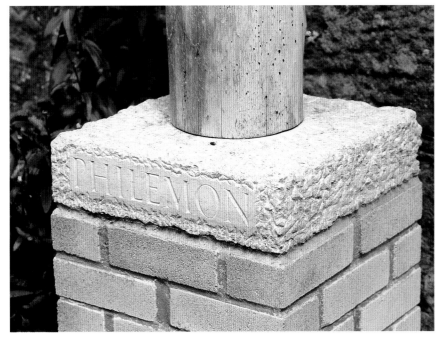

Above and left: The column supports at the entrance to the Temple of Philemon and Baucis.

Overleaf, left: "Apollon Terroriste"
is engraved on the resin-and-gold-leaf head of the god
(Finlay with Alexander Stoddart, 1988).

Overleaf, right: Dürer's signature
is carved into a stone in the Woodland Garden
(Finlay with Nicholas Sloan, 1980).

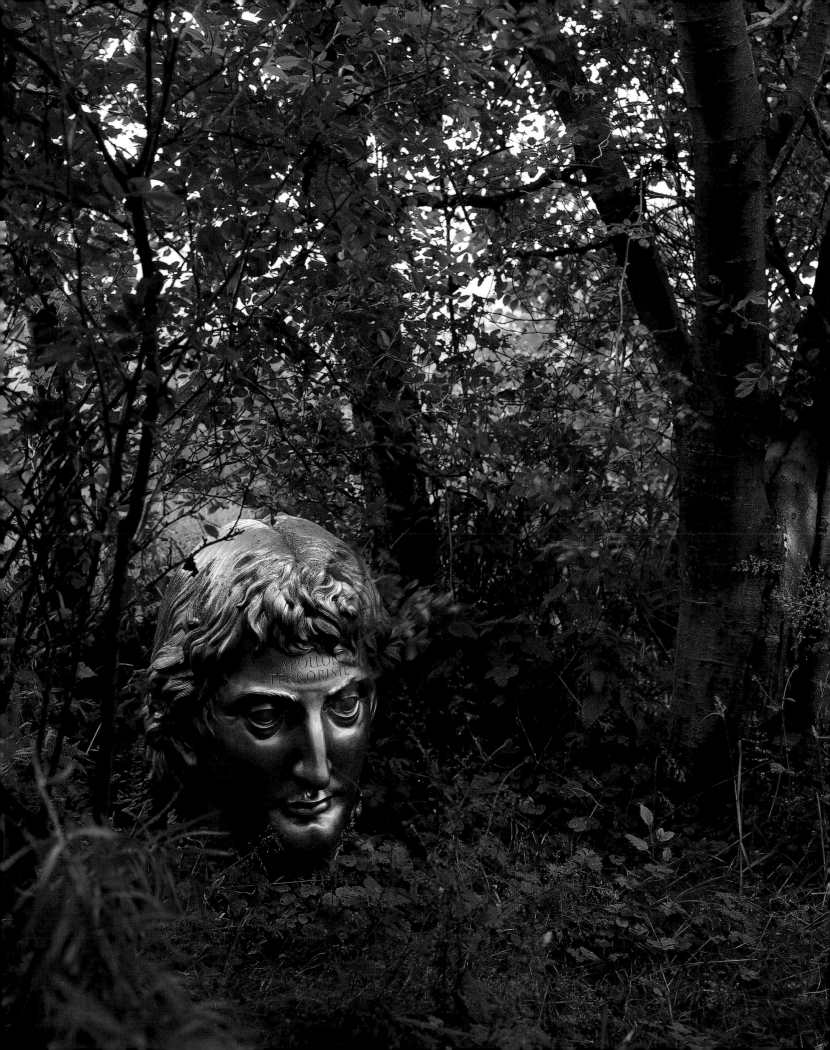

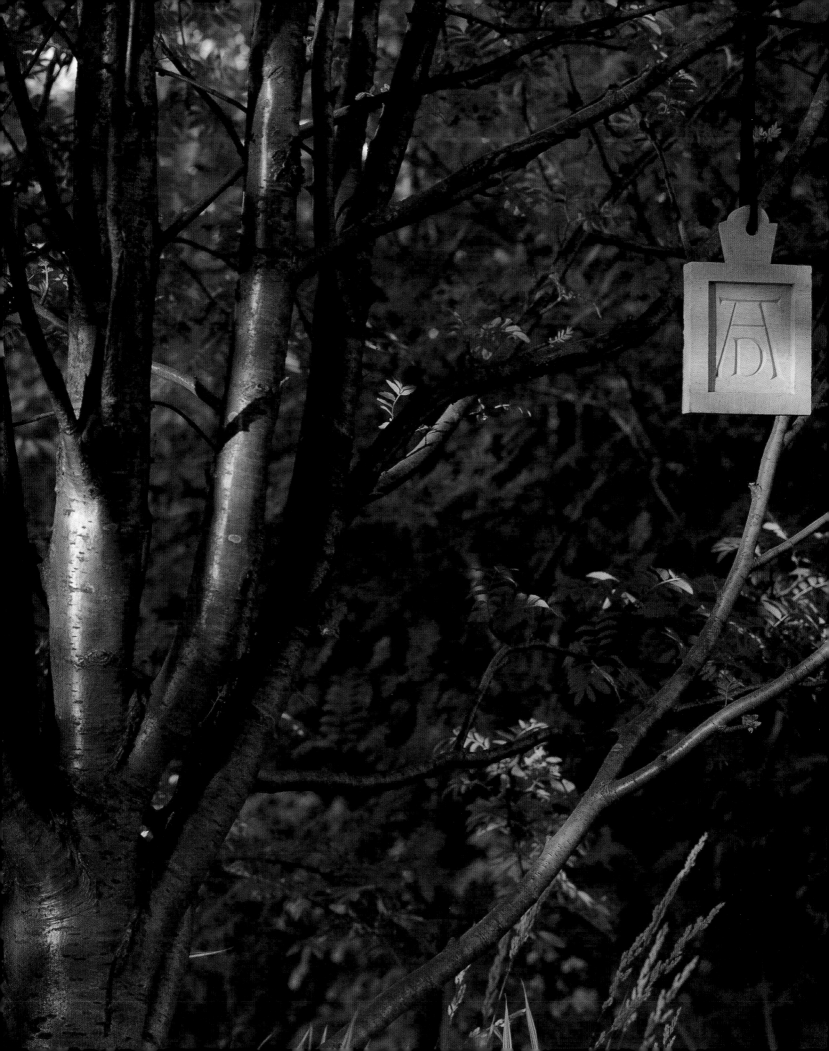

An unfinished Corinthian capital nestles in irises by the Upper Pool.

The "Tree-Column Base" on the hillside
Pantheon is inscribed to Michelet.

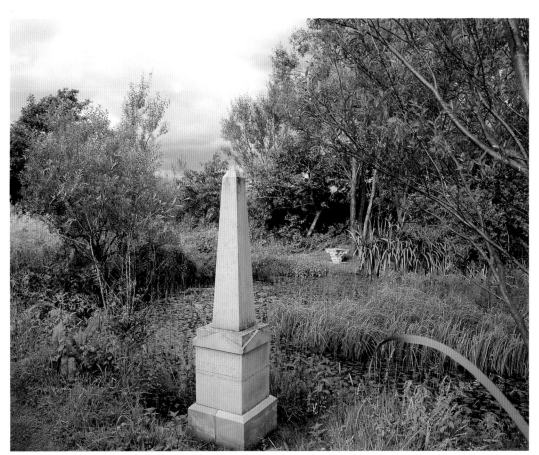

"The Peace of Claude" is engraved on a column
base at the Upper Pool. (Eighteenth-century
British landscape designers strove for the effect
of Claude Lorrain's paintings.)

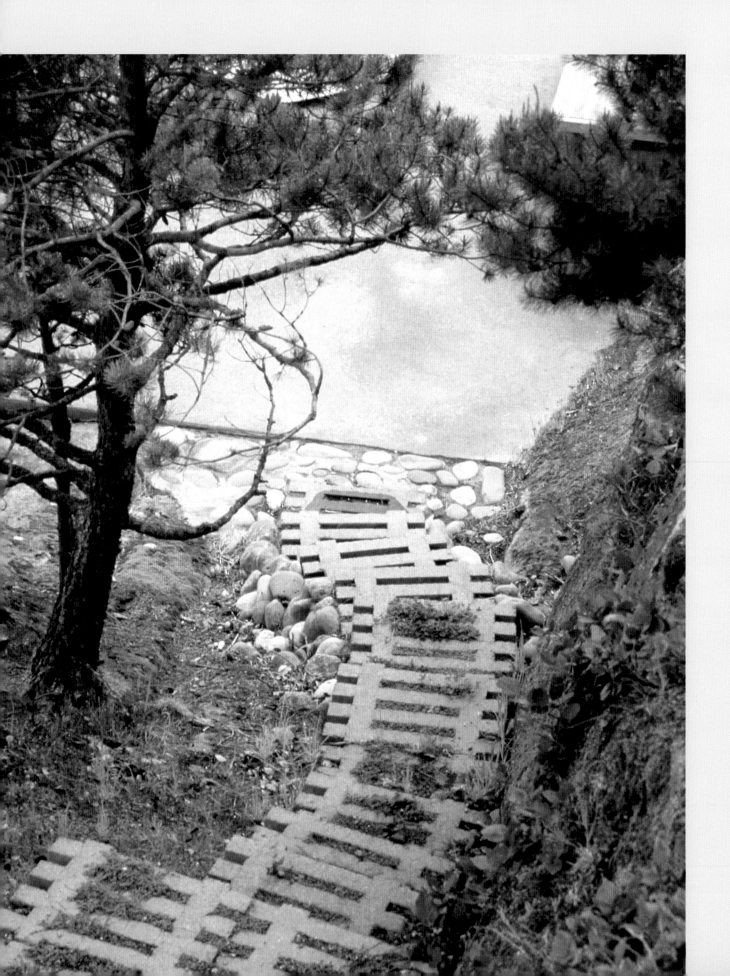

Richard Haag

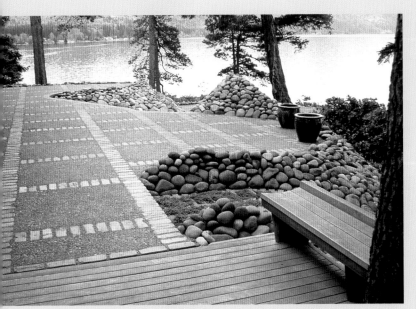

The sculptural stone drifts contrast with the regular brick grid of the terrace, which overlooks Lake Whatcom and the Olympic Mountains.

Opposite: Precast concrete modules form a simple path that both retains and gives access to the slope at the Kukes Garden. Low woodland plants grow in the earth-filled pockets in the steps.

the	COSMOS	is an experiment
the	UNIVERSE	is a park
the	EARTH	is a pleasure ground
	NATURE	is the theater
the	LANDSCAPE	is our stage
Let us	write	the script
	direct	the play
and	embrace	the audience
with compassion and joy		for LIFE

— *Richard Haag*

KUKES GARDEN, LAKE WHATCOM, BELLINGHAM, WASHINGTON

Lake Whatcom, about ten miles inland from Bellingham Bay, in northwest Washington, is an idyllic stretch of water with panoramic views of the Olympic Mountains. A meandering road leading from one lakeshore community into a mature evergreen forest brings visitors to the site of this house and garden. An extremely simple wooden archway with echoes of both Japanese temple gateways and English Arts and Crafts garden arches marks the entrance to this large "summer cabin," as luxurious second houses are called in this lake- and forest-covered part of the world. From the archway, a drive curves through some native pines down to a parking area in front of the wood, chalet-style, lakeside house. Brick and gravel paths, interspersed with decking, lead away from the front door and make a complete circuit around the house, revealing the view of water and mountains.

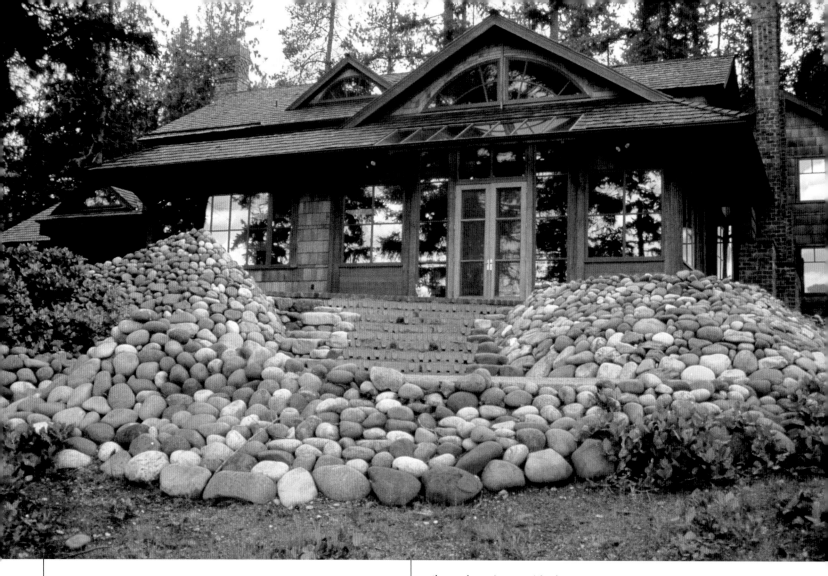

Fifty feet above the water, terraces extend the house so that there is a large area on which to sit or eat or contemplate the natural beauty of the site. Richard Haag's great attention to detail is evident everywhere in the landscape but particularly in the paths and terracing. The terraces are grids of old brick setts filled with smoothly tamped small-stone gravel. The precise grid makes a wonderful contrast to the sculptural drifts and mounds of large, smooth local stones. The beautifully rounded stones define areas and contours in the landscape; they have been carefully and sensitively placed to accent and complement the natural features of the promontory. A small hillock of these stones at the edge of the terrace is an artful design stroke, acting not only as a marker for the path down to the lake but also as a foreground reminder of the mountains across the lake.

At the foot of the path leading down from the terrace, Haag has designed a unique link from the water's edge to a covered wood dock for a speedboat. Four large stepping stones of pebble-faced concrete rectangles with rounded corners seem to float magically over the lake, connecting the rocky shore and the dock.

*Large concrete stepping stones lead from the shore to the wooden
speedboat port at the Kukes residence on Lake Whatcom.*

The randomly set darker pavers
in the Sommerville driveway show Haag's
great attention to detail; they also provide traction
during the long snowy Medina winters.

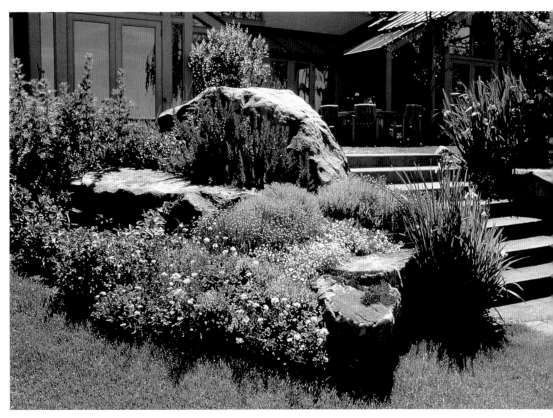

Haag calls the huge central boulder the "mother spirit" of the Sommerville Garden.
Surrounding it are other rocks and plantings of rosemary and santolina
(both green- and gray-leafed varieties) fronted by white verbena; all is contrasted
by the tall yellow sedge iris.

Opposite: In the Sommerville Garden in Medina, Washington, a mature birch
grows among large boulders interplanted with both evergreen and herbaceous
plants: liatrus, or blazing-star, in the center; variegated silvery rubus/ornamental
blackberry on the right; and drifts of white Arenaria montana tumbling
down the steps.

Shodo Suzuki

In the Chichibu roof garden, basalt stone sculptures are set on gravel among plantings of Equisetum hyemale, *the common scouring rush. The boundary is a contemporary version of traditional Japanese bamboo fencing.*

Opposite: The courtyard of the Chichibu house has squares of gravel, marble pavers from Taiwan, and low-growing ground cover of moss, Polytrichum formosum, *with three multi-stemmed* Stewartia pseudocamellia *trees.*

It is no wonder that modern art is related to the natural sciences. I have consciously taken up this relationship in my concept of landscape design. I believe it is very appropriate to adopt forms based on the fundamental principles of the physical world—including those from the macro- and micro-views.

I think highly of this viewpoint. The horizontal and vertical line and surfaces based on perpendicular lines, oblique lines and circles, squares, triangles, parabolae, circular arcs and revolutions are preferable to the conventional freehand line used in the eighteenth and nineteenth centuries.

—Shodo Suzuki

GARDEN, CHICHIBU, JAPAN

Shodo Suzuki is one of the most respected and revered landscape architects in Japan. His philosophy of the landscape is embodied in what he calls the past and the present/future of his country, based on and influenced by its environment and ecology. His present/future landscape architecture projects, mainly in public designs, are enormously influential internationally, particularly in the United States.

His public landscapes and gardens include community centers, parks, factories, housing developments, museums, subway stations, universities, country clubs, plazas, and hotels. Stainless steel, fiber-optic lighting, stone terraces fragmenting into lawns or shrub plantings, contrasting gravels, and rough- and smooth-finished granites are some of the elements in Suzuki's leading-edge designs for public landscapes.

The rich religious past of Japan is more evident in Suzuki's private gardens than in his public projects. Shinto, various Buddhist and Taoist sects, and the teachings of Confucius are his main religious influences. Shinto is Japan's primary religion, and it informs all aspects of Japanese culture. The religion expresses deep reverence for all of nature, including the landscape; a splendid rock, a beautiful waterfall, or a unique tree is each considered divine. Nature is respected, and humans thought to be on a par with stones, plants, and streams. Not surprisingly, Shinto shrines fit seamlessly into their natural landscapes.

Buddhism entered Japan from China in the sixth century A.D. and has become the country's other main cultural and spiritual influence. It enhanced the Japanese respect and worship of nature with a more universal philosophy of reincarnation, which included a spiritual advancement into plants and other natural phenomena.

Over many centuries, these religious roots, limited ground space, and the development of the particular type of Japanese architecture which placed the house or Buddhist temple within an enclosed private courtyard were central to the evolution of the traditional Japanese garden. Suzuki takes the main elements of the Buddhist temple garden—stone, water, moss, gravel, and a limited number of plants—and uses them in a masterly way. The other, equally important quality in Japanese gardens is the arrangement of these elements in space: the simple, spiritually based aesthetic of the Japanese garden comes from the harmonious placement of a few carefully chosen elements in a limited space.

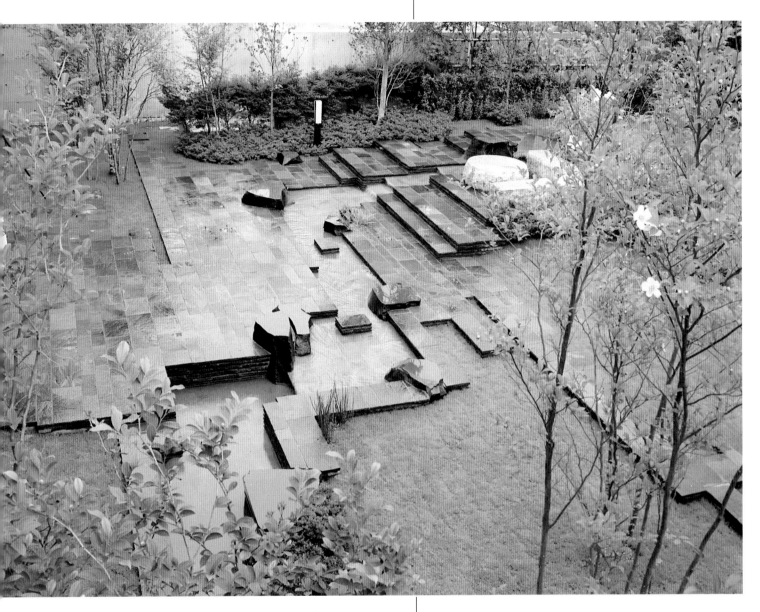

This page and opposite: The main garden of the Chichibu residence features traditional Japanese elements: natural and shaped stone, water, and simple plantings, as well as the Stewartia pseudocamellia *trees of the courtyard garden.*

The Japanese plant palette is somewhat restricted and includes pine, bamboo, prunus, camellia, azalea, magnolia, maple, and some hardy evergreen perennials. The use of these traditional materials, designed and configured as extensions of twentieth-century Japanese houses, gives Suzuki's private garden designs their excitement and beauty.

In 1981, in a large courtyard for a client in Chichibu, he designed a splendid garden of stone terrace and steps that extend the drawing room. The terrace ends at the edge of an angular water course dividing the garden. The far side of the controlled stream has steps that rise gently, climaxing in a massive stone drum table. At a right angle to one side of it are two large stones for bench seats.

Naturally shaped stone contrasts to rectilinear forms in Suzuki's Hasuda Garden in Kyoto.

Plan of the Chichibu Garden.

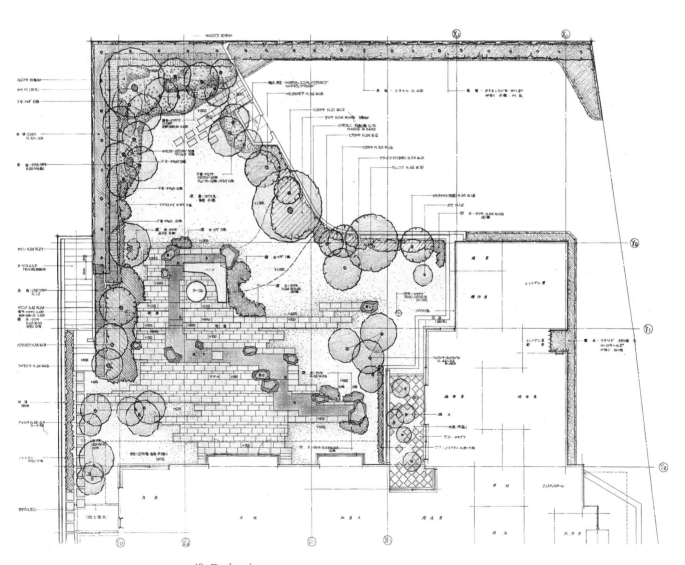

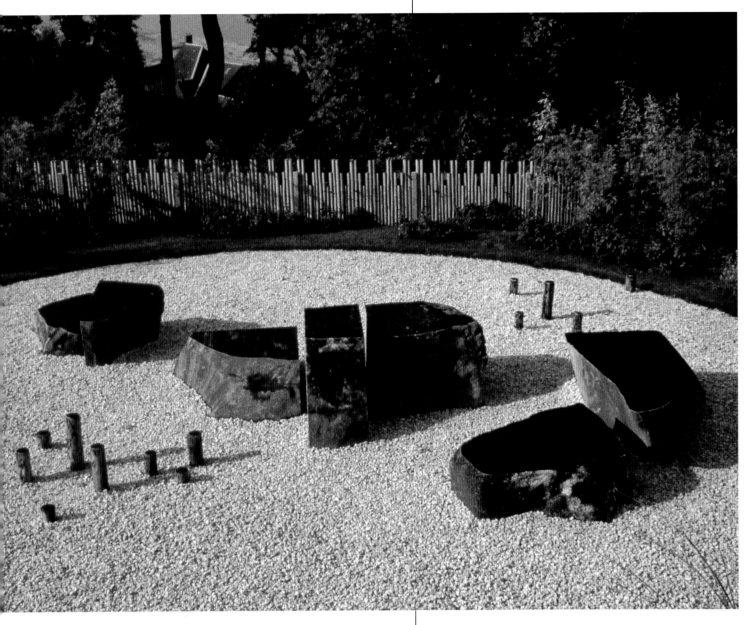

Suzuki created this contemporary Zen design in 1995 for the International Garden Festival, Château de Chaumont, Amboise, France. It is named "The Archipelago"; its theme is the imagination in crisis. Plants are bamboo, Hypericum calycinum, Salvia nemerosa, *and* Iris pseudoacorus.

The superb simplicity of this garden is heightened by the asymmetrical placement of natural flat-topped stones. They are beautifully set on the edge of or in the angular watercourse running through the terrace and the steps, which have low, luxurious risers. Juxtaposed to these stones are lawns through which runs a narrow, raised cut-stone path. The contrast between the natural stone shapes and the precisely cut stone of the terrace and steps enhances the drama of this design. Suzuki's subtle use of garden lighting adds to the atmosphere and enchantment of the garden.

"I have made many attempts besides this one to attach functional utility to gardens," Suzuki has said. "In designing a garden I always put priority on its usefulness, but it does not follow that this suffices for all needs. Naturally, I take aesthetic values into consideration too. The owner takes pleasure in entertaining guests in this garden as well as in the drawing room."

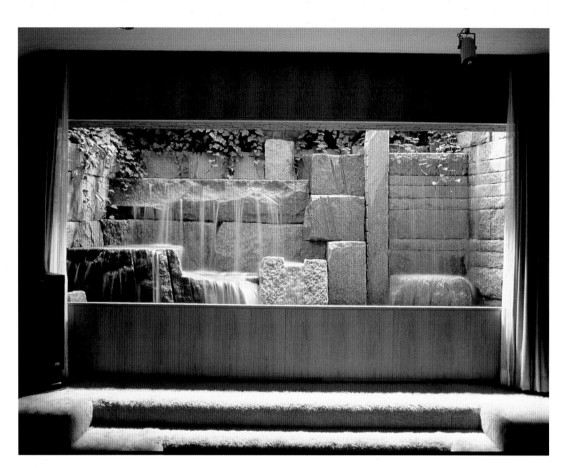

This page and opposite: Suzuki calls this viewing courtyard of stone and water in Hongo "Abstract Expression of the Cascade Scenery of Japan." The only plant is ivy, Hedera canariensis.

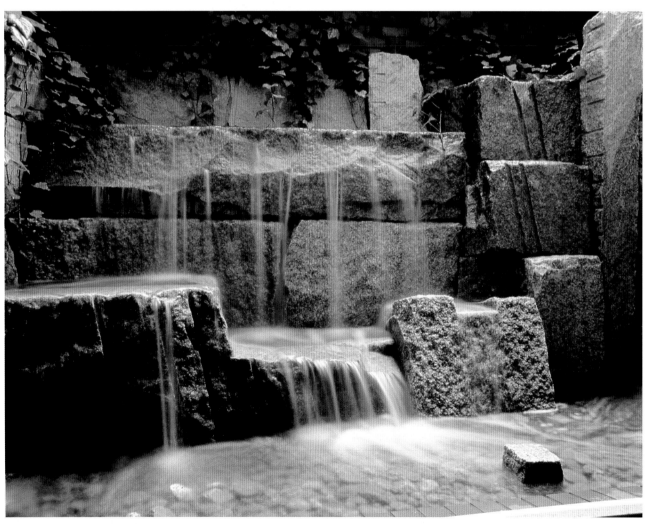

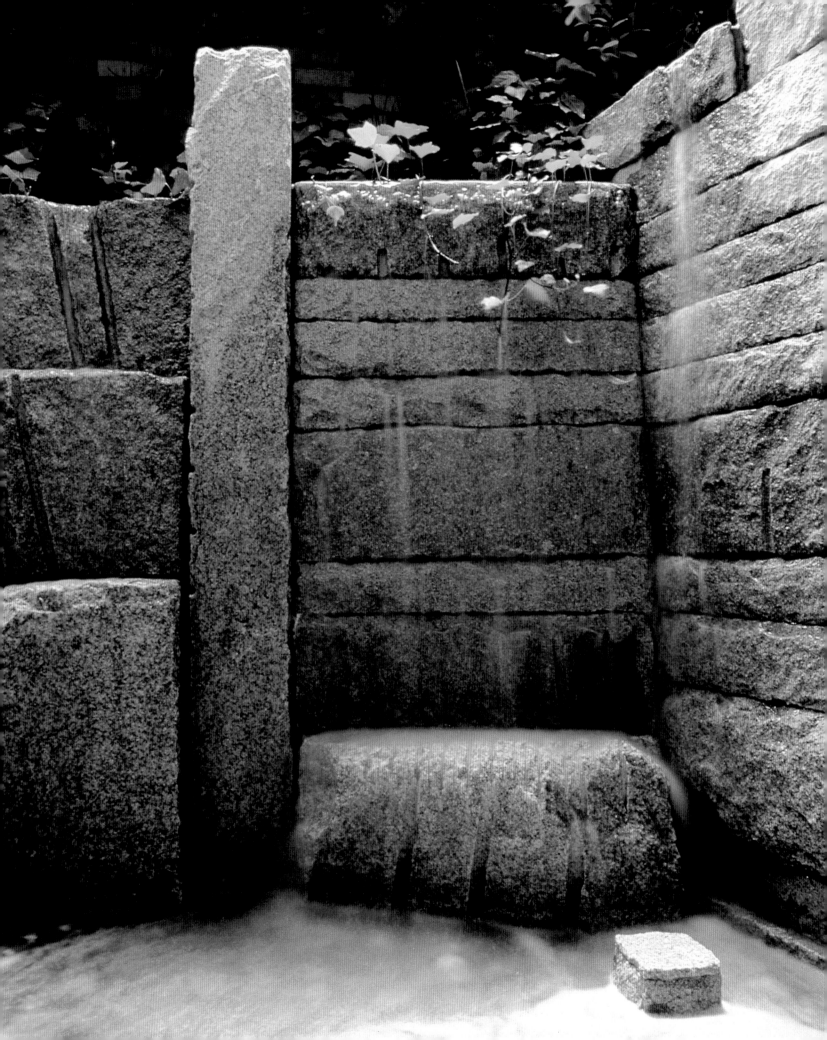

*This page and opposite: Boardwalks stretch throughout
this eighty-acre Grand Isle Garden. The wood joinery details were inspired by local
Adirondack crafts and Japanese construction.*

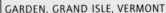

Susan Child

To me, the objective of landscape is to create a work of art. True, it is not an insular art that does not serve people in a functional way like architecture; it is an art at the service of people.

—*Susan Child*

GARDEN, GRAND ISLE, VERMONT

The island site of this garden has dramatic views across Lake Champlain to the Adirondacks in the west and the Green Mountains in the east. From 1988 to 1991, Child Associates worked on gently improving its eighty acres, which include lakeshore, a cove, wetlands, a meadow, a cedar forest, and a beech woodland with some stands of birch trees. The one-story wood house sits in a clearing between the forest and the woodland, within twenty feet of the shoreline.

Good landscape design is often about encouraging visitors to move somewhat unconsciously from point to point through a garden, stopping to admire a view and then continuing their exploration. This need not always be done with a conventional path system. Here, where a major concern was to conserve the landscape, along with the requirement of minimum maintenance, wood boardwalks became essential elements in the design. They also protect the walker from poison oak, which grows vigorously in this area.

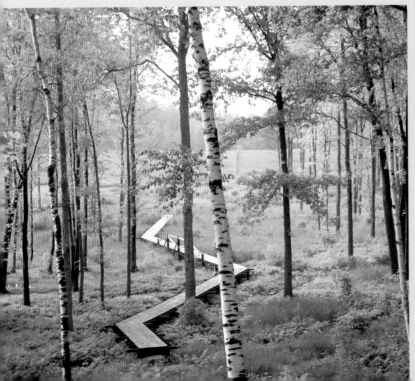

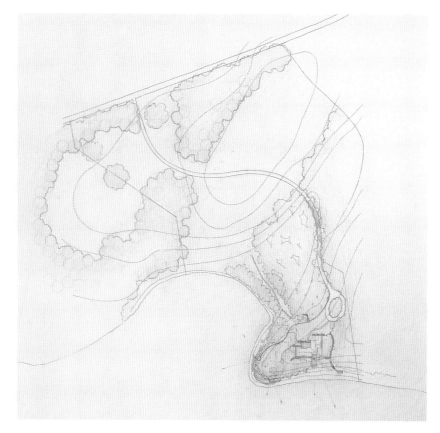

Plan of the Grand Isle garden.

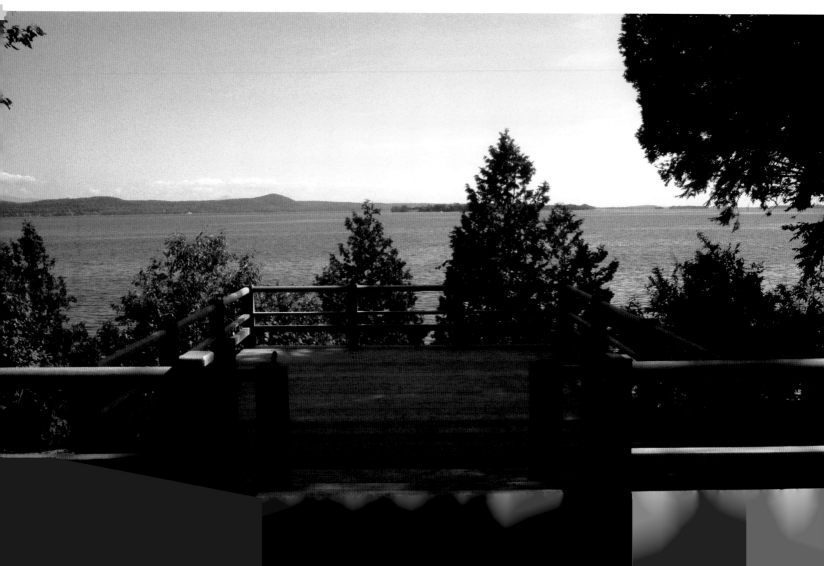

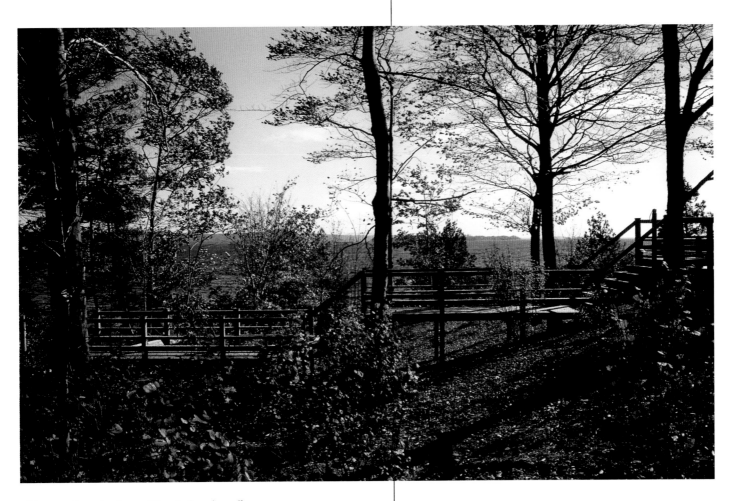

This page and opposite, bottom: The raised wooden walkways through native birch, cedar, and beech trees in the Grand Isle garden provide viewing points out to Lake Champlain.

Although these boardwalks have been very carefully constructed, they do not always connect. It is intriguing to start an investigation through the woods and then find that the zigzagging wooden path stops in the middle. A little careful observation reveals where it starts again, and one can continue through meadows or through another grove of trees or down to the shore. Observation platforms have been built at various points; in one case a hexagonal pavilion has been built, with columns of tree trunks covered with a six-sided copper roof.

By the shore, a wood staircase nestles against some boulders, and a vague outline of a path suggests another way of reaching the terraces in front of the house. These terraces are in fact a bilevel deck with sensational views over the lake. Here Child's clients and their guests can relax and contemplate the lake, which stretches away into the distance.

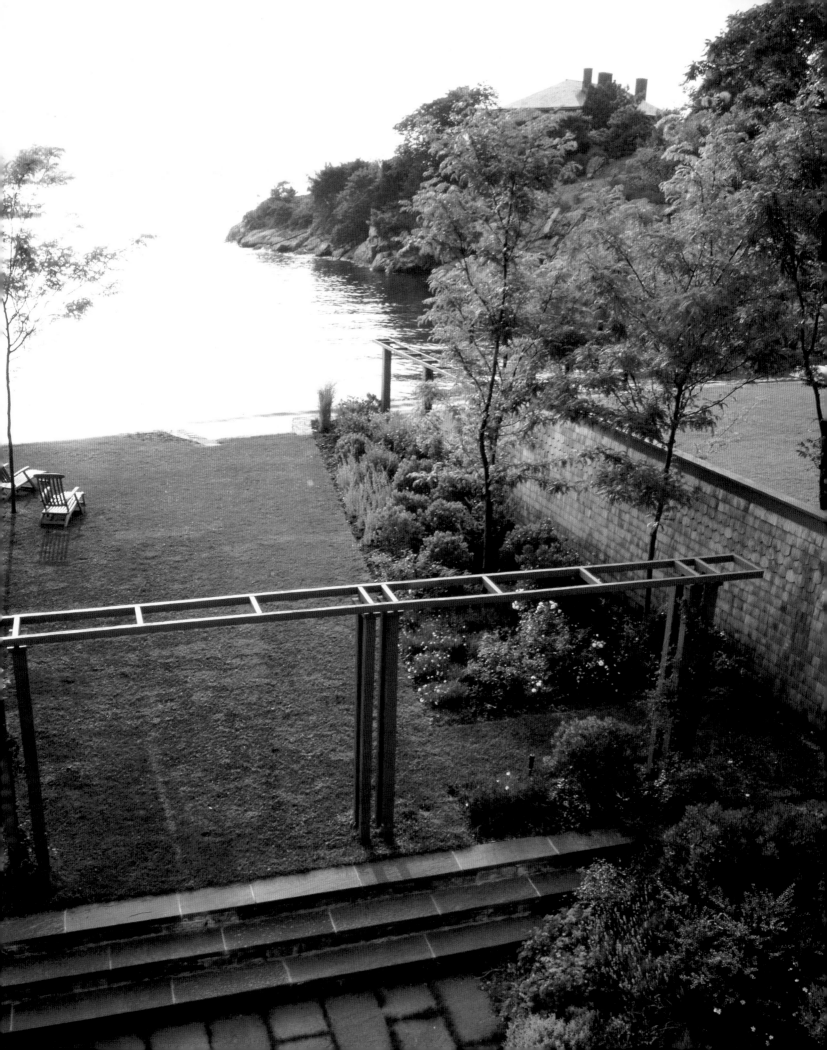

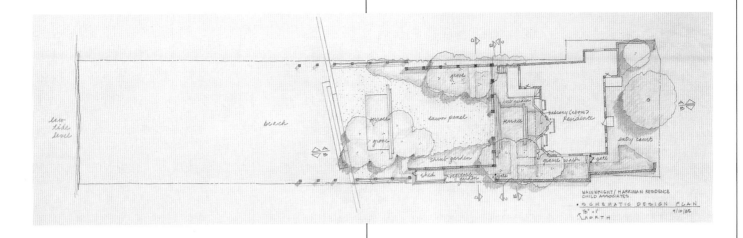

Plan of the Seaside Garden.

*Opposite: A wooden pergola divides the lowered terrace
from the lawn at the Seaside Garden. Susan Child calls the design
a "viewshed" to the harbor.*

*Tucked into the weathered shingle boundary walls of the Seaside
Garden are lighting shields. One part of the border contains
a species of perovksia backed by large purple buddleia.*

SEASIDE GARDEN, GLOUCESTER, MASSACHUSETTS

One of the unique aspects of this site on Cape Ann, Massachusetts, is that even though the house is on the East Coast, it faces west across a small cove, so the clients are able to experience the sun setting into the water, an experience usually reserved for Americans living on the West Coast.

The frontage of the property, one-sixteenth of an acre, is a very narrow slice of land only slightly larger than the width of the house. There are neighbors on either side of the house, so an immediate need was to give privacy, while emphasizing the dramatic view across the cove. This was achieved by building ten-foot-high freestanding shingle walls and trellises on both sides of the property. These are connected by an elegant, narrow wood pergola that divides the patio area from the lawn and frames the view. The terrace immediately in front of the house was lowered to allow more direct access from the ground-floor rooms and to give some protection from strong sea breezes. The elevated lawn between the terrace and an invisible sea wall appears to increase the distance between the viewer and the water.

Borders on both sides of the lawn are filled with perennials and at the waterside end of one of them is a grove of honey locust trees. A twin grove is set asymmetrically next to the house in the opposite border. One of the shingle walls disguises a gardening shed.

Every aspect of this small garden has been carefully considered, and it has responded brilliantly to its changes of use over the last ten years. The clients, who were childless when it was designed, now have four children, yet the space is as amenable to their games as it was to its original purposes of summer living, dining, and water and garden viewing.

GARDEN, RICHMOND, MASSACHUSETTS

The credo for Child's approach to design could be this quote from "Where I Lived, and What I Lived For," by Henry David Thoreau: "Our life is frittered away by detail . . . Simplify, simplify."

Fifty acres is quite big for a private landscape or garden. Yet there is nothing aggressive or overpowering about Susan Child's design for this site in the Berkshire Mountains. Indeed, the design has very subtly connected the three main elements here: an old Shaker farmhouse, a mountain and surrounding hills, and the lake made from a water-filled abandoned quarry. Part of this sense of connection is a result of the design's inspiration in the simple, geometrical farmsteads and communities of the Shakers—Child's design expresses the basic Shaker ideas of simplicity, utility, and economy.

On one side of a comfortably sized old Shaker farmhouse is a two-story barn so settled in that it looks as if it has been there for at least a couple of centuries. The other side, what could be called the garden side, has a brick terrace spacious enough for a number of people to take a meal and relax. Beyond this, the land gently falls away for about three hundred feet down to the water-filled quarry. Woods screen the back of the lake, and a tree-covered hill shelters the site from the east.

Earth was moved to sculpt the land, encircling the house into wide meadow and lawn terraces focusing on views to the lake, the valley, and the hills. The terraces are retained by low fieldstone walls with ramp ends. This is a contemporary variation on the most traditional New England form of wall building; in this segmented form the walls take on an abstract quality, yet they resonate with the simplicity of the landscape, the clapboard house, and the history of the area.

Visitors are inevitably drawn toward the lake; from it, a mown path leads into the woods behind the lake. Once in the trees, the path becomes a narrow wooden walkway raised about one foot above the ground, protecting the woods' undergrowth. Occasionally, where the pathway veers almost to the edge of the lake, the trees have been thinned a little, and the farmhouse set on its recessive lawn terrace is visible across the water.

Halfway around the lake, the path emerges again, and the view reveals lakeside slopes where boulders have been set irregularly in a satisfying pattern. From this vantage point, too, there is a view of nine fruit trees planted in a formal grid, and beside them an iron fruit cage designed on another nine-point system, a further reference to Shaker methods of

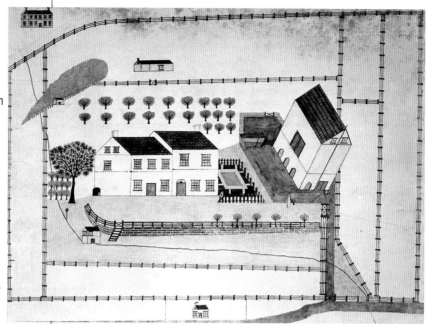

An early American picture of a Quaker homestead.

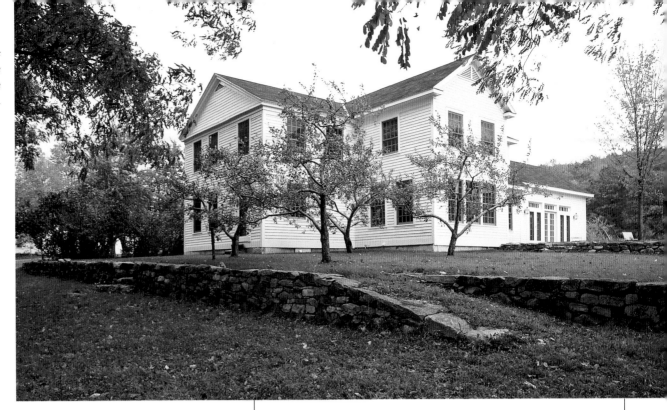

A grid of fruit trees adjacent to the Richmond farmhouse provides a domestic scale within the larger landscape.

The upper window of the house looks across the lawn terraces and quarry lake to the panorama of the Berkshire Mountains. The simple geometric pattern of the brick terrace is reminiscent of Shaker designs.

Overleaf: Fieldstone walls retain lawn terraces and ramps; they also focus views and integrate the Richmond house and landscape with the trees of the Berkshire Mountains.

organization. An irregular stream of sculptural boulders defines the rising ground to the tennis court; adjacent and overlooked by the house is an enclosed vegetable garden.

The site's transformation disguises entirely the mechanics of drainage, foundations, irrigation, and lighting. And because the house is used as a second home, maintenance is also kept to a minimum. But the brilliance of the landscape's creation lies in the simplicity of what is seen now. When the owners bought it five years ago, apart from the quarry lake, there was only a small house, the old barn, and the detritus of a failed farm. Yet today it would seem that nothing has changed in this serene, natural-seeming landscape during the past two hundred years.

Visible from the living room are the Fukuda Garden's sculptural stone waterfalls, pools, and meandering stream—one foot wide and two inches deep. Rocks and gravel-finished concrete edge the stream. Plantings of mat-forming moss, Polytrichum formosum, *in the foreground, ferns, marsh marigold, and decorative grass,* Miscanthus zebrinus, *contrast with the stone and water.*

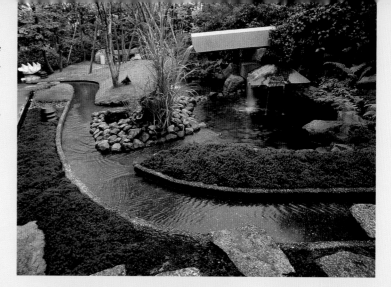

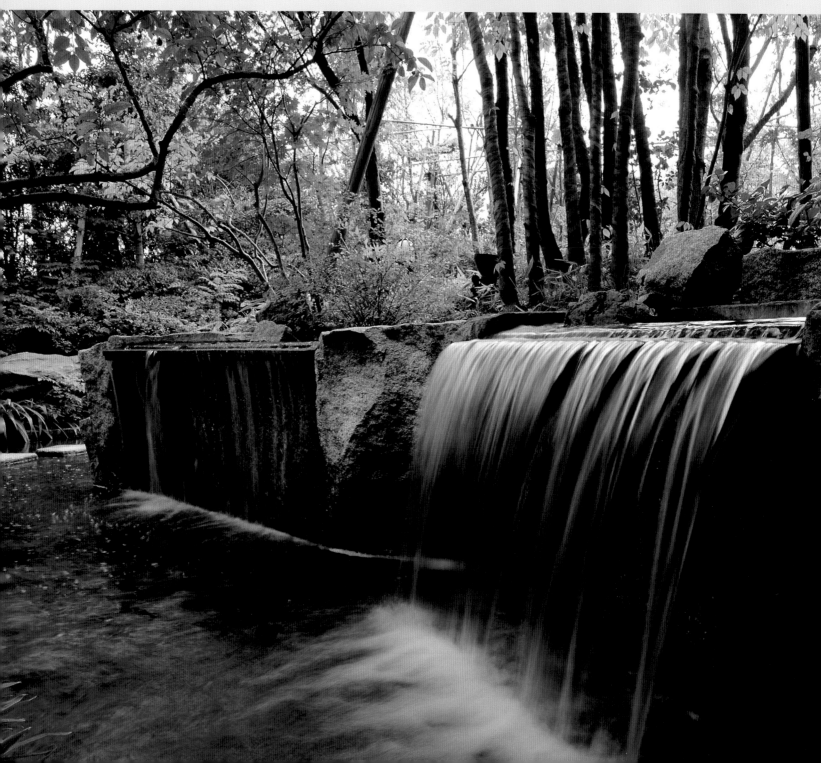

Motoo Yoshimura

Reverence of Nature and the Gifts it Bestows: The distinguishing characteristic of Japanese gardens, simply stated, might be expressed as that which attempts to manifest in the form of a garden the desire to assimilate and become one with Nature. Created not only for pure pleasure, the garden inspired the desire for total harmony with Nature. To some, even the thought of dying to experience the vision of Paradise the garden provided was not unusual.

—*Motoo Yoshimura*

FUKUDA GARDEN, KYOTO, JAPAN

Motoo Yoshimura has a profound sense of the ecology and environment of his native country. From its mountains comes the resource of water, both beneficial and destructive, nurturing the rice fields and devastating the land at flood tide. And Japan has four distinct and varied seasons marked by certain plants and trees: Spring brings the first plum blossoms, irises bloom during the rainy period, and finally the wonderful show of the worshipped cherry arrives. Summer flourishes are mimosa and crepe myrtle, autumn brings the many colors of the magnificent maple, and winter bleakness can show the large golden fruit of the Chinese quince.

Some of these trees were used in Yoshimura's extraordinary large garden for the Fukuda family in the densely industrialized area of southern Kyoto. The garden is used not only for relaxation and meditation by the family but also for larger-scale entertaining, as the building also contains an office. It is a stroll garden, part of the landscape tradition of the imperial villas and noble mansions of medieval Japan, the earliest and most famous of which is the Imperial Katsura Villa, also in Kyoto.

A pair of bold granite waterfall sculptures in the Fukuda Garden front a grove of large zelkova trees, maples, and shrub plantings of camellia, Arundinaria fortunei, *and* Aralia elata— *Japanese angelica tree.*

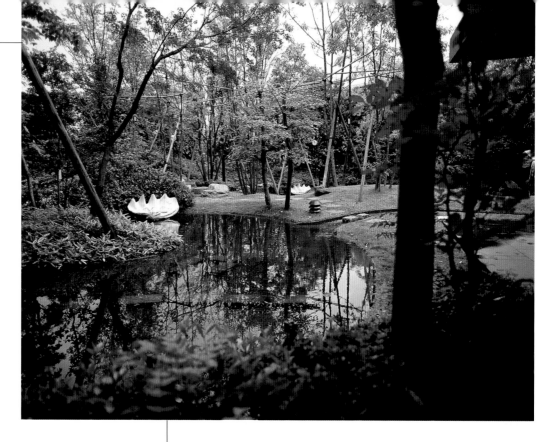

The ground plane of the Fukuda Garden changes easily and gently in relation to the changes of level of the house. The continuous stone terrace creates the facile transition between the house and the garden—between the indoor and the outdoor—that is a traditional aspect of Japanese landscape design. The floor-to-ceiling views of the garden that would have once been revealed when the traditional shoji screens were removed now come through modern plate-glass walls.

The house is designed in the famous "flying geese" pattern—the various sections of the house stand at right angles to each other. All of the streams and water features of the garden can be seen and enjoyed from every room of the south-facing house. At the main entrance, the lowest part of the garden, the lower pond, and two waterfalls greet visitors. Stepping stones in the middle of the pond curve invitingly around one of the waterfalls, leading to the main upper part of the garden, which is viewed from the family's living quarters. Five groups of large sculptural stones along the way can be used as seats.

Yoshimura's use of the traditional element of water is stunning. The centerpiece is a sinuous meandering stream, along which there are four ponds. In each pond is a waterfall from a stone sculpture, each of a slightly different height and width; the resultant sounds have different musical resonances. The falling water represents pure, natural water coming from springs high up in the mountains.

Two other masterstrokes in Yoshimura's design are the placement of two giant glowing white seashells as sculptural elements and three-tiered, matte-black metal garden lights that might have come from the battle kit of a samurai. The seashells bring another reference from nature into the garden—the sea surrounding the islands of Japan.

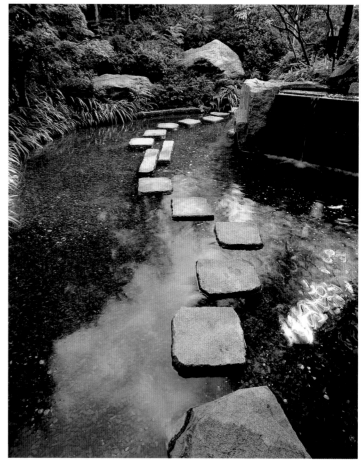

The tantalizing curve of stepping stones in the Fukuda stream echoes an imperial stroll garden.

Motoo Yoshimura

Opposite, top: A quiet reflecting pond in the Fukuda Garden is encircled by lawn and a stand of sasa bamboo. Giant clam shells are symbols of Japan's island geography. Carefully scaled posts and bamboos poles restrain and shape the trees.

A grove of trees and a deep pool are the most sacred places in the Fukuda Garden. The trees include maples and parrotia; main shrubs are laurels, mahonia, and royal and polypodium ferns. Each stone waterfall plays a different musical note. The sculpture on the right symbolizes a white bird with spread wings about to fly out of the woods; it is the headwater for the falls and stream in the garden.

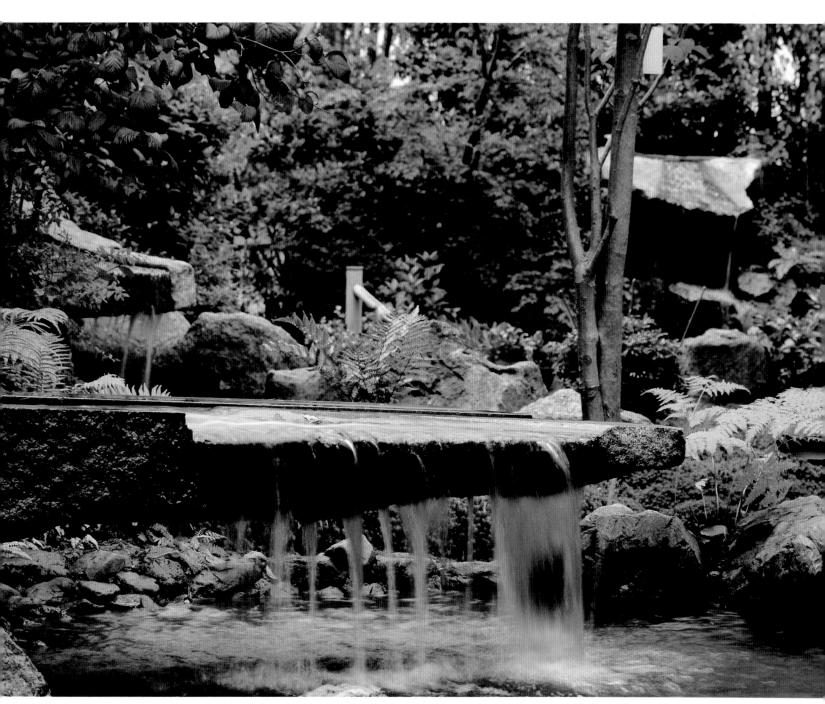

65

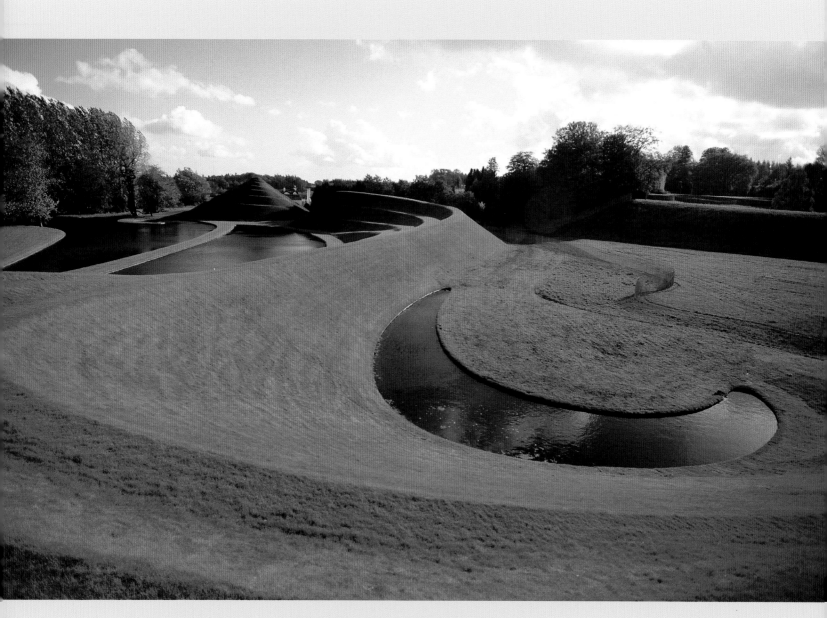

A landscape of twists, folds, and waves of energy resulted from Charles Jencks's obsession with complexity science and chaos theory. These themes inspired the curved ponds and grassed double-wave earthworks.

Charles Jencks & Maggie Keswick

GARDEN, DUMFRIESSHIRE, SCOTLAND

Charles Jencks and his wife, the late Maggie Keswick, collaborated on the design and installation of this extraordinary private garden and landscape in southwestern Scotland; Jencks continues to add new elements. Together, they decided that the three-hundred-acre grounds could be molded and shaped to manifest some of their theories and interests. Keswick's interest in *feng shui*, the ancient Chinese form of geomancy, and chaos theory, a recent focus of Jencks's, are the two bases for this large-scale design. These strands of inspiration, combined with massive diggers and earthmovers and the skills of a carpenter and a mason, have resulted in this truly spectacular creation.

Jencks is well known as the critic who first defined the postmodern in architecture. He continues to document new trends; in his latest book, *The Architecture of the Jumping Universe*, he writes:

> The universe, it now appears, is much more creative, self-organizing and unpredictable than anyone had thought twenty years ago, when it was most commonly thought of as a complex machine. Contrary to the Newtonian view of scientific determinism and the Christian view of Genesis, the universe is, in fact, cosmogenic, meaning that it jumps all of the time to new levels of organization . . . The new sciences of complexity, of which chaos is just one of twenty, show the omnipresence of these sudden leaps at all scales.

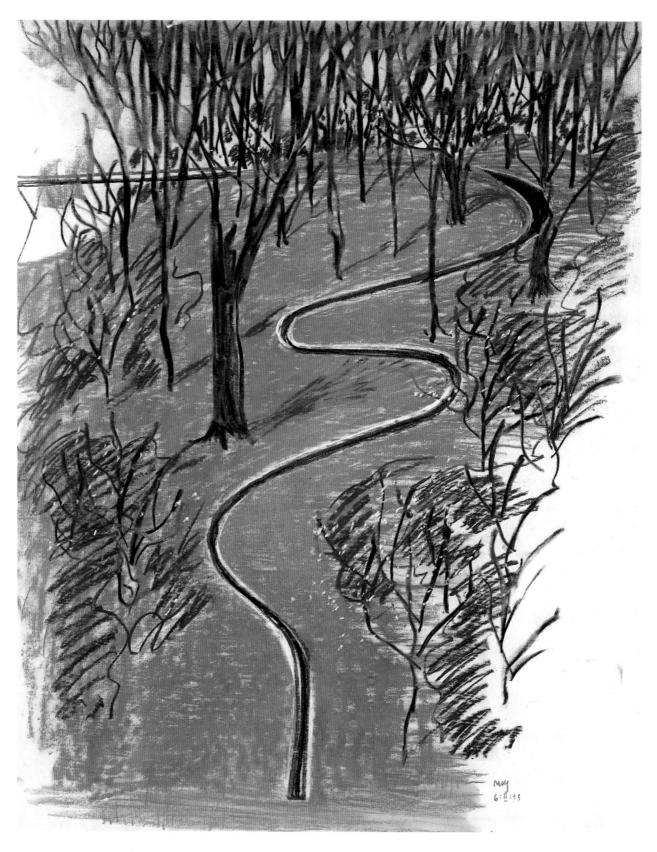

Maggie Keswick drew this fiber-optic stream for a house and garden near Cleveland, Ohio. She collaborated with Frank Gehry, Philip Johnson, and Claes Oldenburg.

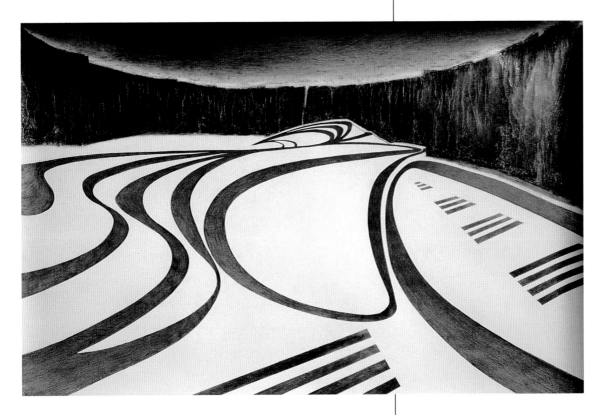

This drawing shows the ponds, twists, and double-wave earthworks of the Jencks/Keswick collaboration.

Folds and twists adorn the Dragon Dance Room, the kitchen/dining room. It is one end of the main axis of this remarkable landscape.

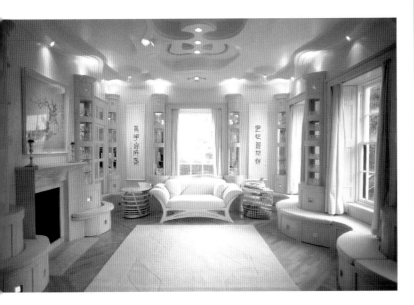

Keswick was a leading authority on Chinese gardens and their design. Chinese geomancy comes from the Taoist tradition of seeing in the topography of the earth, in its winds, waters, valleys, hills, and mountains, what monks and philosophers following Lao-Tzu called the "bones of the earth." They all have currents of energy, *ch'i*, the vital spirit or "cosmic breath of subterranean dragons." These energy currents are dependent on the siting of houses, places of business, and most importantly of all, graves.

In this garden, Jencks has made a tremendous jump in the universe of landscape design. The basis for some rooms in the house and the elements in the landscape was the fact that nature's basic forms are non-linear—curved and continuously changing—forming patterns of folds and waves. Some other primary forms used in the garden came from the shapes of snakes, worms, snails, and dragons.

Jencks says that the garden starts in the kitchen/dining room, what he calls the Dragon Dance Room. On axis from this room and down the steep slope of the ground, Jencks and Keswick planned a series of gardens, some of which are not yet realized, with evocative and witty names. Nearest the house will be the Dry Cascade, linked at the bottom to a large hedge-enclosed apse or semicircle, the future location of the Maze Brain, a foot maze made of white pebbles and green grass. Next on the axis is a *Cupressus leylandii* hedge–bounded tennis court called the Garden of Fair Play.

Inside this eighteenth-century folly is a fractal design by Jencks based on the work of computer scientist Benoit Mandelbrot. Fractals exist between one, two, and three dimensions and are found throughout nature. Below is the Giant Dragon Ha Ha, two intersecting curves of grass and two types of diagonally laid local stone.

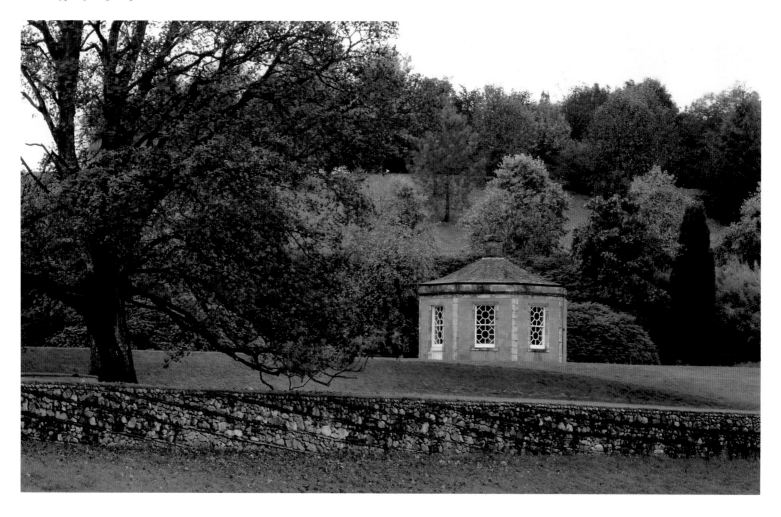

Adjacent to the future site of the Maze Brain is the Physics Garden—a pun on the "physick gardens" of Medieval times—where flowers and fruit are grown. Enclosing one side is a pair of walls of local red sandstone, with a top profile of gentle humps, the Dragon Walls. Views into the garden are through windows in three geometric shapes: a circle for Edible/Harmony, a square for Physical/Reason, and a triangle for Kitchen/Justice. The stone frames and decorative stone grills, constructed by a local mason, Hugh Drysdale, are similar to some in the gardens of Soochow and Hangchow. In the Physics Garden's formal parterre are partly constructed designs that Jencks calls "the six little physics," meant to represent taste, smell, touch, sight, hearing, and his newly invented sense, anticipation.

The Dragon Walls lead to other outbuildings, which have become guest houses, music rooms, library workrooms, and greenhouses. Here there is a working out of more of Jencks's and Keswick's theories and knowledge. From a distance the ridge on the greenhouses appears to be the typical Victorian pretty metal running decoration. Not so; it is wittier and more serious. The ridge is in fact made up of the numbers and letters of the great formulas of mathematics and physics that explain the workings of the universe, fixed to a pair of metal rods running the length of the greenhouses. These rods not only hold the formulas upright, they are also the equal sign, when necessary.

Some other serious but playful garden ornaments are the gate pier finials at entrances to the Physics Garden. The finials are spherical metal models of some of the main conceptions of the universe: the atomic, constellational, armillary, Ptolomaic, and Gaia hypotheses. The last is the name for mother earth, for the ecology and totality of nature. Jencks says Gaia was the epitome of what he calls Old Europe, and that "Gaia, the pre-Greek name for Mother Earth, was a cultural focus for 5,000 years prior to the current focus, Father God. Old Europe enjoyed peace and the arts. New Europe prefers war and money."

In Jencks's model of the Gaia hypothesis, which is central to the complexity theory of the universe, he represents the history of the universe as a spiral of interacting forces. The entwining snake-like bands show the tight coupling of life with physical and chemical elements, all working together for the benefit of life.

The summation in this landscape of Jencks's theories is the grass-covered spiral mound and double-snake or double-wave earthworks as the climaxes of the long axis from the Dragon Dance Room through the garden. The mound had been called by several different names during its making—a snail, a ziggurat, a mount, and a spiral mound. Whatever it is called, it is a dramatic experience of an ancient, elemental shape. From the fifty-foot-high spiral mound the views over the four-hundred-foot-long, thirty-five-foot-high grassy double waves and the house on the hill are spectacular and satisfying.

The Dragon Walls bound the Physics Garden. Carved into a hump is a geometric grille and the ironic label "Kitchen/Justice."

Opposite, top: Gate finials at an entrance to the Physics Garden are spherical metal models of conceptions of the cosmos: macrocosm (the universe), mesocosm (the Gaia hypothesis), and microcosm (the atom). Jencks worked with scientists to devise the models; they are the first of their kind.

Opposite, bottom: Soliton waves, representing pulses of energy, were discovered in 1834 by a Scottish engineer; Jencks transformed them into the Soliton Gate. The latch and support are punctuated with fossils.

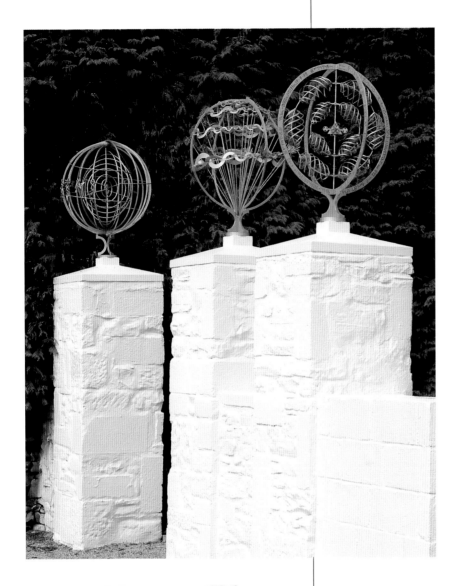

The site of these earthworks had been marshy. It was Keswick's idea to dig them out and to make the two areas of water by tapping into a nearby river. The spiral mound was a way of using the spoil on site rather than paying the expense of removal. The spiral path up the mound is eccentric in relation to the ground plane, so that one is led down in order to go up. Jencks draws a parallel between this and Marx and Lenin's dialectical materialism—two steps forward, one step backward, the notion of "fits and starts" of energy. There is, indeed, enormous energy in the spiral mound and the double-wave earthworks. Chinese geomancy and new science theories included, Jencks and Keswick have created a magnificent and unique private garden, both in design and execution.

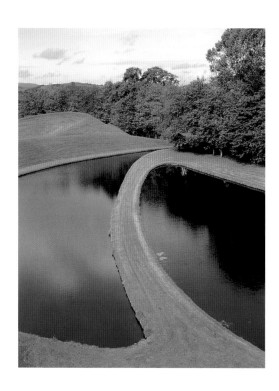

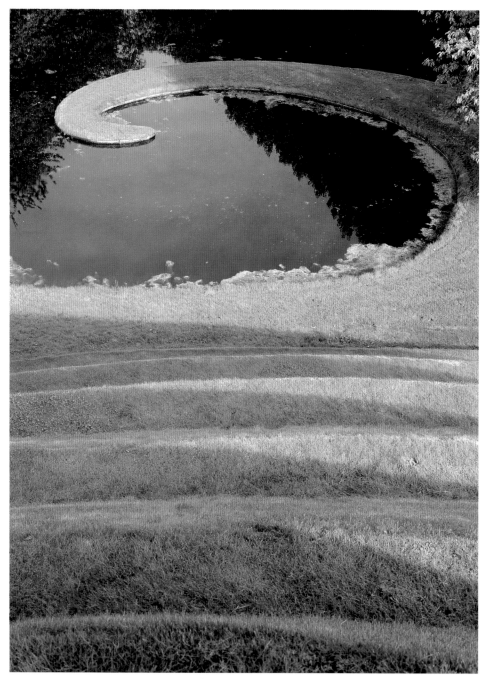

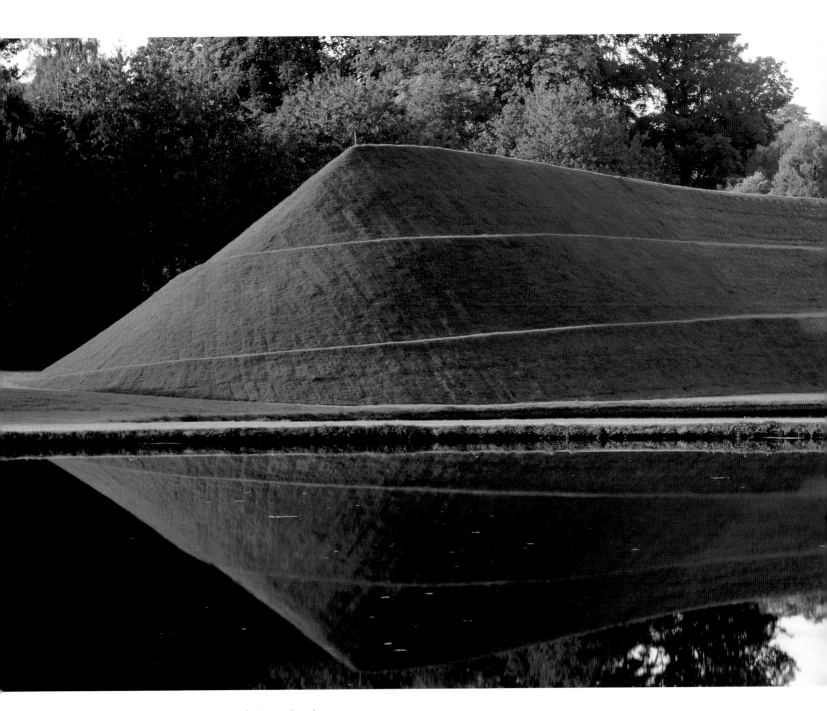

The double-wave earthworks are reflected in one of the curved ponds.

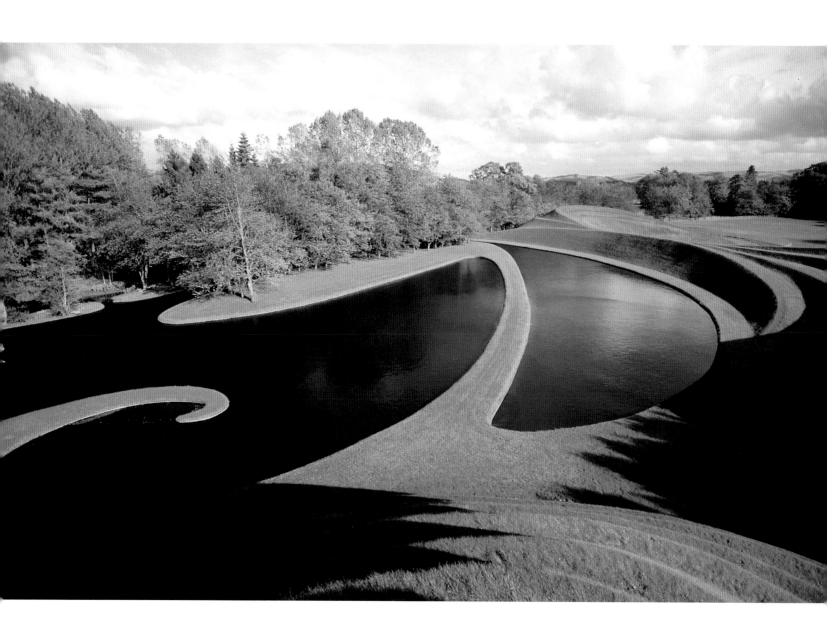

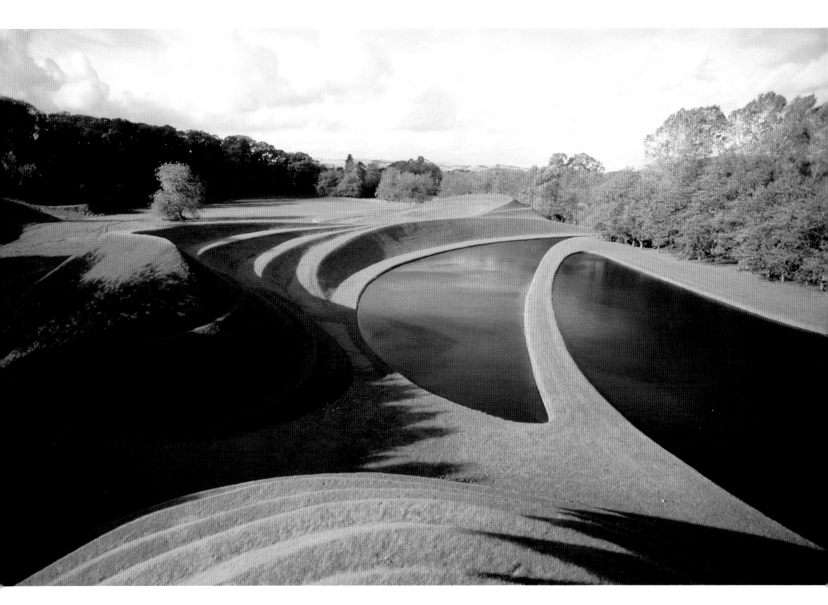

Above and opposite: The double-wave earthworks and curved ponds, with a floating "paisley" spiral, represent the summation of Jencks's theories.

Innovation

Sympathetic modern design,
imaginative, of good workmanship
and making skilful use of local materials,
is in every case better
than the reproduction of an ancient example,
how admirable so-ever.

—Gertrude Jekyll

V. J. Walker

At night, indirect lighting in the Boston viewing court emphasizes the three colored windows. A single clematis in one corner is the only plant.

VIEWING COURTYARD, BOSTON, MASSACHUSETTS

Gardens vary enormously in size, particularly gardens in the middle of cities, whether in New York, Paris, or Tokyo. In Boston's historic Back Bay, in the shadows of an alley, is a tiny garden measuring eight by sixteen feet.

In 1985, Victor Walker was asked to create a world from this tiny space, a world to be seen from within the first two floors of the building that would delight the inhabitants and also obscure the alley, cars, and garbage cans. His clients were busy professionals who were seldom at home during the day, so there was an emphasis on low maintenance and on the nighttime qualities of the garden.

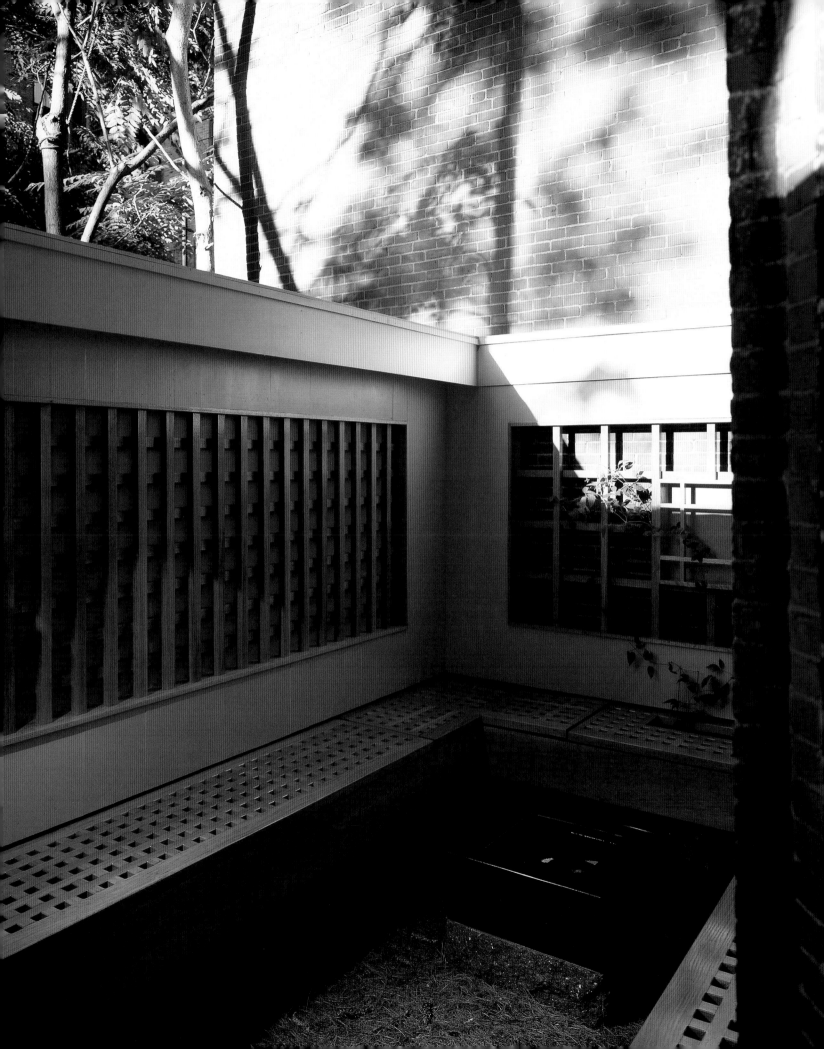

V. J. Walker's design sketch of the courtyard garden with the proposed "Captured Landscape Frieze."

Walker's solution was to frame the garden in oak trellis and lattice-patterned oak benches which follow three of the yard's walls. A square black granite basin filled with water sits on the ground for cooling bottles of wine or champagne; the gravel surface of the ground can be covered with pine needles and leaves from the few nearby trees. Since there are no views from the small, enclosed space, three windows of color, each with a distinct lattice pattern, were added to provide visual interest. The only plant is a clematis, grown in a pot sunk in the lattice-work of one bench.

A decorative running border for the top of the trellis, called "Captured Landscape Frieze," has been proposed. The design is of a distant range of miniature mountains, which will contrast with the simplicity of the courtyard's other elements.

"During the evening hours," Walker explains, "the warmth of the salmon-colored, painted wood background plane is brought forth through the grid of the light oak trellis with concealed lighting. The interplay of light and shadow between this richly colored plane and the visual texture of the trellis, in combination with the simplicity of form, adds a sense of abstract distance, expanding the apparent scale of the garden."

By day, a little sunlight catches some of the surfaces of the trellis, the bench, and the single clematis, but as night approaches, and the indirect lighting is turned on, the colors of the three windows become more important. The garden is then transformed into an oasis of calm, light, and color, a tranquil courtyard for a drink, contemplation, or subdued conversation.

Opposite: By day, sunlight sets the oak trellising and lattice benches aglow.

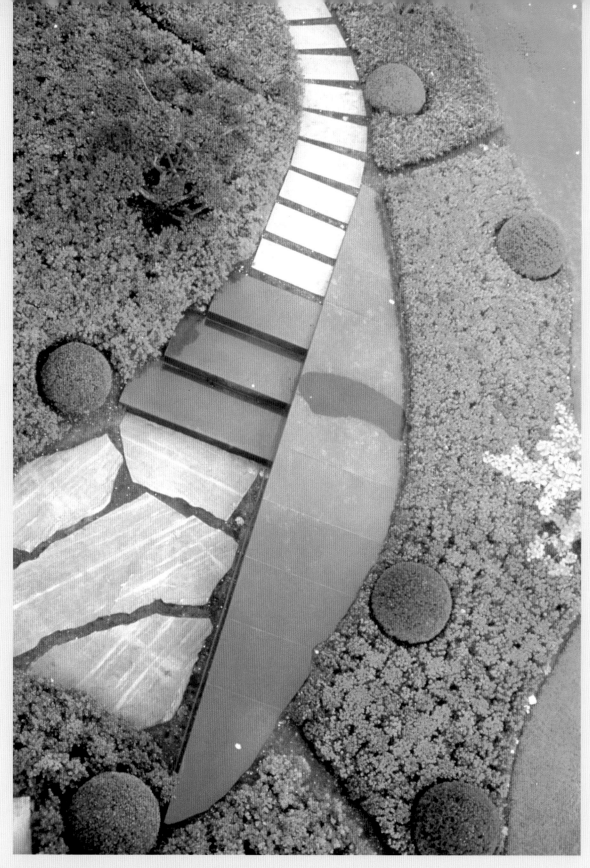

The path is a dramatic combination of gray granite from Norway, polished black Italian granite, and local sandstone;
it is set between solid shapes of clipped box hedging and leucothoë scattered with yew topiary balls.

The main garden path is composed of triangles of polished and honed black granite from
Italy and milled pink limestone from a quarry near Thuringen in eastern Germany.

Ludwig Gerns

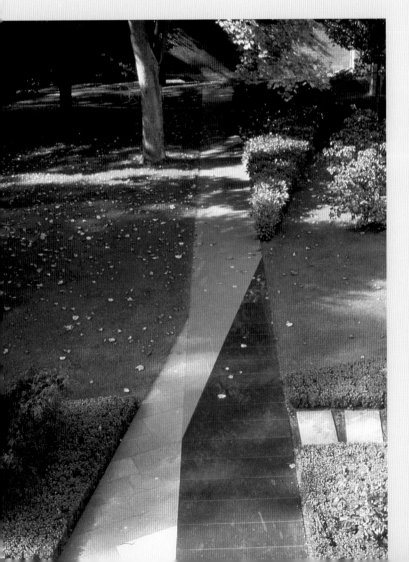

DESIGNER'S GARDEN, HANOVER, GERMANY

This house and private garden are set in a suburb of nineteenth-century villas built by the prosperous upper middle class of Hanover. The many mature trees and the large public park that characterize the area give no indication of the type of garden Ludwig Gerns has created here. When one arrives at the house, however, and sees the translucent glass and stainless-steel-slatted perimeter wall, with its polished black granite skirting, and the long solid triangle of neatly clipped yew trees in front of the neoclassical villa, expectations are raised. And they are quickly rewarded once the substantial glass door swings open—the sharp yew triangle is just the first beat in a very strong and exciting garden. The neoclassical villa is in the style of Karl Friedrich Schinkel, the great nineteenth-century German architect, and dates from around 1840, with an Italianate tower addition from 1890. The main house has been painted white and the tower a pale gray to emphasize the different eras of architecture. On the approach to the house, between a pinkish concrete path and the lawn, are wide, solid plantings of box in free-form biomorphic shapes, inspired by Roberto Burle Marx, with yew spheres set for punctuation. At the top of the steps leading to the main entrance, a substantial chunk of thick, triangular, clear glass penetrates the landing as a balustrade at an unlikely thirty-degree angle.

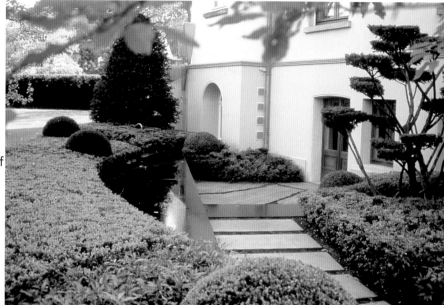

In Gerns's unique garden design, completed in 1995, there is constant interplay and contrast between the soft curves of organic shapes, the angular linearity of the hard landscaping of paths and pools, and the soft landscaping of the plantings. The neoclassical shapes of the house provide the central point to which these garden elements are counterpoints. The sinuous shapes of most of the plantings are contrasted with two formal plantings of box on either side of the main terrace, lattices of box hedging filled in with low clipped squares of the same shrub, and enormous clipped yew spheres. (These pieces of formality would not have looked out of place in the garden Schinkel designed between 1826 and 1833 for his commission at the Schloss Charlottenhof in Potsdam, the Court Gardener's House.) The evergreen shrub *Leucothoë walterii* has been used as well as box to make large, solid swathes out of which grow medium-sized trees such as cornus and "cloud pruned" yew, with stark stems that contrast with the solid base plantings.

The garden paths are both curved and straight. For the main path, Gerns has juxtaposed long interlocking triangles of polished and milled black granite and honed pink limestone. A dark rectangular pool mirrors the house, the boundary trees, and the sky; it is bounded by narrow bands of river-washed pebble setts. The waterfall at the end of the pool vista is a ribbon of highly polished stainless steel; on either side of it are thin slabs of rusted-steel retaining walls holding plantings of evergreen azaleas and Japanese irises.

Twentieth-century landscape architects and artists of all kinds have inspired Gerns, beginning with Burle Marx and Russell Page. Other influences, direct and otherwise, include Alexander Calder, Vassily Kandinsky, Bach and Schubert, the Bauhaus, Le Corbusier, Hollein, Frank Gehry, and Philippe Starck, and Barbra Streisand and Techno-Pop. Gerns agrees with Page at his most extreme, that flowers can be so much "colored hay." He has planted bulbs and annuals in out-of-the-way corners and behind hedges. This is partly because he wants to focus the design on variations of green, and also because he thinks that coming upon a hidden bed of flowers is more exciting than if they are always in view.

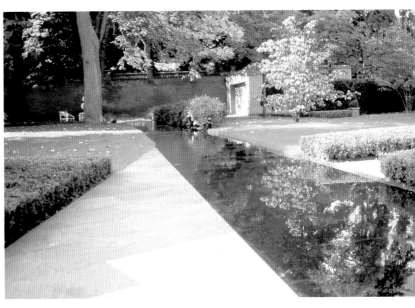

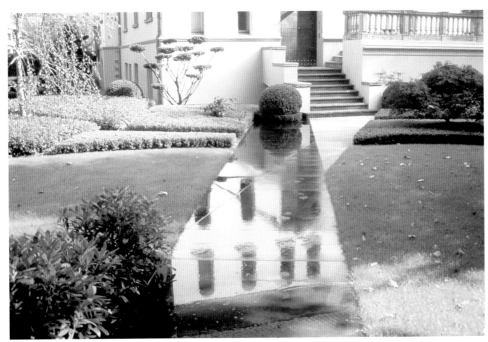

This page and opposite: A glass-and-steel boundary wall and a triangular yew hedge announce the Hanover garden from the street; between the composition and the neoclassic villa is a small stand of beech trees. The paths throughout the garden are juxtaposed with cloud-pruned yew shrubs and abstract hard landscaping. The villa and a maturing dogwood, Cornus florida, are reflected in the polished black granite of one path.

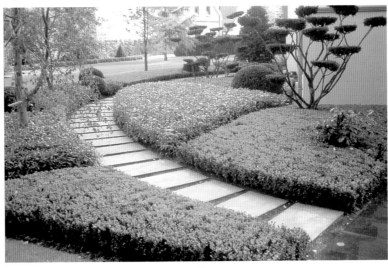

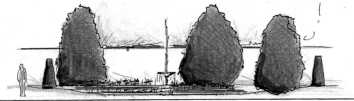

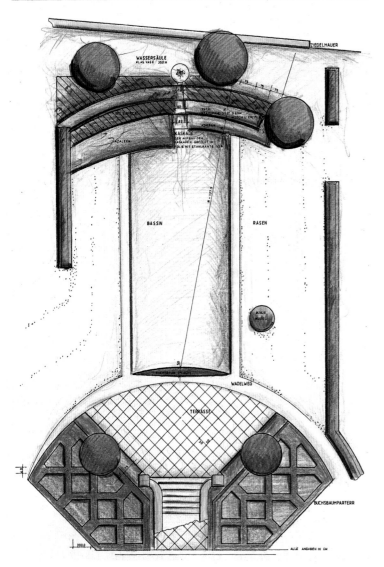

ZIEGELMAUER

WASSERSÄULE
KLAS VASE 250 H

KASKADE

AZALEEN

BASSIN RASEN

TAXUS
MODELL

BUCHSBAUM

WADELWEG

TERRASSE

BUCHSBAUMPARTERR

200.0 ALLE ANGABEN IN CM

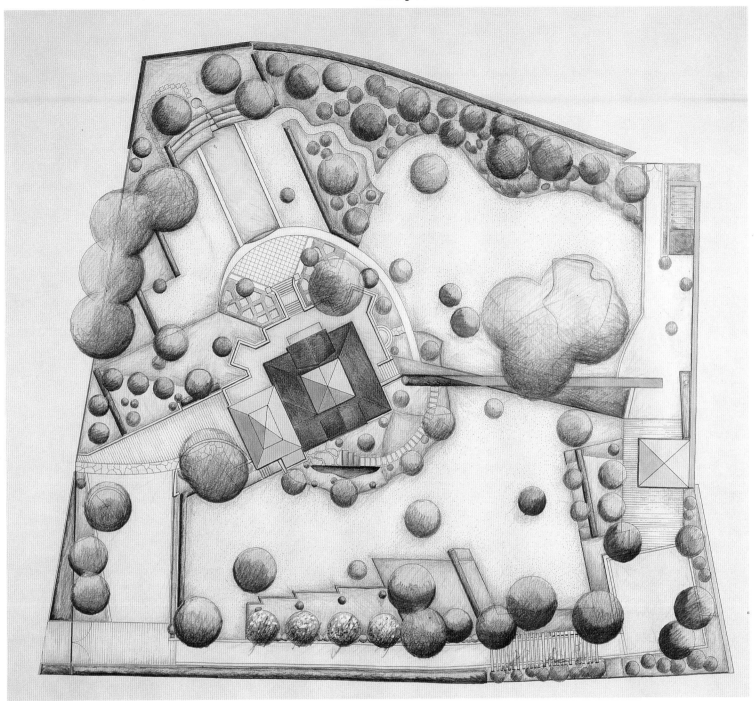

Overall plan of the Hanover garden.

*Opposite: The plan of the garden side of the villa shows two lattice designs
of formalized box hedging (also in the photograph), the terrace,
the rectangular pool, rusted-metal retaining-wall arcs, and the central stepped
waterfall of polished aluminum.*

Dean Cardasis

PLASTIC GARDEN, NORTHAMPTON, MASSACHUSETTS

Dean Cardasis is a professor of landscape architecture at the University of Massachusetts, Amherst, and has designed many private gardens. He is also a cofounder and the director of the James Rose Center for Landscape Architectural Research and Design, set up to preserve the gardens of Rose, a seminal modern landscape designer.

In 1992 Cardasis created a novel and exciting garden for a vinyl-siding-clad house in a recent suburb. Following a "simple contemporary contextual idea"—a plastic house demands a plastic garden—he updated the typical American garden while enlivening the existing elements of the subdivision.

The Plastic Garden was built in an environment hostile to creative and lively landscape design. The subdivision it lies in consists of set-back houses on uniform half-acre lots, with the forest that used to cover the land cut back to the edges of the houses' backyards. Between the houses and the forest is an open, dead (though sod) landscape. Cardasis's clients requested privacy and a play area for their children (with all the open space between house and forest, there was no real place for neighborhood play).

Birch trees are silhouetted against a Plexiglas panel in the Plastic Garden.

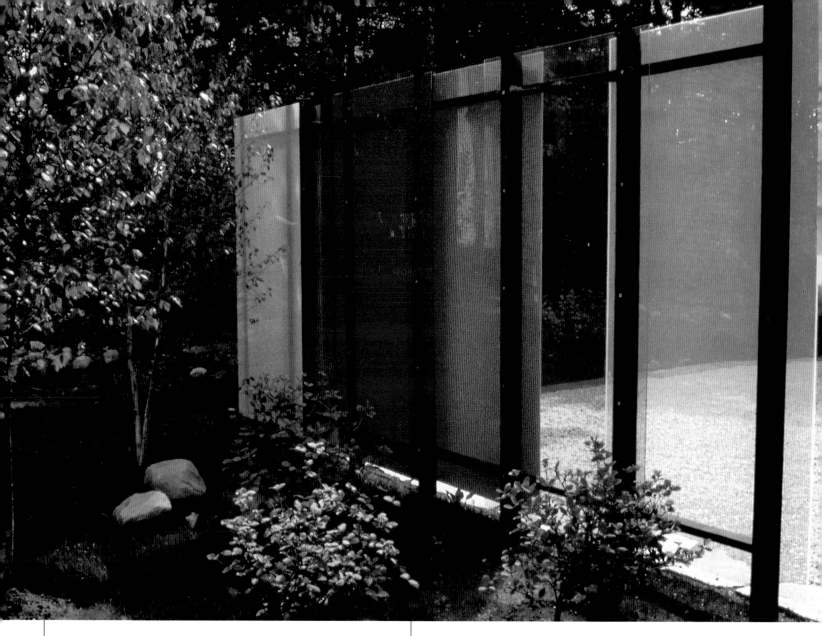

Colored plexiglas panels surround a gravel terrace.

Cardasis began with "a desire to bring the razed forest edge back to embrace the outer shell of the house" and to create "useful spaces flowing from the interior spaces of the house." To achieve these goals without a jarring juxtaposition between forest and plastic house, he formed the Plastic Garden, a transition space between the existing artificial and natural elements, a "positively formed space made from the interaction between plastic and 'natural' materials."

Large colored sheets of Plexiglas create an enclosure around a gravel terrace, transforming the light and engaging the stone, wood, and plants of the surrounding garden. "The result," Cardasis writes, "is that the static patterns of the neighborhood are counterpointed by the complex and playful spatial geometry of the garden . . . The experience unfolds within the garden, redefining the outer context of sky, woods, and subdivision by coloring, blocking, and silhouetting it; and forming an inspiring, useful spatial experience for the family and the children who play there."

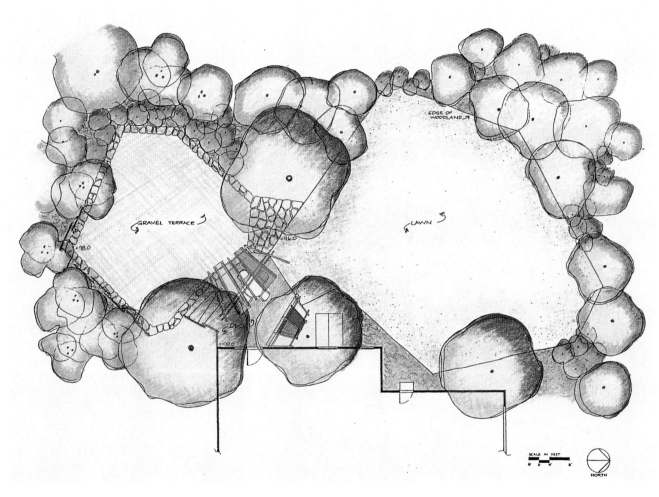

Plan of the Plastic Garden.

Chip Sullivan

PROFESSOR'S GARDEN, BERKELEY, CALIFORNIA

The influences that help shape Chip Sullivan's garden designs stretch from the seventeenth century to the present and encompass a great range of arts: Francesco Borromini and the great Baroque gardens of Italy in the 1600s, the Cubist gardens displayed by Gabriel Guévrékian and Andre Véra at the Paris Exhibition of Decorative Arts in 1925, the California garden style of Thomas Church and Garrett Eckbo in the 1940s and 1950s, and the prose of Jack Kerouac and the improvisational jazz of the late 1950s and 1960s.

The best example of a garden coming from this eclectic mix of inspiration is that made by Sullivan in his own backyard. Sullivan's house is a 1923 Craftsman-style bungalow inspired by the work of Greene and Greene, the Southern California architects who popularized this modest, accessible type of domestic housing. The house had been owned in the early 1980s by architect and professor Lars Lerup, who had used it as a laboratory for design. He gutted and remodeled the house, opening it up so that there was an "avenue" of space from the front yard through the open living area, and then through French doors to the backyard.

The Art Deco shapes on the ground, the Renaissance-baluster birdbath, and the previous owners' roses are only some of the elements in this eclectic contemporary garden.

Sullivan's own version of a sixteenth-century Italian garden perspective is the focal point of the garden; four cypresses and purple-mirrored globes on pedestals that decrease in height increase the perceived depth.

When Sullivan bought the house the "garden" was just a lawn and a few red and white rosebushes. However, with the new, modern space in the house, there was great potential for him to create a personal, contemporary garden. Sullivan has converted the garage into a studio with large windows facing the garden, where his experiments with landscape form happen within space he experiences every day.

A strong central axis that leads out from the center of the bungalow divides the garden, terminating at the focal point of a trompe l'oeil painting. The painting, the most memorable element of the garden, is of a sixteenth-century garden in perspective. Cypresses frame the scene within the painting, and an illusionistic trellis frames the painting itself. The scene is based on a false perspective Borromini used in the Palazzo Spada in Rome; Sullivan was impressed by this Baroque example of "fooling the eye" while he was living in Italy during 1984–85 as winner of the Rome Prize.

Sullivan has used a range of other illusionistic devices to expand the small backyard space. The central axis of the garden breaks into brightly colored, asymmetrical ground plane spaces based on Art Deco designs. Moving through the garden, the planar points of view are constantly changing. Purple gazing globes are placed opposite his studio windows, reflecting the garden in different ways as the light changes through the day. The globes are placed on pedestals of descending height to enhance the central perspective illusion. The central trompe l'oeil painting has secondary forced perspectives terminated with mirrors; when Sullivan views these from his drawing board they create a further illusion that the garden is much larger.

Four cypresses remind Sullivan of Italy, where he yearns to return—the hills of Frascati meet those of Berkeley. The once haphazardly set roses have been transplanted to provide a backdrop to the ground plane. When they are in bloom and the birds are playing in their Renaissance-baluster-supported birdbath, Sullivan says, this is his paradise.

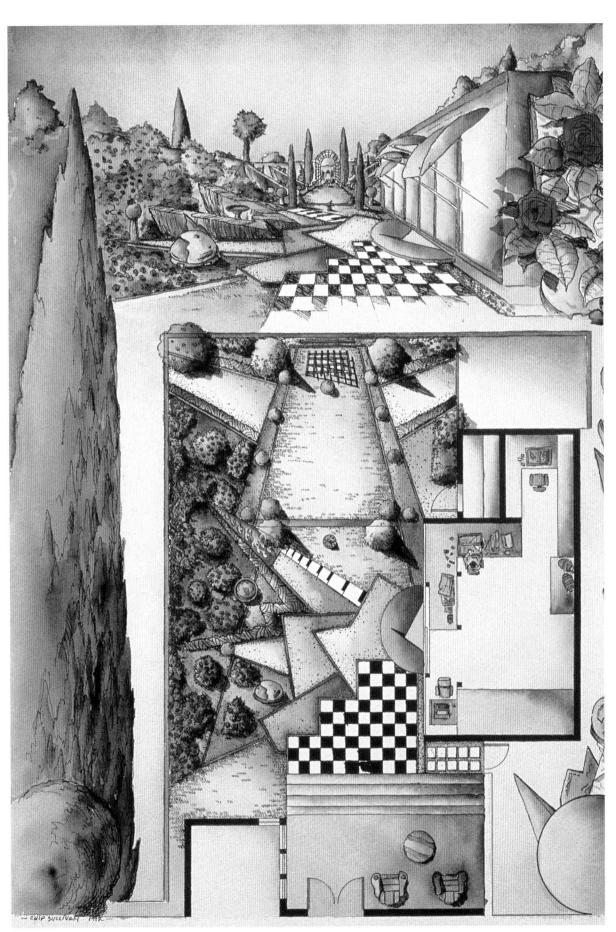

Opposite: Sullivan's plan and perspective painting of his own garden reflects the myriad influences on his landscape design.

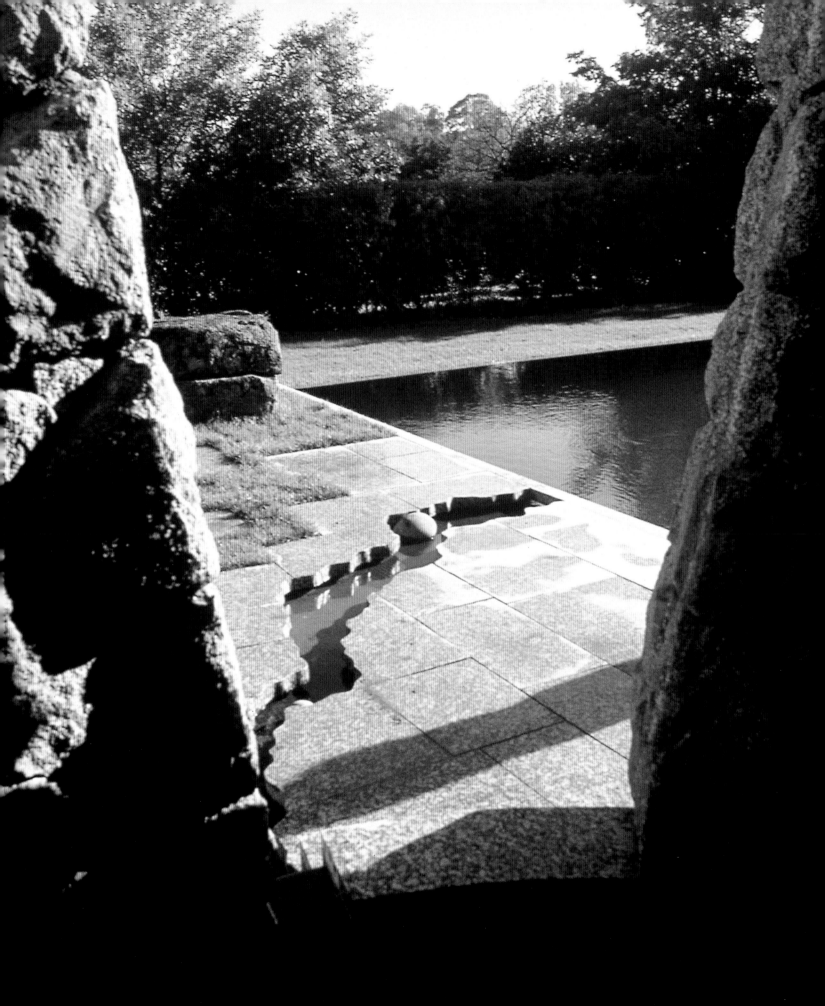

Vladimir Sitta

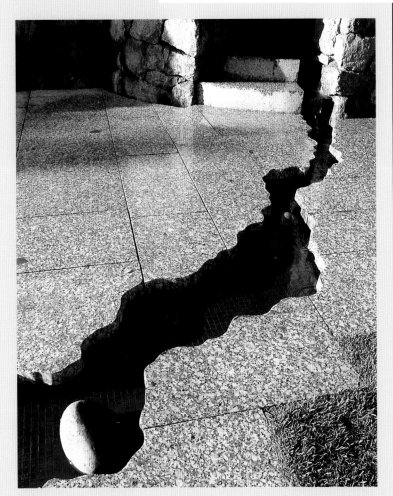

This page and opposite: Between the stone Folly Cone (the source of clean, ionized water) and the swimming pool of the Homestead Estate is an "eroded" channel lined in black mosaic.

This garden is not for those expecting the usual.

—*Vladimir Sitta*

HOMESTEAD ESTATE, NEW SOUTH WALES, AUSTRALIA

Polo and its related activities are the obsession of the owners of this private estate, which began in the last century as a homestead. Vladimir Sitta, a landscape designer originally from Czechoslovakia, was given free rein by his adventurous and sophisticated clients. Their only definite requirements were that he should accommodate a tennis court, a swimming pool, and a kitchen garden.

Sitta's design was a continuing collaboration with the owners, which took elements from a list of many possible solutions. They recognized that plans would not be sufficient to realize all the areas of the landscape, and that amendments and improvements would be made to Sitta's scheme as the work progressed. The project is shown here in 1991.

Where the garden and the rest of the homestead meet, Sitta has used a device that he calls a threshold. Fragmented local references—granite boulders, charred tree trunks, bones, and detritus from farming activities—act as quotations of both the past and the present life of the homestead. These elements are employed to point to views and directions in the landscape, but not through any symmetry or traditional axes—they point with subtlety toward some opening or disclosure.

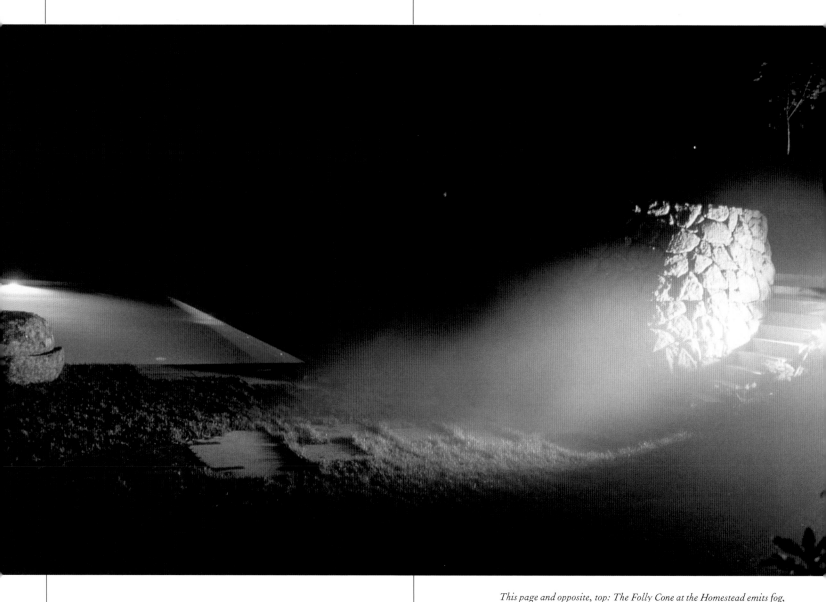

This page and opposite, top: The Folly Cone at the Homestead emits fog,
which appears to dematerialize the stone; the cone is crowned with twisted copper wire.

In contrast to the vast natural landscape, the garden near the house
seems hidden; enclosed by paddocks, it appears to be sculpted from them.
The homestead's earlier landscape is referred to with the renovation of the
buildings and by the retention of some mature trees. Although Sitta
believes that the landscape architecture profession has overemphasized
ecological aspects at the expense of the visual and artful, the ecology here
has been necessarily respected: all rainwater is collected, irrigation runoff
is channeled to the lake, and drought-resistant trees and indigenous
grasses will be planted on large areas of the landscape.

Sitta's design includes some radical contemporary features. A Green
Cathedral is a circle of alder trees planted around a circular, grassy pit,
all tilting toward the center. A stepped spiral path descends to the cen-
tral focus, a large, ancient slab of stone. From this point, the viewer
has a new and unusual experience of the sky, trees, light, and shade.
Eventually, a metal ring will be put into the stone, which, Sitta says,
will relate to the Earth below.

Plan of the Homestead Estate.

Tilted alder trees around a pit form the Green Cathedral.

Closer to the house, the sculptural Folly Cone is made of irregular stone and is topped with a tangled canopy of solid copper rods, a brilliant contrast to the stonework. The cone, located near one corner of the swimming pool, services the pool with pure ionized water, which seeps through the joints of the stone. The cone thus appears to have a large leak; however, the water is actually being channeled through a black-glass-mosaic-lined fissure in the granite deck surrounding the pool. According to Sitta, "The extreme contrast between the strength of the stone and the fragility of the [copper] canopy constitutes a metaphor of the human mind—firmly anchored in earth and yet always full of unrealized ambitions and dreams."

A fog-making machine gives the Folly Cone a mystifying atmosphere and makes the stone seem less solid. Plants will enhance this effect once they have begun to cover parts of the stonework. Sitta dreams that the pool area could become a fragment of a set for a Peter Greenaway film or a staging of "The Phantom of the Opera."

Sitta's design has elements that disturb viewers expecting to experience the traditional serenity and refreshment of the spirit, a received and current notion about the primary function of a garden. This effect is intentional, and he gives full credit to his clients for being adventurous and tolerant and for giving him such a rare opportunity. With his designs he tries to offer more than the ordinary and predictable: "This we owe to our art. It is for us to create that which is lacking, not merely repeat what exists."

Below and bottom: The vast landscape surrounding the Homestead
is recalled in the hedge- and tree-lined path to the house and the horse trough,
which is bordered by hedges trimmed only on the inside.

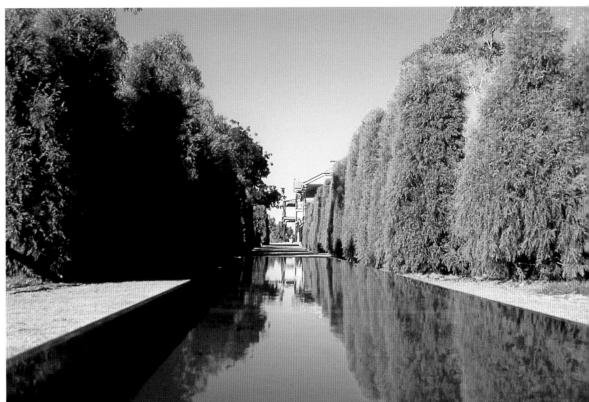

G. 14.12. 90

This page and opposite: The sketches show Sitta's unexecuted "Scar in the Land."
The "scar" represents the wound left by the settlement of Australia by Caucasians.
At one end are ridges of underfired clay containing metal parts of old farm machinery.
At the entry to the scar is a large boulder lintel, the Weeping Rock, which has two
parallel holes, one dripping water, the other with a glass prism and lens directed toward the
sun. At noon, sunlight is directed into the smoothly polished water receptacle in a black granite
boulder. The entire scar, lined with raku clay fired in situ, is a constant reminder
of fire and its power. The clay walls carry imprints of human hands and bodies and traces
of repeated attacks with hammers and picks.

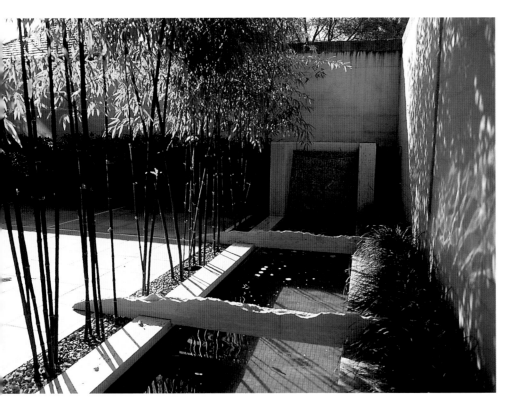

Above and right: The Smith's Garden in Sydney shows the influence of Japanese garden design on Sitta.

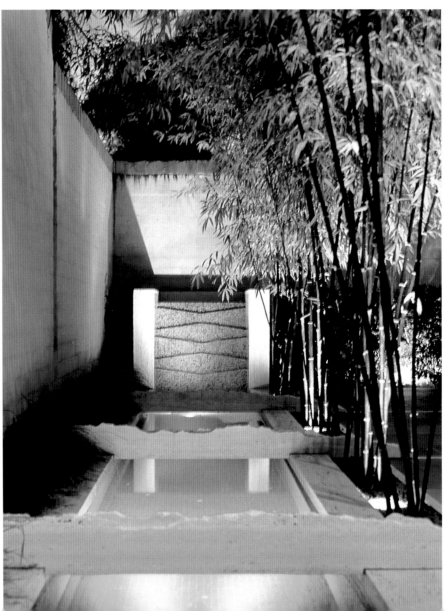

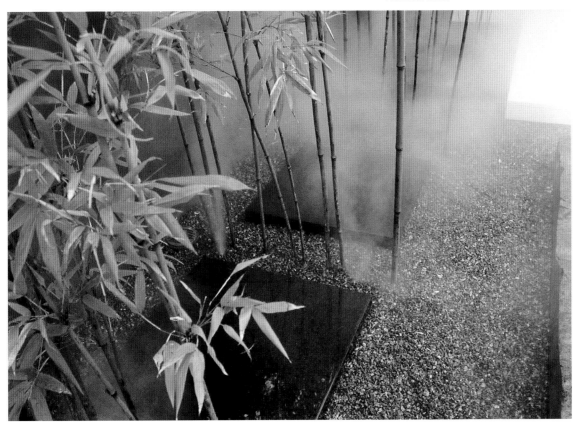

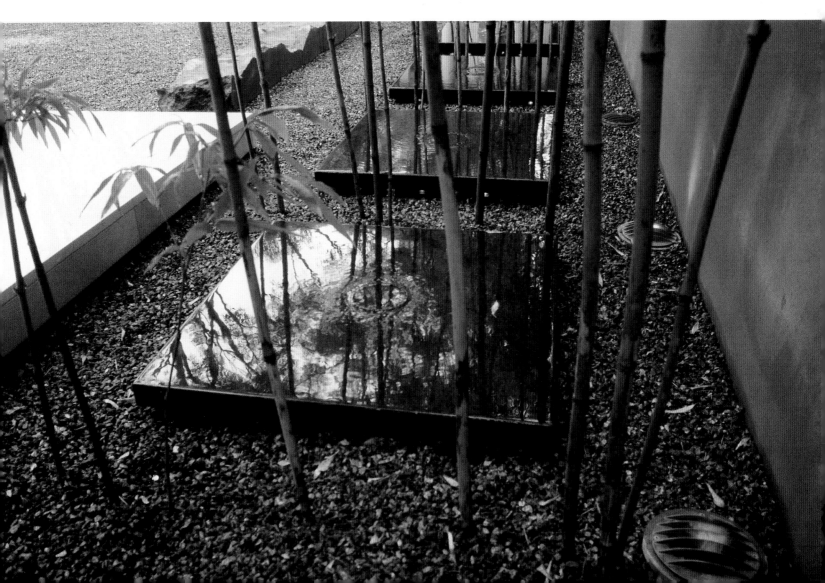

A Sydney installation, the Garden as Theater of Lights features the water features and artificial fog of the Homestead Estate in different forms.

Water lilies, corn, flowers, and vegetables are grown on the Roof Garden Practical.

Tom Oslund

ROOF GARDEN PRACTICAL, MINNEAPOLIS, MINNESOTA

As a child, one imagines that the Hanging Gardens of Babylon were hundreds of feet high; it is disheartening to learn that those ancient gardens were probably only about seventy-five feet high. But the idea of a roof garden, regardless of how many stories it is above street level, is still romantic and extraordinary.

However, the problems involved with such gardens are considerable. Ironically, the most significant problem is leakage, while with earth-bound gardens, the most basic site consideration is drainage. The climate, or more accurately, the microclimate of a roof garden can differ greatly from that of the surrounding area. Temperatures may be much hotter or colder, and it may be sunnier or shadier several stories above the ground. Wind conditions can also vary considerably; recently a newly installed inflatable plastic pool on the New York roof terrace of Linda Yang, a gardening writer for the *New York Times,* fell nineteen stories just twelve hours after it had been installed. It was recovered by the shocked but efficient superintendent. Weight is another factor, of course; building regulations and some prudence determine what the tolerance levels are for ambitious rooftop planting schemes.

A simple and productive design was established in 1993 in downtown Minneapolis, Minnesota, on the fifth floor of a building now surrounded by skyscrapers. The client wanted a flower and vegetable garden, which was created by assembling planters, ranging in depth from one

Nasturtiums climb a black-wire obelisk in the Roof Garden Practical.

foot to two-and-a-half feet, based on a module of planters four feet square. In one case this module has been quadrupled in size and made into a pond planted with water lilies and other aquatic plants. A rooftop situation can be beneficial for plants; when ground-level gardens are being nipped by frost in the early spring, the rooftop plants begin to grow, and in the autumn the plants on the roof flourish longer than their cousins down below.

The success of any roof garden depends on irrigation and drainage, both of which have to be even more carefully monitored than in gardens at ground level. Here, the planters were raised above the existing roof in order to conceal all the necessary irrigation and drainage pipework. The planters are arranged in a formal grid plan with an arcade-like series of metal-wire arches as the focal point at one end. These arches are covered with climbing plants during the summer, which are firmly secured to prevent wind damage. To give height on one side of the garden, a series of two-foot-high containers topped by three-foot-high black wire obelisks forms perfect frames for scarlet runners and nasturtiums during the summer.

Plan of the Roof Garden Practical.

Tom Oslund

Geraniums, hibiscus, and pansies are grown, with petunias and alyssum used as groundcover around the vegetable crops of potatoes, zucchini, cabbages, and the taller plantings of corn and tomatoes. The quantity of vegetables and flowers culled from the garden during the comparatively short growing season more than satisfies Oslund's clients.

With its extensive use of garden lighting, this rooftop *potager* is magical at night. During the day it also gives great pleasure to many of the people living and working in the surrounding high-rises. The garden shows how a rooftop space can be imaginatively used for very practical purposes and still be an attractive place for sitting and contemplation.

The metal arched pergola atop the Roof Garden Practical is a twentieth-century update of a garden device that originated in ancient Greece and Rome.

ROOFTOP PLAYFUL, HOPKINS, MINNESOTA

The first question for a garden client is not what fantasy they wish created or how much money they wish to spend, but how much time they or their helpers will actually spend in the garden. One of the ironies of life is that as people get older they have more time to be in gardens but less inclination to look after them. Near Minneapolis, in 1987, a client ordered a rooftop garden to look at, play in, and on occasion take shelter from the weather in. The garden was also required to have minimal maintenance needs. The six-thousand-square-foot garden overlooks a borrowed landscape of a park and a lake.

The planting was primarily confined to large, low containers around the perimeter of the roof filled with mainly evergreen shrubs and some colorful annuals. The main area was covered with Astroturf, a material that has improved dramatically in the last few years and now comes in many shades and textures other than its once singular bright viridian green. To one side is a square, glass-enclosed summer house where the changing landscape can be viewed comfortably except in the most extreme weather conditions. The main point of entry leads to a paved circular area where the tiles are laid out to form a giant checkerboard (which is occasionally used as such). Beyond that, a shuffleboard court lies on a strong diagonal to the rest of the garden, pointing toward steps descending into the surrounding landscape. High white hoops over the shuffleboard court give some vertical interest to the design and resemble a large, exaggerated croquet set.

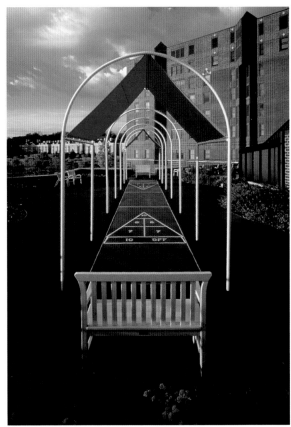

Below and opposite: The elements in the Rooftop Playful are Astroturf, shrubs and annuals in low containers, a round checkered courtyard, a shuffleboard court, and the summer house.

Plan of the Rooftop Playful.

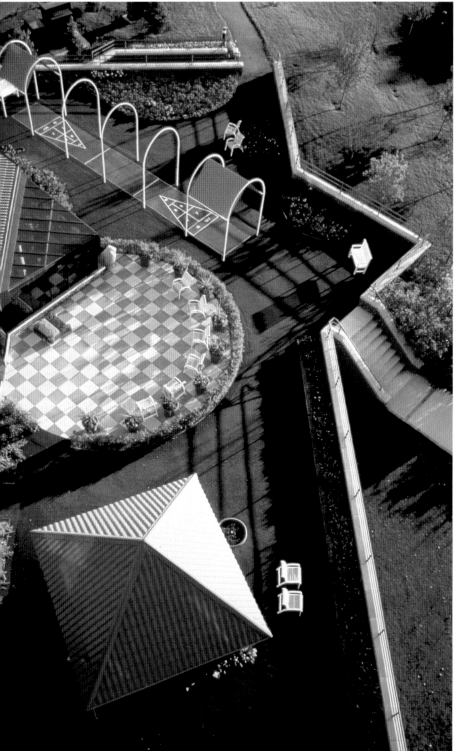

*This page and opposite: Brick fountains and crab apple trees set into white stones are arranged in a grid in the courtyard
of the Dickenson House, near Santa Fe. Grids are said to have originated in the ancient Persian garden.*

Martha Schwartz

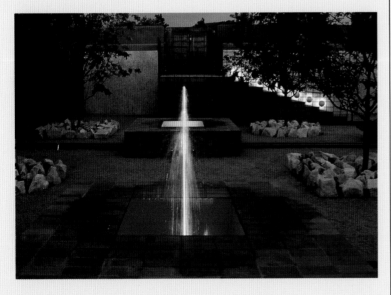

DICKENSON GARDEN, SANTA FE, NEW MEXICO

Martha Schwartz's office in Cambridge, Massachusetts, likes to challenge traditional concepts of landscape architecture while still focusing wholly on the nature of its projects. Her team is a small group of artists and landscape architects who explore the relationship between art, culture, and the landscape. "I do pride myself on our ability to build well," Schwartz has said. "I think in one sense that's a distinction between us and a lot of the artists who are out there doing landscape. It's not their medium. My view is that it's the highest art form. You take this raw material and you produce a vision for living out of it."

In 1979 Schwartz created the Bagel Garden in Boston, an event that sent shock waves through the landscape architecture profession and university departments across the country. It was a small front garden installation of a classic French *parterre de broderie* made of purple aquarium gravel ground cover, clipped box hedges, and marine-lacquer-preserved bagels set proportionally between the hedges. These juxtapositions made a witty and provoking statement, caused tremendous controversy, and signaled the beginning of irony in late-twentieth-century garden design. In an interview, Schwartz outlined the genesis of the Bagel Garden:

I thought the bagel the perfect land-scape material. It was easy to get, it was cheap, it was biodegradable, any-body could plant it, it did well in the shade, you didn't need to water it. What I was saying was that my profession is by and large som-nambulant. There is a series of rules by which people are trained and are expected to act.

Schwartz's latest private garden, made in 1991, is at a house in Santa Fe owned by Nancy Dickenson. According to Schwartz, "Nancy saw the Bagel Garden and she loved it. Given her particular sensibility and her interest in folk art, I can understand why it may have appealed to her. She could see that it was a very Dada move."

The Santa Fe design is a series of chambers bound together by the huge vista of the Sangre de Christo Mountains and the Rio Grande Valley. New Mexico has a very strong desert personality, with arid plains and dry hills dominated by distant mountains, colors ranging from palest yellow to gold to deep browns, and from this garden, the light and dark green of the valley floor under the intense sun.

One arrives at the house and garden via a series of dirt and gravel roads through the undulating hills of the desert. A red security gate opens to reveal a small terrace overlooking a formal rectangular court-yard inspired by Moorish and Spanish-colonial gardens. On the points of a formal grid, nine crab apple trees have been planted into a groundcover of large, sculptural white stones. Within this grid are four raised brick squares, each containing a small pool with a simple jet fountain. The fountains are kept at low levels so that the fall from the jets resonates within the painted metal linings. The four pools are con-nected by raised runnels with copings and inner facings of brightly col-ored mosaic tiles. The groundcover of the courtyard is a fine golden gravel. It could be the dream of paradise for an updated Islamic warrior or a Spanish conquistador, with the sight and sound of cooling water and the dark shade of the trees, all protected by high adobe walls. The detail and scale are entirely contemporary and reflect Schwartz's unique vision of landscape and style.

Outside the master bedroom suite is a surreal aerial lawn terrace; Nancy Dickenson calls it an "Ode to Ohio."

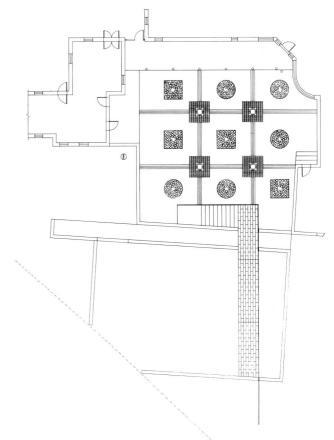

Sketched plan of the Dickenson Garden.

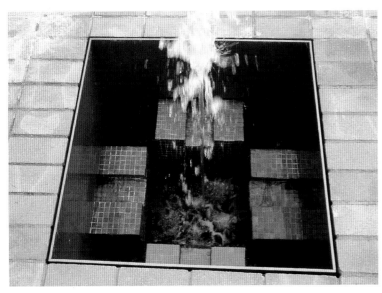

Left and below: The sound of falling water emanates constantly from the fountains, which are joined by tile-lined runnels.

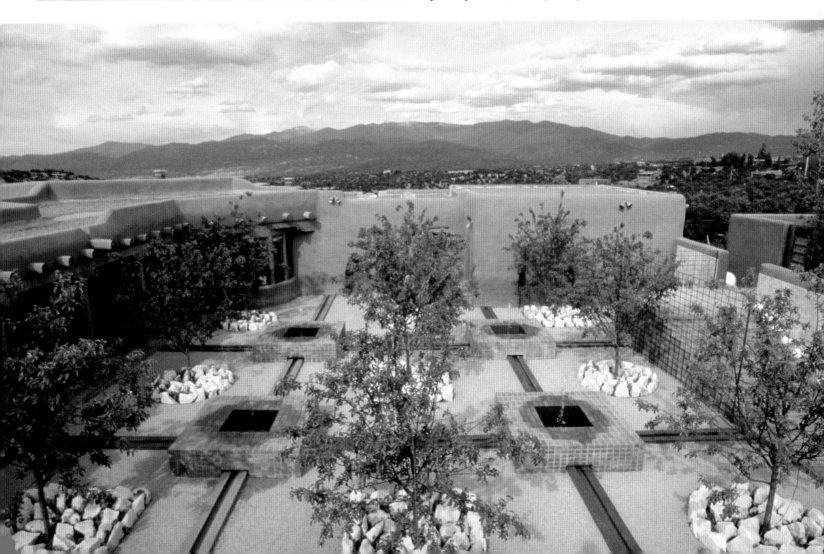

The staircase leading to the formal court at the Dickenson House is lined with domed lights and Theves poplars.

On the other side of the house stretches the panorama of desert and mountains. A long terrace steps along the changes of level dictated by the plan of the house and at one end rises to meet an aerial lawn. At first glance, the lawn merely looks like an enclosed space above the changing rooms of the swimming pool; closer inspection reveals that the raised area is a lush lawn directly outside the master bedroom that seems to hang in space above and in surreal and antic contrast to the desert site. It serves not only as a terrace but also as a croquet lawn, as well as being a reminder of the client's native state—she calls it an "ode to Ohio."

A bank of yucca separates the swimming pool from the main terrace. A gap in the encircling adobe wall at one end of the pool makes it seem that a swimmer might be able to swim straight out into the desert. Beyond the pool a sculpture made from dry branches is a reminder of the inhospitable but beautiful landscape surrounding these gardens, which cunningly play on earlier traditions, transmuting them into an elegant and playful contemporary design.

Below and bottom: *Martha Schwartz's 1979 Bagel Garden in Boston created significant controversy in the American landscape architecture profession at the time.*

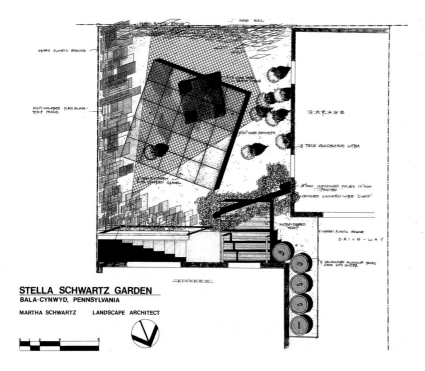

STELLA SCHWARTZ GARDEN
BALA·CYNWYD, PENNSYLVANIA

MARTHA SCHWARTZ LANDSCAPE ARCHITECT

This page and opposite: Schwartz designed this garden for her mother's Philadelphia yard in 1984. Its contemporary materials include turquoise- and green-striped Astroturf, scraps of Plexiglas, suspended netting, and trash cans painted with epoxy-sealed glitter. On completion, one neighbor called the police.

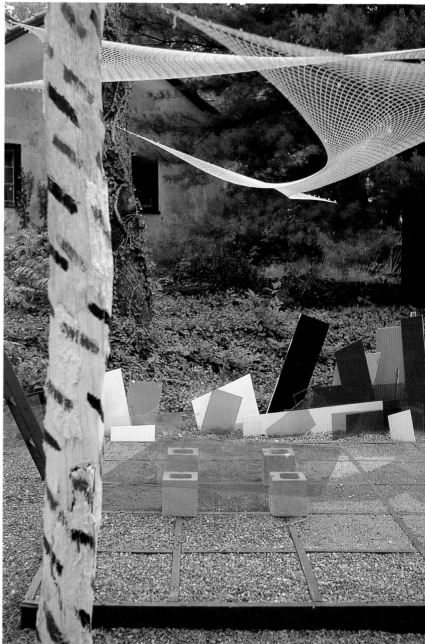

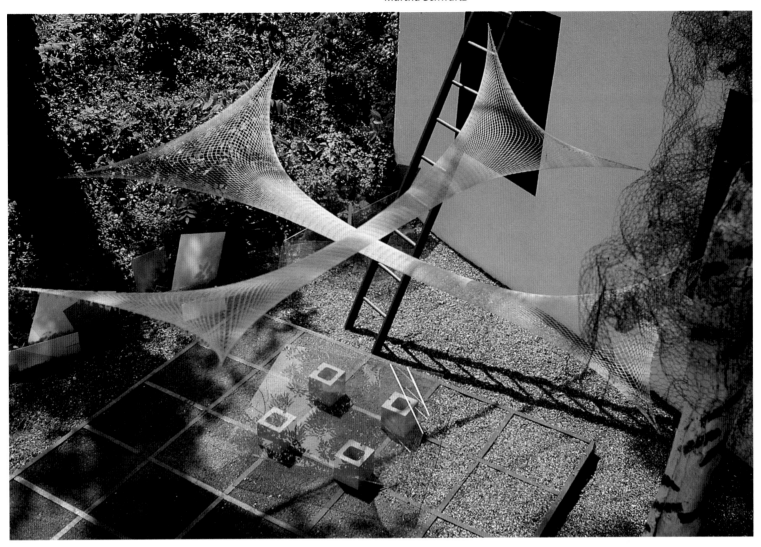

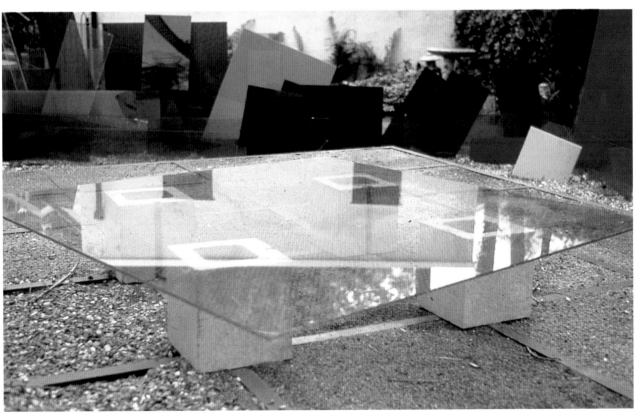

Tradition

Ryoan-ji garden in Kyoto
is the greatest piece of architecture in the world.
—Philip Johnson

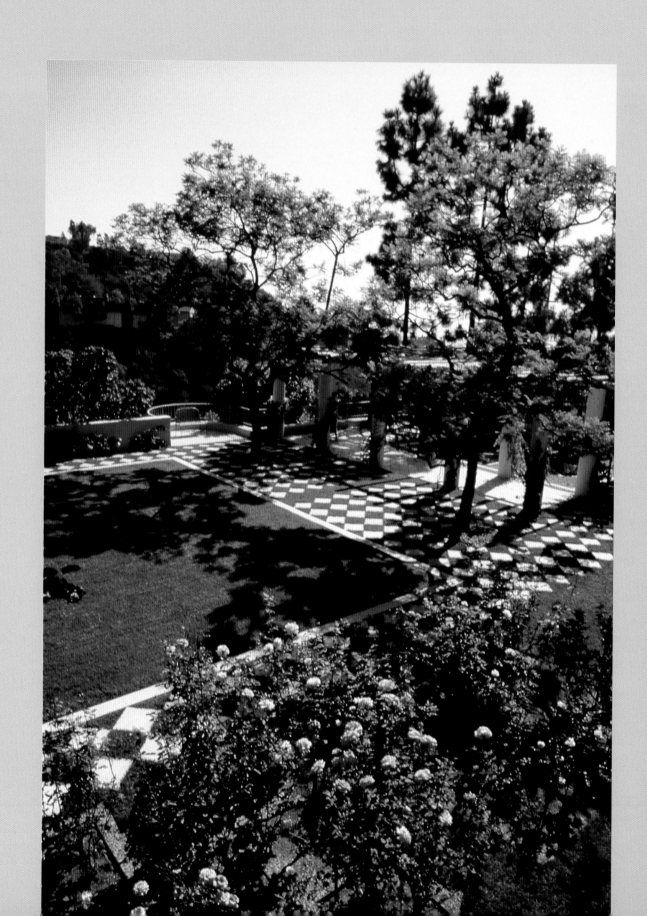

Dan Kiley

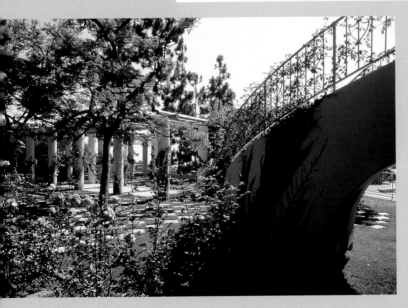

Above and Opposite: The formal rectangle of lawn (formerly the tennis court of this Brentwood house) is encircled by alternating squares of stone pavers and grass, a bed of roses, and a wooden pergola.

Maybe the role of design, and especially landscape design, should be to try and reconnect man with his space and his background.

We are one with the Universe. It's not Man and Nature . . . or Man in Nature.

Man is Nature, just like the trees. Both live and grow.

—Dan Kiley

GARDEN, BRENTWOOD, CALIFORNIA

Dan Kiley, the leading landscape architect in America, has been designing landscapes for fifty years. He is a master of the formal style, which he has adapted to modern architecture, in part from the seventeenth-century designs of Europe, especially those of André Le Nôtre. The angularity of both Le Nôtre and architectural modernism has been an inspiration for him.

In 1992 Kiley completed this garden for one of Hollywood's most notable and successful producers. The house and garden are on the crest of one of the many canyons in the hills that overlook downtown Los Angeles and the Pacific Ocean. The site's southern and western aspects give full growing advantage to the garden; in the sunny California weather many Mediterranean plants flourish.

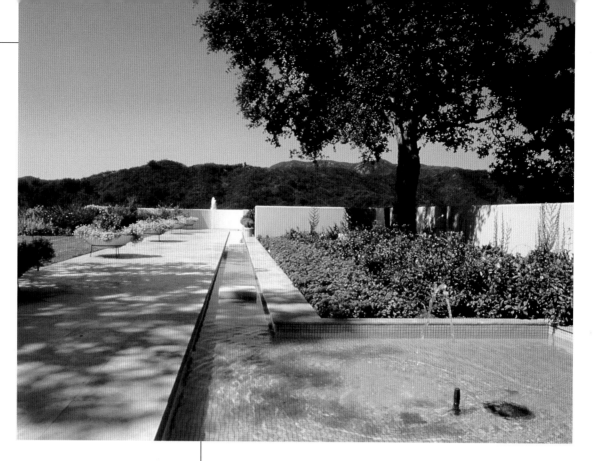

The long straight lines of the limestone terrace, the narrow canal, and the planting bed converge against the distant hills.

From the canyon road, a driveway descends to a formal courtyard, where two trees stand as sentinels before the front door and five trees protect part of the parking area. On the east side of the house an unobtrusive gate leads via a staircase down to a formal garden, which in turn leads to a wooden pergola. Kiley's superb attention to detail is immediately evident in the pergola—its cross pieces are not sawn, prepared lumber, but sections of small tree trunks that have been stripped of their bark. On one side of the pergola is a stone-edged rectangle of lawn bounded by a striking diamond-pattern of dark green grass and very white paving stones. On another side is a small, formal herb garden of eight triangular beds radiating around a circle, all set in gravel.

Beyond this, steps lead through a small, symmetrical grove of parkinsonias to the swimming pool, built on a platform above the surrounding canyon. From here the immense size of the panoramic view becomes evident. Ten miles away, the gigantic metallic ribbon of the Pacific Ocean glints in the sun, and silvery metal- and glass-faced skyscrapers rise in the middle of Los Angeles.

Steps lead from the swimming pool back to the main terrace in front of the living rooms, and continue around the side of the house to an even more private and dramatic garden on the west side. Here a narrow terrace/pergola is fronted by concrete columns up which grows bougainvillea, and Kiley has installed a long terrace and narrow canal of water, with its two square stepping stones reminiscent of Islamic and Indian designs. The stones give access to the planting bed, most of which has low evergreen planting, although the band nearest the water has seasonal plantings. This band of seasonals also appears in five raised planters on the edge of the terrace adjacent to a stretch of lawn.

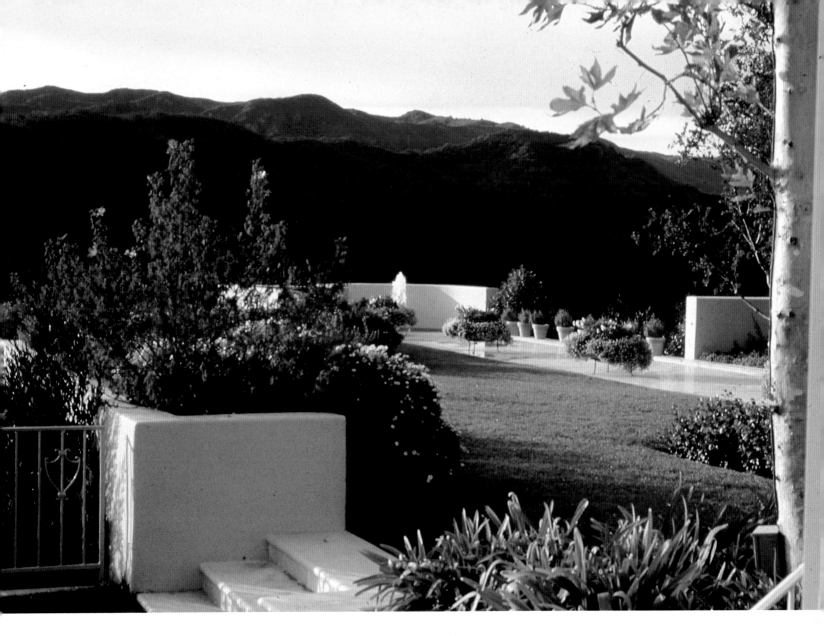

Along the promenade terrace are garden dishes on tripods for seasonal plantings. In the foreground are agapanthus, marguerite daisies, and roses, all of which thrive in the climate of California.

Plan of the Brentwood Garden.

The water moves almost imperceptibly as it flows from a rectangular pool with a low jet through the canal to a semicircular pool at the end, also with a single jet. From here there is a dramatic view down into the canyon and to the mountain ridges beyond. An outside staircase gives direct access from the master bedroom, so the owners can wander through this area of the garden to watch the changing light of Los Angeles from sunrise to sunset.

LEHR GARDEN, MIAMI, FLORIDA

When Myra Lehr asked Dan Kiley for help with her small garden in 1993, he said that he was extremely busy but he would be delighted to give her advice over the telephone. Kiley has noted, "Design is only a description for a process where you go and help somebody or help yourself to find a place in space." Mrs. Lehr's garden, in the center of tourist Miami, sits by an inland waterway, the far side of which is covered with very large apartment houses and condominiums. And that monument of 1950s kitsch munificence and grandeur, the Fontainebleau Hotel, is about two hundred yards further up the causeway.

The garden terrace of Mrs. Lehr's house opens onto a space divided approximately into thirds, with two-thirds given over to the swimming pool and one-third reserved for sitting areas—a generous wooden deck and a patio of grass inset with formally placed square paving stones. These squares and other variations on the square evidence Kiley's masterly use of formal shapes here.

The square is the main design element used in this plan: three squares of white concrete wall alternate with three squares of dark green ivy to make a boundary for the swimming pool area; a single square wall on the opposite side of the garden is used for family film showings; and a grove of palm trees near the pergola is planted on the points of a tight square grid. The pergola is the focal point of the garden and provides a shady sitting area and a light screening of the apartment buildings across the waterway; the uprights of its frame define open squares.

The garden is neither large nor immediately exceptional, but Kiley's telephone calls of design advice to Myra Lehr have meant that the scale and proportion of each element have been so calculated that their formalization in relation to the total space has made this garden more attractive, usable, and a great pleasure.

This page and opposite: The concrete boundary walls, grass-and-paving-stone patio, grid of palm trees, and pergola proportions of the Lehr Garden are all based on the square.

In 1994 Kiley completed the design for a 630-acre Connecticut estate; the building elements include a pergola.

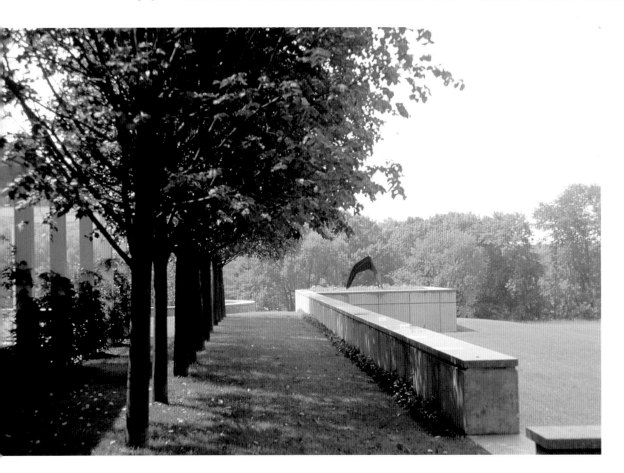

Retaining walls across the Connecticut site create level lawns on all sides of the house. Linden trees parallel part of one wall.

One-hundred-foot-long formal canals border the croquet lawn of
the Connecticut garden; the water is at the same level as the lawns.

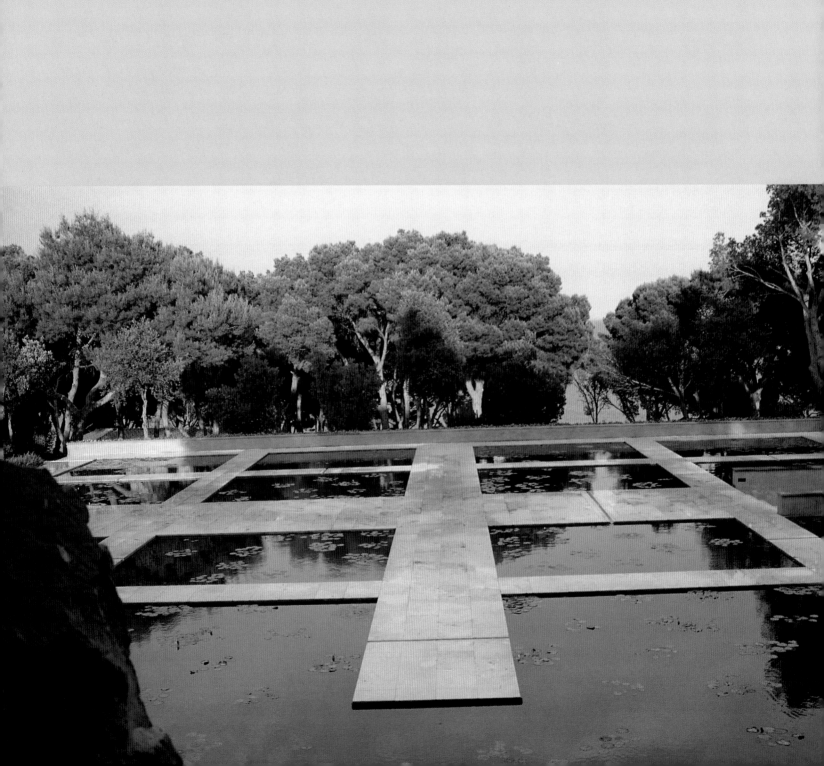

Fernando Caruncho

S'AGARO GARDEN, CATALONIA, SPAIN

Fernando Caruncho's garden designs come out of the great tradition of the gardens of Spain, where he was born and raised and where he undertook his first commissions. Since his first designs twelve years ago, when he was twenty-two, he has made thirty gardens for private clients and companies.

Caruncho's family has roots in northeast Spain and in Andalusia in the south, where Islamic influence has been pervasive since Moorish armies conquered the region in the eighth century. (Moors ruled until 1492, when the armies of Queen Isabella and King Ferdinand captured the palace fortress at Granada.) Among the highly developed arts and sciences Islamic civilization brought to Spain were the tradition of botanical studies and advanced agricultural methods, including sophisticated irrigation. These disciplines developed from the enormous influence of Persian garden design and led to the emergence of the great Moorish gardens in the southern regions of Spain.

The most magnificent of all the Moorish gardens in Spain and the oldest large-scale garden in Europe was built for the Alhambra Palace at Granada in the thirteenth and fourteenth centuries. The palace sits on the high escarpments that dominate the city; its gardens lie in a series of varied-size courtyards with commanding views of the city below and

The formal stone and water parterre in the S'Agaro Garden, inspired by the Persian "carpet garden," is the ultimate luxury: a water design next to the sea.

133

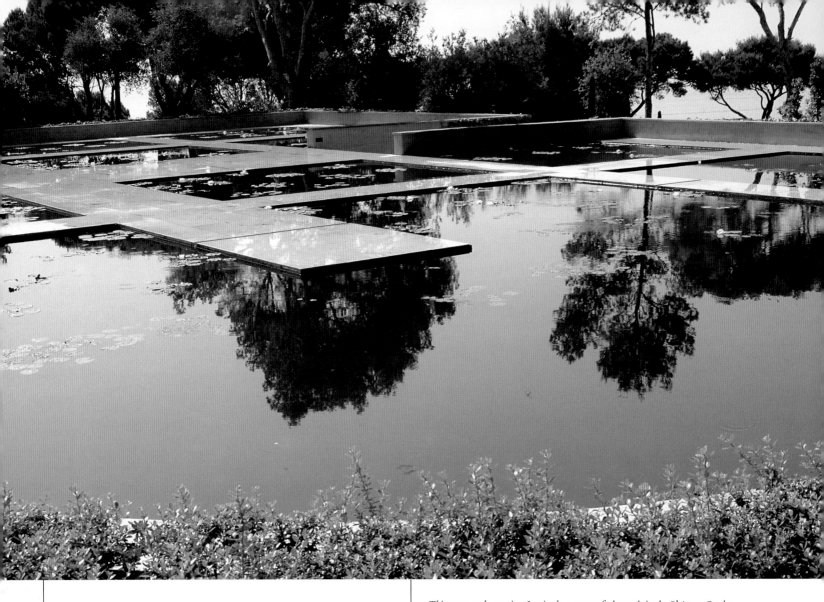

This page and opposite: Jets in the corners of the pools in the S'Agaro Garden cool the stone grid; when the jets are turned off, reflections of aleppo and stone pines glisten among a few water lilies.

breathtaking ones of the distant Sierra Nevada Mountains, which in winter burn luminously as the light changes the fallen snow from pale pink to roseate to dark rose.

Throughout the gardens of the Alhambra is water on every level and in every configuration, from small, gurgling Persian-inspired marble basins set in terraces connected with underground piping or narrow open runnels to the Courtyard of the Myrtles, where a large, rectangular pool is edged with the sweetly scented shrub. One small courtyard, bounded on three sides by the foundation walls of the palace, contains only a raised pool shooting a single jet of water with very tall cypresses at each corner. The design expresses great simplicity and restraint, made more splendid by the panoramic view of the ever-present mountains.

Fernando Caruncho thinks of himself as a gardener, not a landscape architect or landscape designer; he finds those terms superficial. He came to the landscape from his studies of philosophy. His contact with the classical Greek thinkers first influenced him; their view that the landscape and the garden form a spiritual link between the physical and

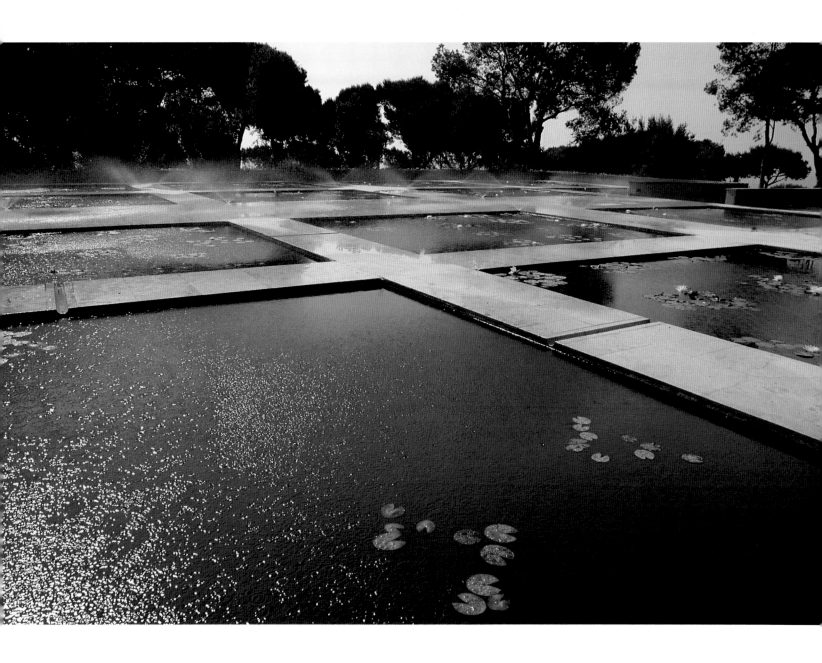

The Ollauri Garden in the Rioja is another of Caruncho's modern interpretations of the formal garden. It features a foot labyrinth of gravel and brick-edged box hedges; the hazelnut trees that encircle the maze will grow to a height of twenty-five feet.

White stone semicircular steps join the two levels of the Ollauri Garden.

A centered Mediterranean cypress is the focal point of one of the Ollauri pools.

the metaphysical has energized his design. Indeed, he is very serious when he maintains that the ancient Greek philosophers taught their students in the groves and gardens of ancient Athens.

Caruncho is also influenced by the great twentieth-century formalist garden designer Russell Page. His own formalist point of view makes him hate the philosophy of Jean-Jacques Rousseau and, as he puts it, all those eighteenth-century pastoral scenes with sheep, shepherds, and shepherdesses. He also loathes the nostalgic English garden with its pseudo-natural appearance, whether the picturesque trees and lawns of the country house or the Arts and Crafts cozy-cottage garden plantings.

In a garden there is an opportunity to re-create in a given enclosed space, as in medieval stone gardens and walled Moorish paradise gardens, a model of idealized nature that cannot be found in the natural world. Caruncho thinks of gardens as philosophic prototypes and would like to see the same attention and care he gives to his gardens be used in polluted delta watersheds, on hillsides wrecked by housing developments, and in the fragile rain forests of South America.

The European lime trees at the far end of the Ollauri Garden screen out views of the new town below and also provide a windbreak.

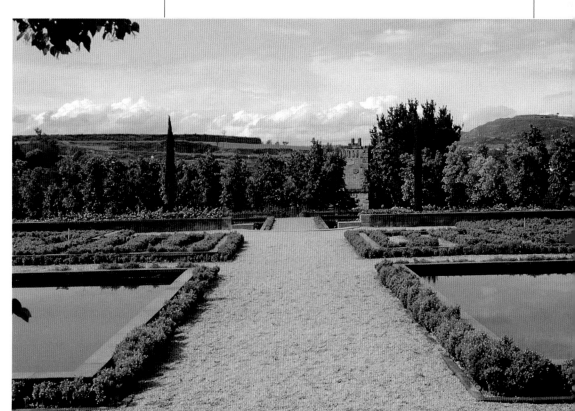

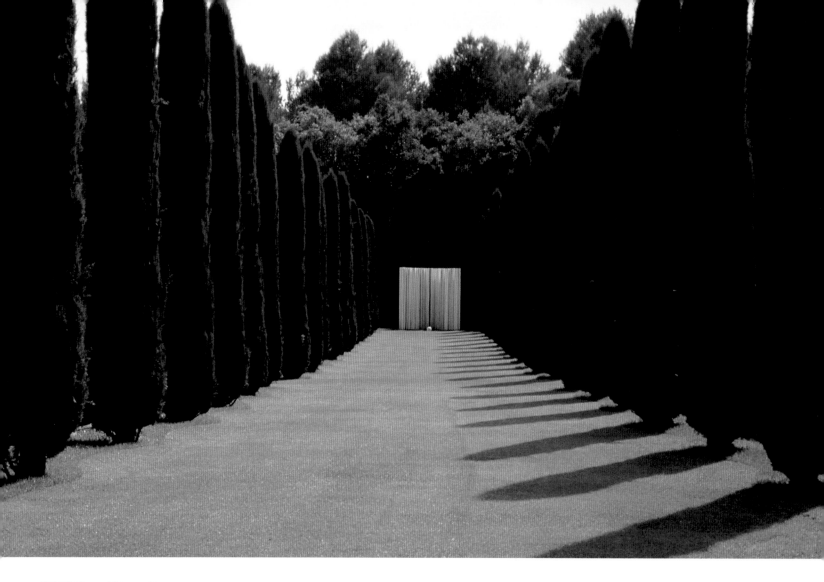

In the Mas Floris Garden, near Gerona, a cypress allée focuses on a white marble sculpture by Javier Corbero.

An apse and an allée of cypresses draw the eye from the Mas Floris Garden terrace to the distant Ampurdan hills.

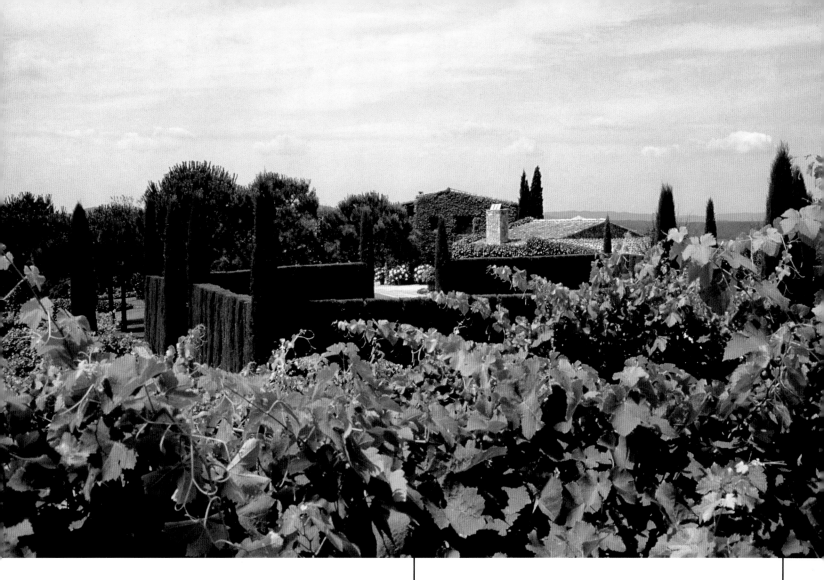

A clipped cypress hedge enclosure at Mas Floris is punctuated by Mediterranean "green candle" cypresses. The enclosure is the central "hall" for the three main vistas: to the house, to the stables, and to the Corbero sculpture.

The garden at S'Agaro in Catalonia in the north of Spain, completed in 1987, is Caruncho's most accomplished work. The site has views to the sea through mature umbrella pines, oaks, cypresses, and arbutus, all native to the Mediterranean. S'Agaro's centerpiece is a large grid of paving and water that forms the terrace between the main house and the sea. Although Caruncho is using the most formal language of design, the generous scale of this modern parterre and the adjacent summerhouse transform the plan into a contemporary garden. The summerhouse is the simplest rectilinear shape, with heavy-gauge metal mesh walls up which evergreen ivy is trained, providing a coolness of color and allowing breezes to filter through the leaves on hot summer days. The summerhouse also has a large fireplace for taking the chill off sunny but cool early spring and late autumn days.

This water and stone design is a splendid adaptation of the traditional Moorish aesthetic. The size of the pools, the width of the stone paths enclosing them, and the use of jets work perfectly on this site. The placement of the jets in the corners of the pools not only cools the paths in the fierce summer heat but also gives the pools a restrained silvery sheen from the fine falling spray. When the jets are not on, the pools become perfect black mirrors reflecting the sky and clouds, interrupted only by a few restrained plantings of water lilies and the shiny flash of small fish.

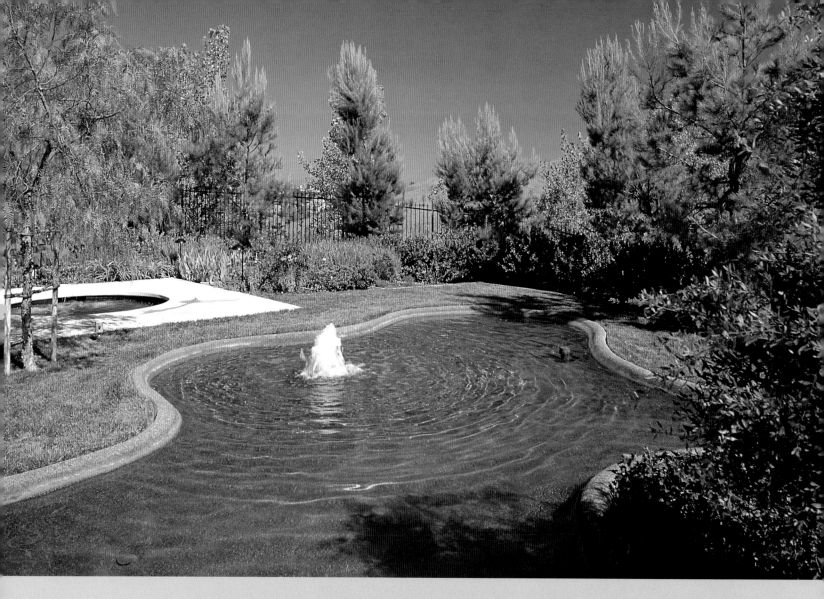

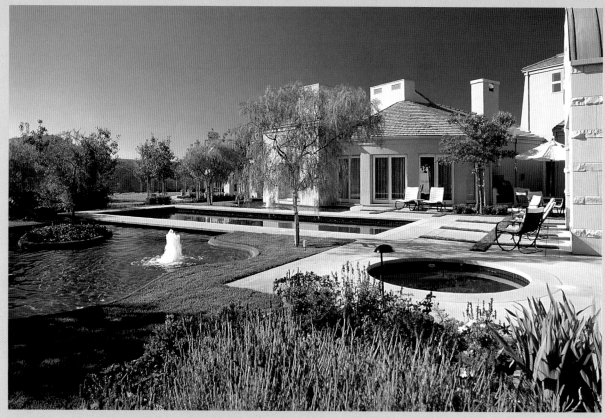

John Wong

NAGELBERG GARDEN, VENTURA, CALIFORNIA

Often the last area to be considered in designing a new house or renovating an existing one is the garden. In both cases, money intended to be spent on the garden or the landscape almost invariably begins to disappear into the building or reconstruction. The Nagelberg house and garden are an unusual case, in that landscape designer John Wong, a principal of the SWA Group in Sausalito, California, and the architect, Michael C. F. Chan, were both involved in the design process from the very beginning of the project, which was completed in 1994.

It is instructive to follow the evolution of the initial sketch plan for this garden. The arrows show the main axes of the house and garden, which were important in the positioning and use of the rooms in relation to the landscape proposals, and how they evolved into the final plan. The client had several design criteria: the garden was to be innovative, unique, and modern; it was to be one story in height, with some areas two stories; it was to have maximum privacy and views, a variety of water features, a swimming pool with spa, a large lawn area for informal games, and multiple entertainment areas; and it was to provide adequate screening of two neighboring properties. (The site is located

Opposite: Three of the several Nagelberg water features (both in the house and the garden) are the freeform ornamental pool, the round spa, and the rectangular swimming pool. The trees, pines for the most part, provide screening and protection from the wind. Lavender, cosmos, and irises fill the flower beds.

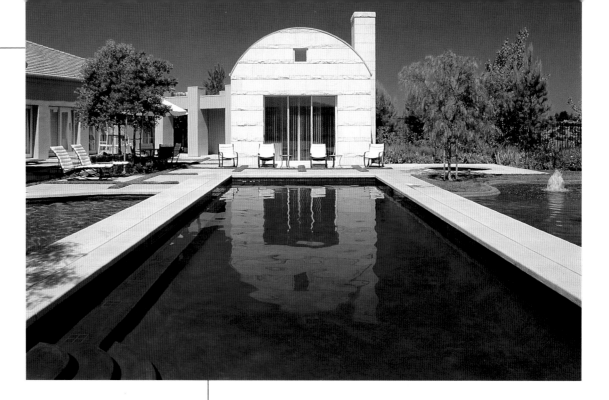

Plans of the Nagelberg house and garden show the main
axes of the site and their incorporation into the final design.

within a residential golf community, which means that there are houses
on either side and views across the golf course to distant hills). The
Southern California environment also demanded, following the
Spanish/Islamic tradition, the use of water, for both solace and sound
in the hot climate. The hills in which the development is situated are
still covered with the drought-resistant trees and groundcover native to
the area.

An initial strong statement about the house is made by a freestanding
gatehouse on axis with the entry into the paved parking area, framing the
house's front door across the lawn. The open gatehouse leads into a large,
enclosed courtyard dominated by a small structure surrounded on three
sides by water. This is the library; its moat is further enclosed by a low ter-
race of grass, with two stepping stones crossing the water, somehow
daring visitors to enter the building. In the courtyard's opposite corner is
an expanse of curving window, which is mirrored in a similarly shaped
reflecting pool below. Large windows in the main hallway of the house
reveal this courtyard as well as an indoor-outdoor pool, so the presence of
water is continuous. The use of water is even more creative outside the
family wing of the house, where another irregularly shaped moat is inter-
rupted by a rectangular swimming pool at the property's edge.

Two formal allées, one of large pots and one of trees, lead the eye toward
the distant, dramatic arid landscape. The intricacy that has been wrought
in this garden, with its combination of drama, privacy, water—both
moving and still—and shade, is an example of what can happen when two
disciplines, that of the architect and that of the landscape designer, work
together, particularly when given a clear mandate by the client.

The entrance gate offers a view of the lawn and the house.
The pots feature seasonal plantings.

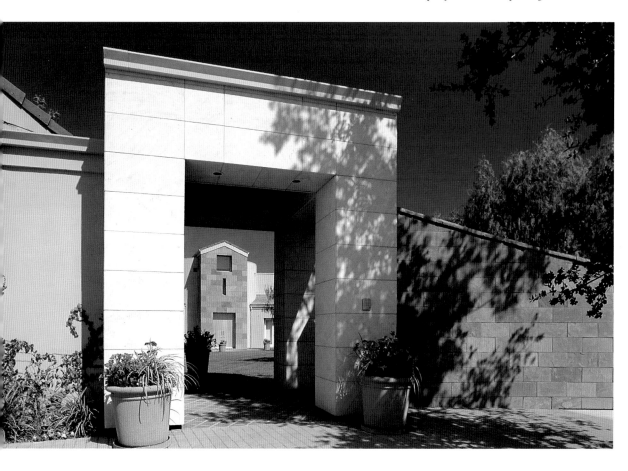

Stepping stones seem to hover above
the tile-lined moat around the library.
Tulip trees next to the house will
provide shade when mature.

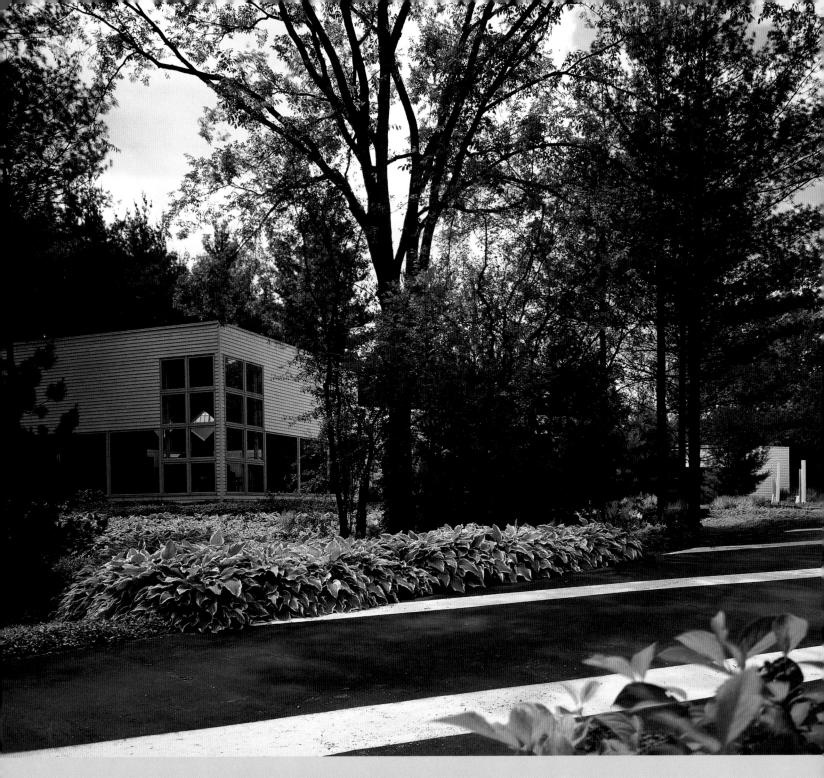

*Ornamental grasses and other hardy ground cover plants in generous drifts
and serpentine shapes counterpoint the angularity of the Rotter house.*

An aerial view of the Rotter Garden shows the boldly striped driveway.

Grissim / Metz

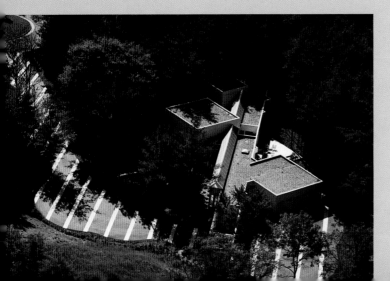

ROTTER GARDEN, BINGHAM FALLS, MICHIGAN

Downtown Detroit still shows the ravages of the 1967 race riots, as well as the scars of decades of industrial decay and abandonment. Long before the riots, many of Detroit's more affluent citizens had moved from the city to the surrounding suburbs, which boast a wonderful mixture of traditional architectural delights in such towns as Grosse Pointe Farms and Farmington Hills. Every imaginable style, from English-Tudor-with-Carport and Georgian-with-Screen-Porch to French-Mansard-Diminished-Versailles-with-Barbecue and Ranch-House-with-Cathedral-Ceiling, has been built and enjoyed.

So it is a bit of a shock to find at this house, beyond a generous turning circle, a driveway of ordinary black tarmacadam painted with very bold, diagonal white stripes leading to the parking area and the house. These diagonal stripes make no concession to the small wood screening the house from the road, nor does the large white modern one-story house to which they lead.

A double-sided, rectangularly arched gateway extending from one side of the house—a reference to the great Mexican architect Luis Barragán—marks the entrance. (Earlier in the century, this would have been attached to the front entrance and called a porte cochere.) After passing the arch, the white stripes of the driveway change to a pinkish color

145

Four allées of Bradford pear trees lead to the Forbes residence in Bloomfield Hills.

as they edge the three very broad steps leading up to the front door. A sculpture of a trio of half-round metal pipes of varying lengths, painted white on the outside and yellow on the inside, signals the owners' taste for the modern; indeed, inside is a collection of modern art.

The other impressive aspects of the landscape, which was completed in 1992, are the perennial plantings leading up to the entrance and in the main garden area. Large, river-like swathes of low, contrasting evergreen and herbaceous perennials have been used, including pachysandra, hostas, astilbes, vincas, and ornamental grasses. These wide, generous plantings are quite attractive, particularly in the summer, and the undulating curves of their serpentine shapes make a fine and expressive contrast to the modern angles of the white house and link it to the tall evergreen trees just beyond.

FORBES GARDEN, BLOOMFIELD HILLS, MICHIGAN

A primary function of palaces, houses, and gardens has always been to make a personal statement about wealth and power. The grandees and magnates of the past—the Fuggers in Germany and the Medicis in Italy during the sixteenth century, the Rothschilds in Europe and the Vanderbilts in the United States during the nineteenth century—have been succeeded by a new breed, the American tycoon, a category that includes such names as Gates, Turner, and Perlman.

Evidence of wealth is clear in this beautiful suburban garden and house set on a small lake northwest of Detroit. The architectural model for the house seems to have been a stripped-down, simplified version of Château de Maisons near Paris, by François Mansard, with the baroque proportional U ground plan, long sloping roofs, and high, prominent chimneys typical of Mansard, although the architect, Hugh Jacobsen, of Washington, D.C., was in fact inspired by the work of Sir Edwin Lutyens. The garden was installed in 1989.

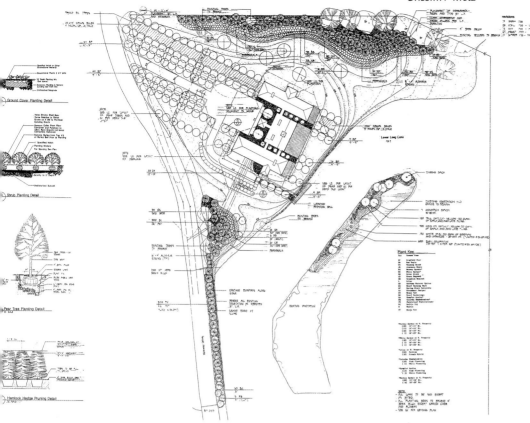

Plan of the Forbes Garden.

Much of landscape architecture and design is about directing and "fooling" the eye, whether the plan is formal and traditional as in the Forbes Garden, or diverse and contemporary. Photographs of this garden give the impression that the allées leading up to the mansion could have come from a seventeenth-century garden design for a château or palace in France, but Grissim/Metz has used these allées of trees in a contemporary way. Four lines of Bradford pear trees on either side of the driveway frame the house; the length of the lines differs, but their mass and simple formality in relation to the grand house give the impression of power and importance.

The allées continue in short extensions on the garden side of the house into a lawn that reaches a stepped retaining wall at the edge of the lake. These formally set trees frame views from the tall ground-floor windows across the terraces, lawn, and lake, including a small, wildly planted island just off the shore. A single line of smaller trees near the house curves off from one side of the allées and leads visitors around the house to a parking area and the garden.

A curved, somewhat irregularly stepped wall retains the shore of the lake in front of the house, with a boat landing at one end. The lower courses near the water have randomly set plantings. The retaining wall is an unlikely and modern part of the design, considering the classic formal French references of the house and allées, but it is also an excellent example of a landscape architect making a very good and practical design improvement. The wall is most expressive when seen either in an aerial photo or from the lake, when the house seems to be either protected from the lake's waters or sitting on a podium of stability, respectively.

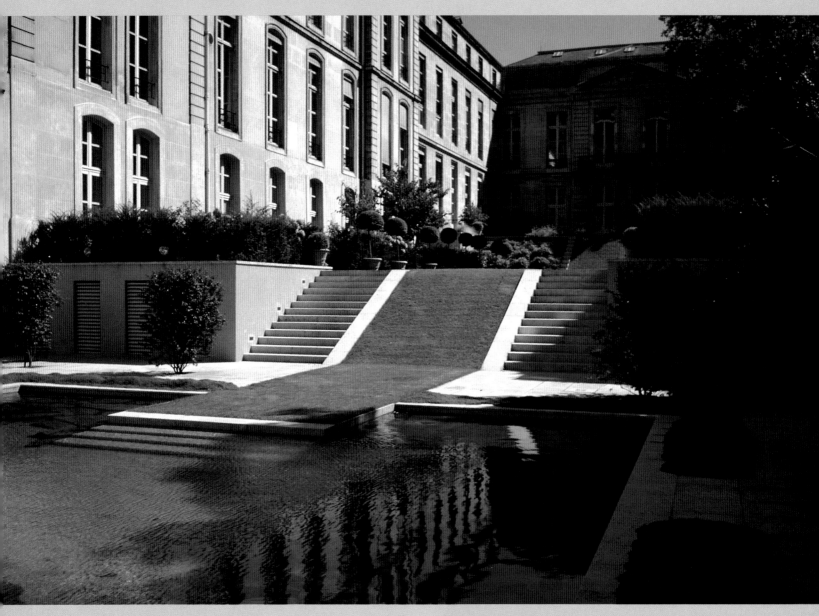

The pool is the climax of this garden for a grand Paris townhouse.

Gilles Clement

Along the sides of the grass "carpet" are proportionally set ball-headed box trees.

TOWNHOUSE GARDEN, PARIS, FRANCE

Traditionally, the French and the British have had diametrically opposed views on almost everything. Given the choice between a grand house in town and a country estate, the French will choose the former, the British the latter.

Hôtel particuliers, the grand private homes of Paris, have been a feature of the city's life for centuries. They were usually large townhouses built around inner courtyards, and sheltered the owner, the extended family, and often some paying tenants. Today many of these houses have been divided into highly desirable apartments, the most sought after of which is always the one between the court and the garden.

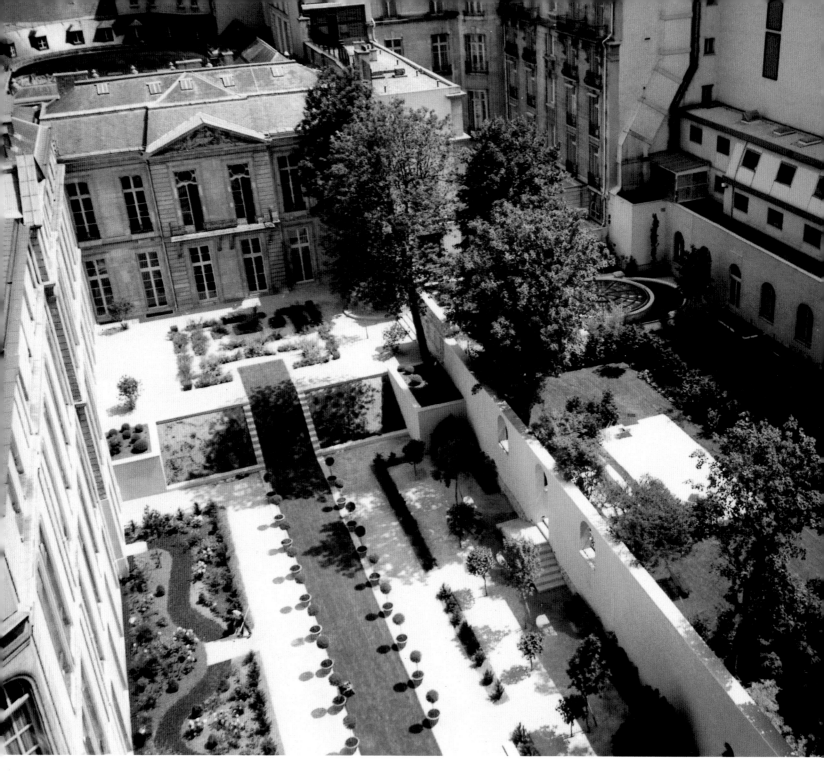

This page and opposite: Aerial views of the formal Paris garden show its immediate context: the hôtel particulier, the side gardens, and the adjacent, more informal upper garden with lawns, trees, and shrubbery.

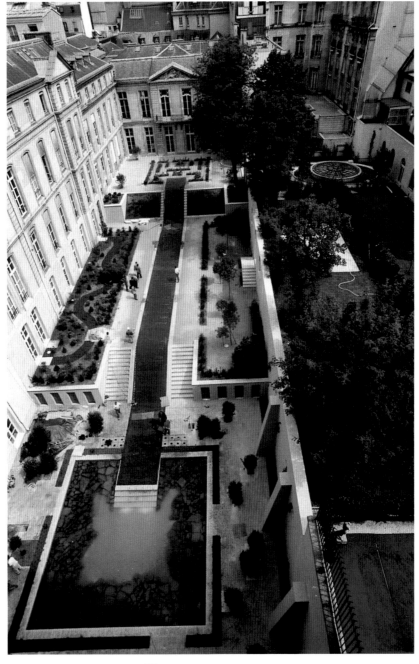

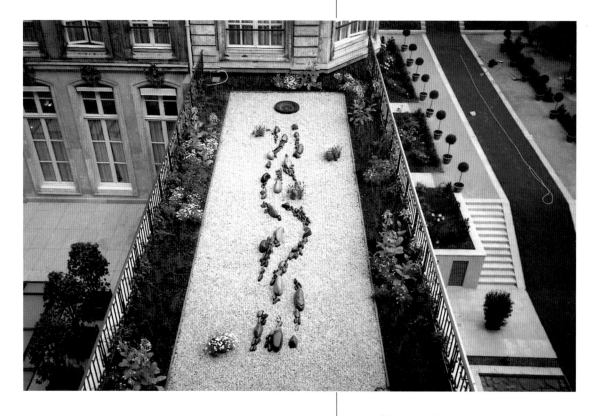

One of the side gardens is a reinterpretation of a Zen gravel-and-stone garden.

A spectacular new garden has been created for just such a townhouse in the center of Paris. The garden measures approximately twenty-five by ninety-five meters and gently slopes down from the front. On the terrace outside the ground floor living rooms is a formal knot garden set in pale-colored stone. A green carpet of turf rolls down the adjacent slope, along the next terrace, down another slope, and into the rectangular pool at the far end of the garden. On the terrace the green carpet is bordered by standard box tree balls in pots, which in turn have small, informal gardens on either side. One such garden features a sinuous path curving between perennials, and the other is an enclosed area marked by box and yew hedges.

The garden's drama is increased by the final descent into the pool, which is again surrounded by pale-colored stone. Under the water a drift of large, gray pebbles and rocks similar to those on a seashore impedes entry except by shallow steps leading to the pool's center. At night the pool is lit from below, and from within the pebbles comes dramatic fiber-optic lighting.

At one side, another terrace is raised and retained two stories above the main garden. It is a long rectangle of gravel surrounded by some perennials; on the gravel is a drift of pebbles somewhat influenced by the Japanese tradition, with superb scale and detailing.

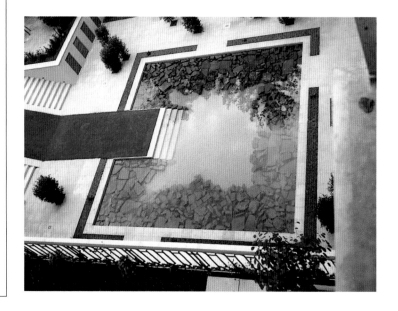

Fiber-optic night lighting in the Paris pool.

Opposite: An aerial view of the pool shows the rock "drifts" in the water.

Jacques Wirtz

Domed summer houses of clipped beech trained over metal frames guard the canal bridge railings in the Kontich Garden; on either side of the bridge is the aquatic plant typha, the cattail.

A garden is a theater set. The hedges are the wings from which the characters come and go. There must be an element of mystery, lots of surprises. A garden should reveal itself.

—Jacques Wirtz

KONTICH GARDEN, NEAR ANTWERP, BELGIUM

Jacques Wirtz, a native of Belgium, has been described as the André Le Nôtre of the twentieth century. Wirtz denies the comparison to the great French master, but it is an interesting one, for he was chosen by President François Mitterrand to redesign the Jardin du Carrousel between the Louvre and the Tuileries in the heart of Paris. He was a co-winner of the competition to design the entire stretch of gardens, but Mitterrand, who was the absolute ruler of France's main public works, the Grands Travaux, was advised that it might be better to divide the designs between some French designers, I. M. Pei, whose office produced the glass pyramid in the Cour Napoléon of the Louvre, and Wirtz. Wirtz not only rejects the Le Nôtre label, he disputes the very notion of a French or an English style. He maintains that a garden is similar to a piece of music—it should speak for itself. He has created over one hundred gardens, both public and private, at sites from Portugal to Japan.

Opposite: Clipped beech turrets and hedges line the canal of the Kontich Garden.

Oxygenating plants keep the canals of the Kontich Garden free of algae invasion.

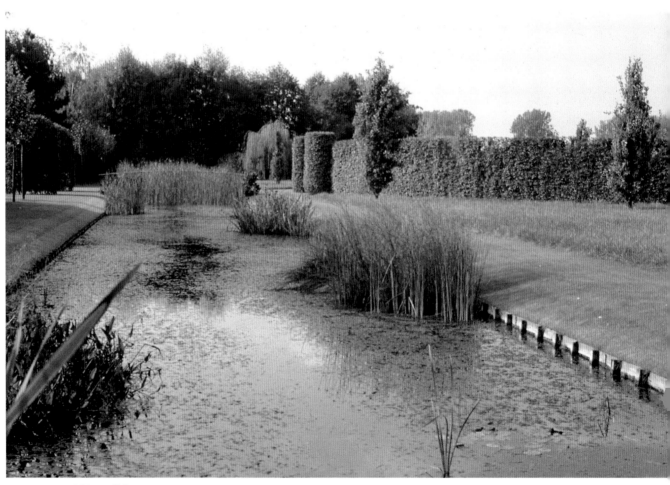

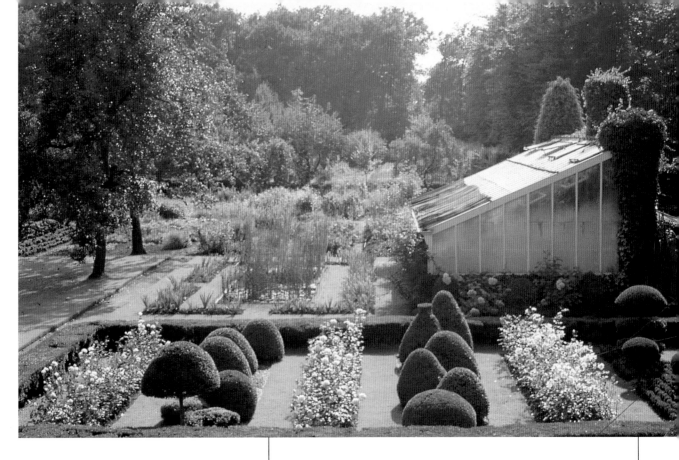

Wirtz's own private garden and nursery at Botermelk, near Anvers.

He was trained at a rigorous school of horticulture in Belgium and began his career with a wheelbarrow and a spade. He started by growing plants at his family's small house in the country near Antwerp and designed his first garden in 1949. He is assisted now by his sons Peter and Martin; the practice both designs and builds. Wirtz works in grand and smaller, more domestic styles. In a large garden, he thinks the designer is freer to make grand incidents, which he enjoys doing, while smaller-scale projects should be approached with the finesse of a gem cutter shaping a diamond.

The gardens Wirtz has designed rely on simple, sculpted forms, whether they are paths, hedges, grasses, shrubs, or existing mature trees. Water often appears as formalized rectilinear pools retained by wood horizontal and vertical posts, a traditional Belgian mode that can be seen in canals, ditches, and the remains of moats near Antwerp. Hedges are another signature of Wirtz's designs—hedges rectilinear, hedges stepped, hedges labyrinthine and in maze form, hedges spiraled, planted in hornbeam, box, beech, and yew. He uses them as readable elements, to provide equilibrium. He also uses large-scale plantings of grasses as a stunning contrast and as a strong but yielding element in the landscape at all seasons. For Wirtz, a garden that is not beautiful in the winter is not a beautiful garden.

The Kontich Garden, built in 1988, is very beautiful, with its interplay of hornbeam hedges, water, aquatic plants, and lawns. To resolve the basic design problem of a T-shaped site, with the house and its immediate gardens in the stem, Wirtz laid out near the house very formal parterre gardens, herbaceous borders, and a hedge-enclosed space divided into a radiating star design.

Opposite, bottom: At the entrance to the hornbeam rondelle in the Kontich Garden are flat-topped turrets. Fastigiate, or upright oaks, stand between the hedge and the water. The aquatic plants are cattail, cortaderia, scirpus, and Iris pseudoacorus.

From the area around the swimming pool the eye is drawn to four large, almost symmetrical turrets of hornbeam that flank a bridge. Two of the dome-shaped turrets are unusual summerhouses; the two flat-topped ones mark an entrance. Tall aquatic grasses growing in the water on either side of the bridge and in staggered design along the length of a canal make an informal contrast.

It is only when crossing this bridge and entering the "cross" of the T-shaped site that the full extent of the landscape becomes visible. Two hornbeam turrets mark the entrance to a large rondelle made of an outer circle of hornbeam hedge and an inner circle of trees that forms a generous secret garden. Three more pairs of turrets mark the other openings from the rondelle into the two large lawn spaces planted with asymmetrically set upright oak trees. The perimeter is planted with even more mature trees. This arrangement, Wirtz says, reflects his wish for a contrast between the few formal elements and the pagan spirit of nature.

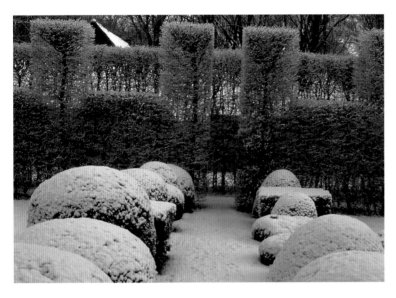

This page and opposite: The plantings in Wirtz's own nursery garden will be used in landscapes designed and built by Wirtz and his sons. The plants include formally clipped box and yew topiary specimens. The two-hundred-year-old box hedges and the apple, pear, plum, and black mulberry trees (still bearing fruit) remain from the time this area was the potager of a nearby château. The hedges have transmuted over time into the beautiful organic shapes often seen in Japanese gardens.

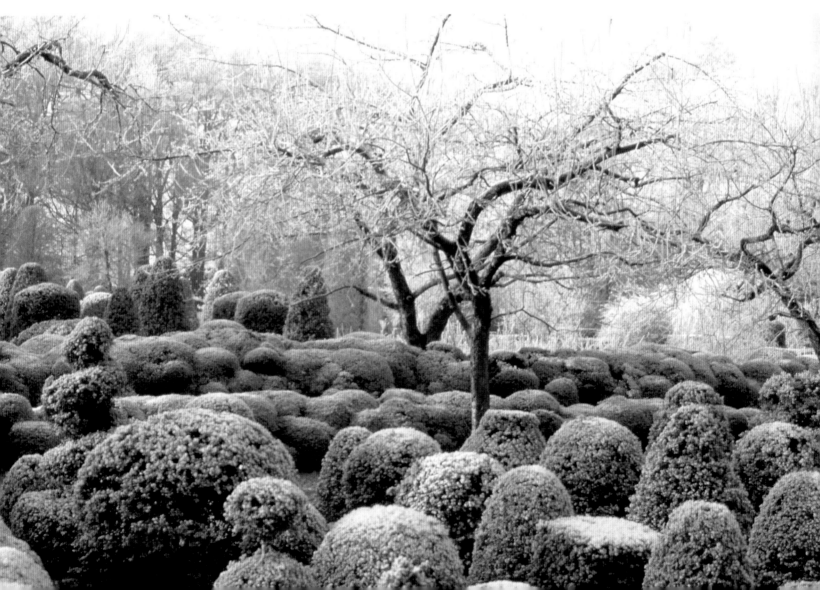

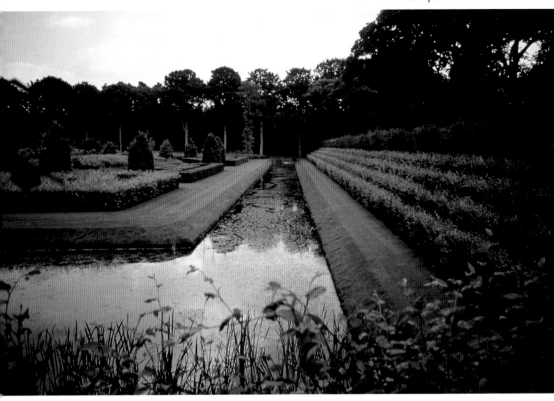

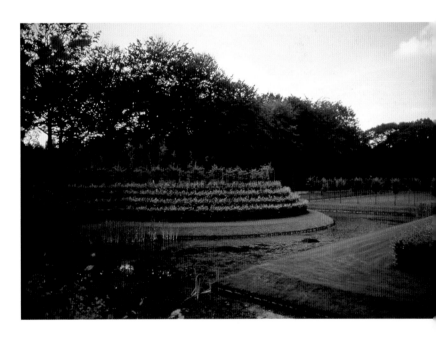

This page, opposite, and overleaf: La Petite Garenne at Schoten has a vast parterre and two smaller ones; the garden is three-and-one half acres. Throughout, Wirtz uses variations on formal garden geometry: circles, half-circles, squares, rectangles, and triangles, whether with hedges, water, stone, gravel, lawns, or other plantings. The six massive triangles are set with pinnisetum and molinia grasses interplanted with cornus and roses. The large pieces of semi-abstract, seventeenth-century broderie are staggered rows of beech hedges.

In reality, landscape design is outdoor sculpture, not to be looked at as an object,

Abstraction

but designed to surround us in a pleasant sense of space relations.
—James C. Rose

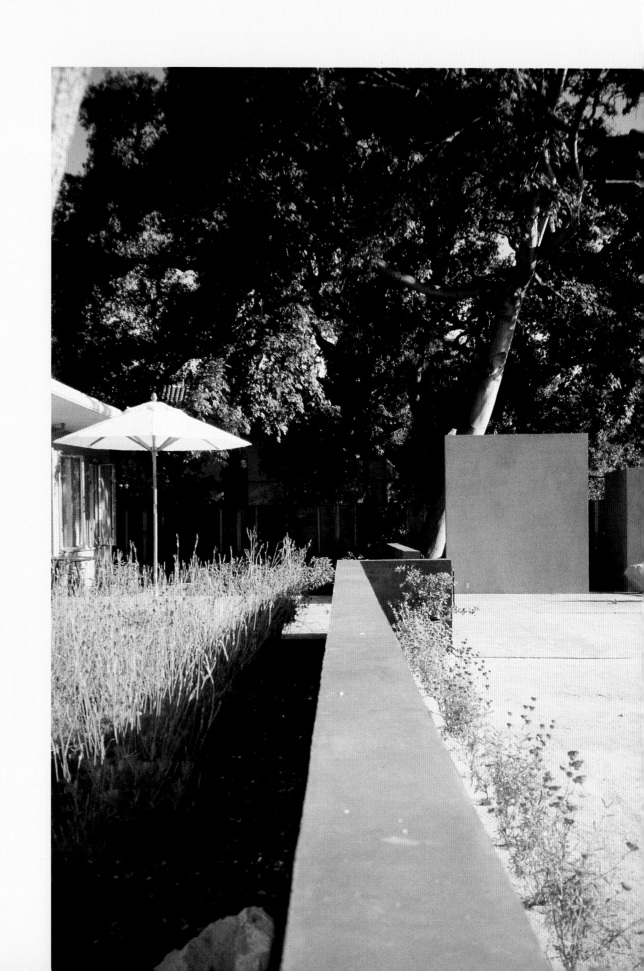

Abstraction
Delaney & Cochran

Gardens should be freed from the boxwood of history.

—Topher Delaney

KUHLING GARDEN, PALO ALTO, CALIFORNIA

Jokey brightly colored metal sculptures at the street entrance and in the front garden of this somewhat ordinary Spanish-style house signal that its owners are interested in a more creative way of life than might be typical on this suburban street.

Topher Delaney's 1993 design for the house's forty-by-sixty-foot back garden is a reinterpretation of the work of Luis Barragán. The low walls that define the patio around the house are painted in shades of soft blue and lavender, and these colors are enhanced by a pair of parallel lavender hedges to one side of the main courtyard.

The focal points of the main courtyard are the golden gravel, the stone paving for seating and entertaining, and two freestanding, dark gold stucco walls. They are Barragánesque in their luminous color and pure geometry—one rectangular and one square—and practical also, screening the storage and tool sheds. Running along one side of the courtyard is a tall metal screen covered in cerise flowered bougainvillea, red trumpet vines, and red blaze roses, as though great floral chintz curtains had been incongruously festooned next to the rigorous geometry.

Soft blue and lavender walls are enhanced by the dense planting of lavender in the Kuhling garden. The Italian market umbrella is a necessary item for California living.

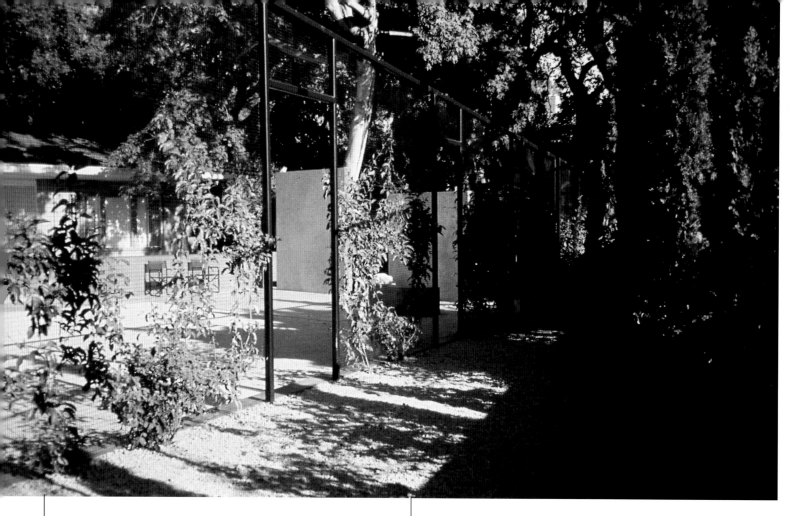

But sophisticated geometry is at play here as well: the sixty-foot metal screen is punctuated by five openings, each increasing one foot in width from one end of the screen to the other, while the height of the screen descends from fifteen feet to eight feet. Through an opening is another metal screen that forms a very long trapezoidal space narrowing from twenty feet to one foot.

The firm tries to personalize each garden from each client's "personal narrative"—the client's past, present likes and dislikes, future obsessions, current occupation, and family. (After one client's particularly nasty split from her husband, his gift of a stone table was used as an upended sculpture, near a planting of partially buried, jagged paving stones: the Garden of Divorce.) The client for this garden works as a venture capitalist and wanted something in the garden that was calm and reflective, an antidote to his high-pressure work. This element of tranquillity and reflection was provided by the metal screen, whose five openings cast exquisite shadows as the sun moves through the day.

GARDEN, CONNECTICUT

The clients for this four-acre landscape are collectors of modern and contemporary art. Their house is contemporary in design, with rooms on different levels providing suitable spaces for their collection. It was with this sensitivity to and interest in the modern that the landscape design team of Andrea Cochran and Morgan Hare, led by Topher Delaney, set out in 1992 to create a landscape as dynamic as some of the art inside the house.

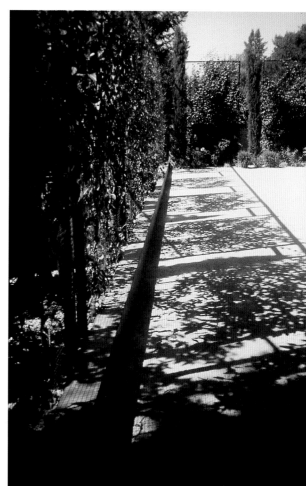

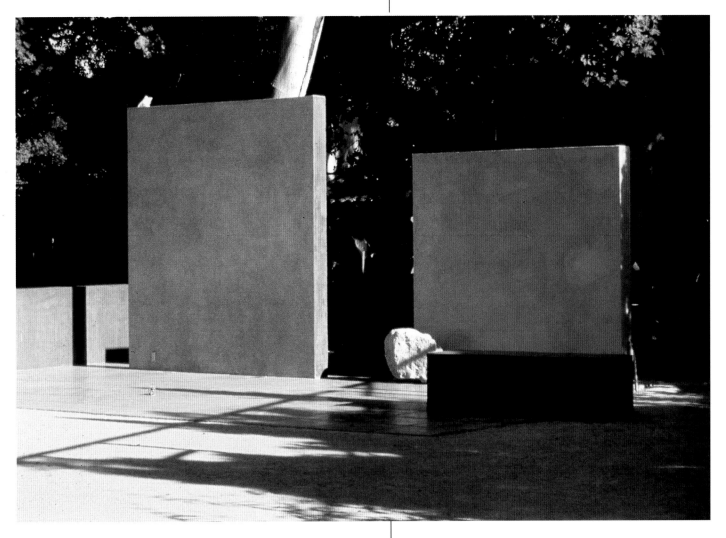

The dark gold walls of the Kuhling Garden were influenced by the work of Luis Barragán, the great Mexican architect and landscape designer. A simple stone bench and a single natural stone increase the dramatic simplicity of the design.

As the entrance drive leads to the front of the rectilinear gray wood and glass forms of the house, a stainless steel arc in front of a single tree stands as the hub of the turning circle and announces in one bold stroke that this is a contemporary garden. Other arcs of this metal appear as design elements elsewhere, sometimes to mark changes of level, sometimes to contrast with other basic construction materials such as stone or whitewashed concrete walls. The contrast between concrete and steel is at its most dramatic and effective in the parking area, where concrete retaining walls slice through longer, lower metal walls. Large, wide stripes of white paint on the black surface of the auto court assertively direct vehicles to park or to enter the house's garages.

At the back of the house is an irregularly shaped swimming pool. On the far side of the pool, flat boulders are set in a more natural composition, designed variations on the much larger rock outcroppings uncovered on the site, which have been incorporated into the slopes with planted drifts of perennials.

Opposite: The metal screen in the Palo Alto garden has openings that increase in width as the height of the screen decreases; it was designed to follow the daily course of the sun.

Delaney and Cochran's own description of their proposed designs to improve the garden further reveals the dynamism of their design process:

> Moored in descending waves of hardwood forest, the prow of a concrete and glass deck pierces through the leafy undertow—the steel hull is stripped bare to reveal the structure of the construction. Tendrils of climbing vines twist through the mnemonic struts of the deck's understory—the enclosure of horizontal staves fastened across the hull are relinquished for the dynamic visual access of natural growth . . . The arms of the circular deck envelop the edge of geometry: the house. Vases of aluminum hold bouquets of grasses, unbound rosecanes spill unrestrained over the rails to the gravel below, bunched patterns of macleayas' broad leaves contour the spaces between the cones which surround the fulcrum of the colored tapestry of a concrete deck inset with shells, stone, and aluminum. A lavender plane of terrazzo embedded with colored glass floats between the fulcrum of the hearth—the house and the trapezoidal deck plane of suspended motion.

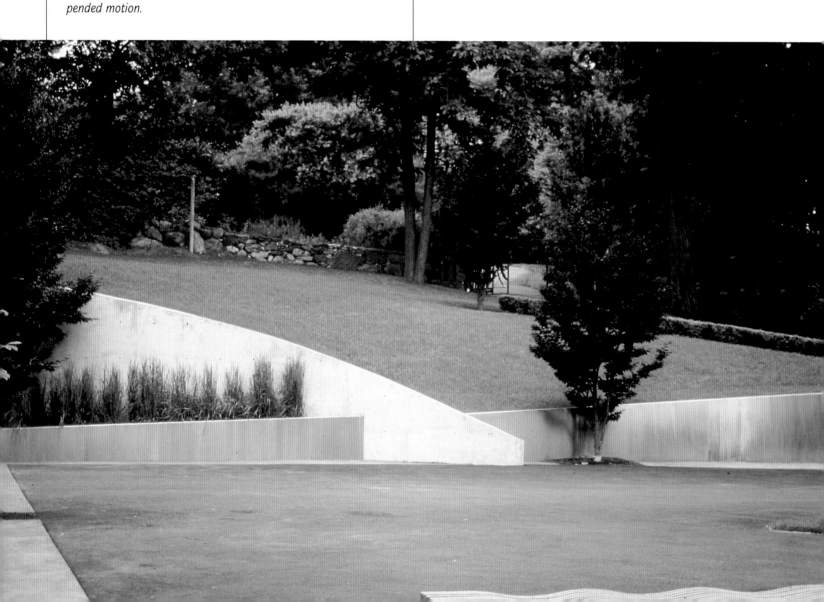

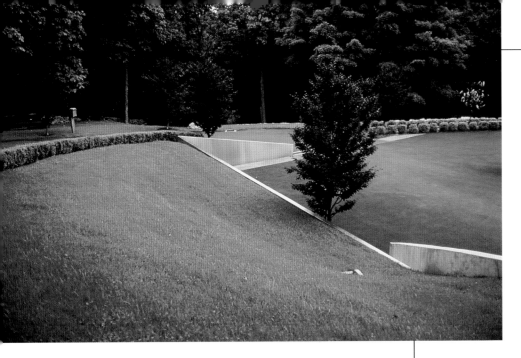

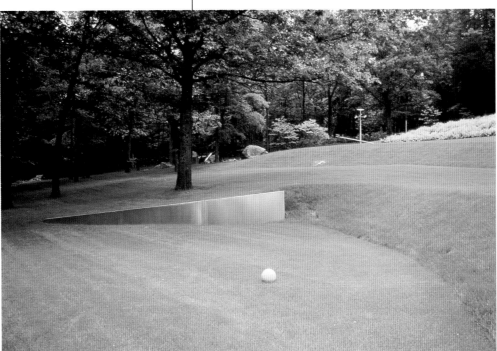

This page and opposite: The garden in Connecticut features bisecting, abstract, white-concrete and stainless-steel walls to complement the clients' modern house. The land is carefully modeled, and purple-leafed beech trees are planted on a generous grid.

The experience of this landscape is dichotomous. On the one hand the fringe of trees enclosing the landscape, the informality of the boulders, and the plantings that appear to follow natural contours are entirely reassuring. But the three ribbons of perennial flowering plants and the three white cones topped with letters spelling "S E X" seem both startling and arbitrary, as do the large verdigris metal letters spelling out "R O M A" and the ironwork tree with branches laden with empty wine bottles. These anomalous elements were additions made by the client, not part of the original design. But as Delaney noted in a lecture at Kew Gardens, a garden finally belongs to the client and any additions to the design have to be accepted.

This page and opposite: Sketches for the proposed steel ship's prow for the Connecticut garden.

The Pemberton Garden in San Francisco is bounded with black vinyl mesh generously planted with Hibertia scandens, *a climber. The garden is a study in variations on concrete: integrally pigmented, cast, aggregate, sand-finished, veneer, sculptural; soft, beautiful colors result from the use of this old material in very new ways.*

Arches of textured concrete render the San Francisco garden dramatic. Through this arch are blue-flowered agapanthus, scirpus (rush), and sword-leafed Phormium tenax *planted on a diagonal.*

Left and below: The Garden of Divorce, features the remains
of a stone table, a gift from the client's former husband, and jagged pieces
of concrete from a terrace he had laid.

Regina Pizzinini &
Léon Luxemburg

We strongly believe in a symbiosis between architecture and structure and, by that, showing structure whenever it becomes an object of beauty, but not necessarily trying to show architecture as a working machine image. We search for simple, logical, but exciting and unusual solutions.

—*Regina Pizzinini*

GUEST HOUSE/LIBRARY GARDEN, SANTA MONICA, CALIFORNIA

Some garden design and architecture problems can seem almost insoluble. But Regina Pizzinini, an Italian, and Léon Luxemburg, an Austrian, two European expatriates who have established an architecture practice in Santa Monica, overcame such a quandary with their design for this garden, guest house, and library. The clients for this project were a husband and wife who work as producers in the movie industry. Their existing house was set on a slope and had a fine, unencumbered view. They wanted to add a guest house and library but did not want to interfere with the existing garden or view, and they wanted the new structure to be easily accessible from the house. The architects' solution, completed in 1991, was as simple as it was effective: the new guest house and library were built ten feet down the slope below the main house. The garden was extended to form a roof garden over the addition, retaining the existing landscaping and preserving the view.

The pure colors and severe wall planes of this Santa Monica garden are similar to those used by the Mexican architect Luis Barragán.
The high walls focus the view on the California landscape beyond.

Overleaf: The view from the original house includes the blazing colors of the staircase, the sheet-metal library roof, and the sculptural skylights. The bright blue agapanthus, or Egyptian lily, complements the assemblage.

177

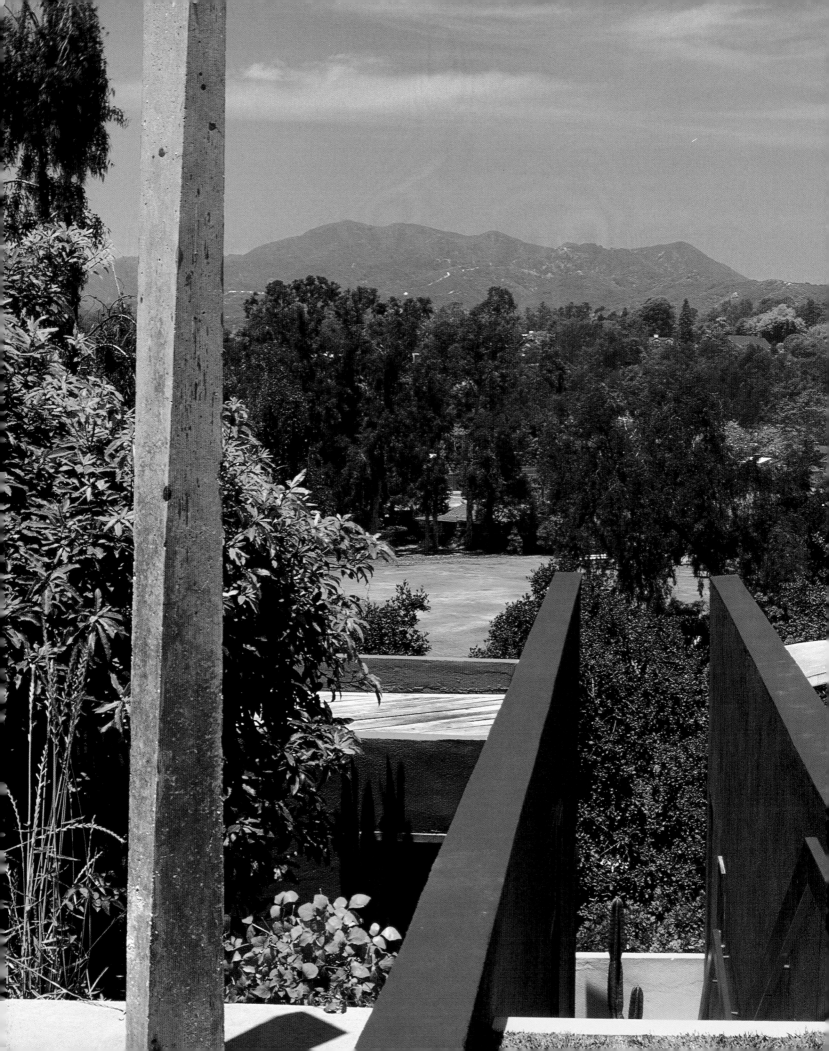

A dramatic bright yellow staircase with tomato-red walls leads visitors down to the lower level, where a single cactus in a slightly off-axis terra-cotta pot stands in front of the yellow boundary wall. According to Pizzinini,

> The stairs with huge walls leading you down toward the view are red, most obvious, most inviting. The volume of the guest house—human-scale integration—is green. The library—science complementing nature—is blue. The skylights are yellow, creating a play of light through their rotation, set in a sand garden. The roof at the entrance to the library is sheet metal. All these elements act as signs that something special is happening.

The architects have created two distinct roofscapes that signal the different sections of the house. On the guest house side are the yellow-framed skylights set in sand. These light ports have been inspired by Le Corbusier's Ronchamp Chapel, yet they also work as some sort of abstract art objects in relation to the bright red and blue pieces of the building near them. On the other side of the building is the plain sheet-metal roof of the library. The trees and lawn of the existing garden come close to the vivid blue walls of the guest house, contrasting with the sand and steel roofs.

This new and attractive piece of architecture is an exuberant foil to the existing garden. The planar part of the design makes reference to the work of Luis Barragán. The joyous primary colors that define various parts of the building could have come from any of the sexy, naive giant sculptures by Niki de Saint Phalle. Strong colors are used in all of Pizzinini and Luxemburg's projects; they think that they are a useful tool for reinforcing their ideas, and that they help achieve their highly individual solutions for each project.

The roof of the addition is level with the house's original garden.

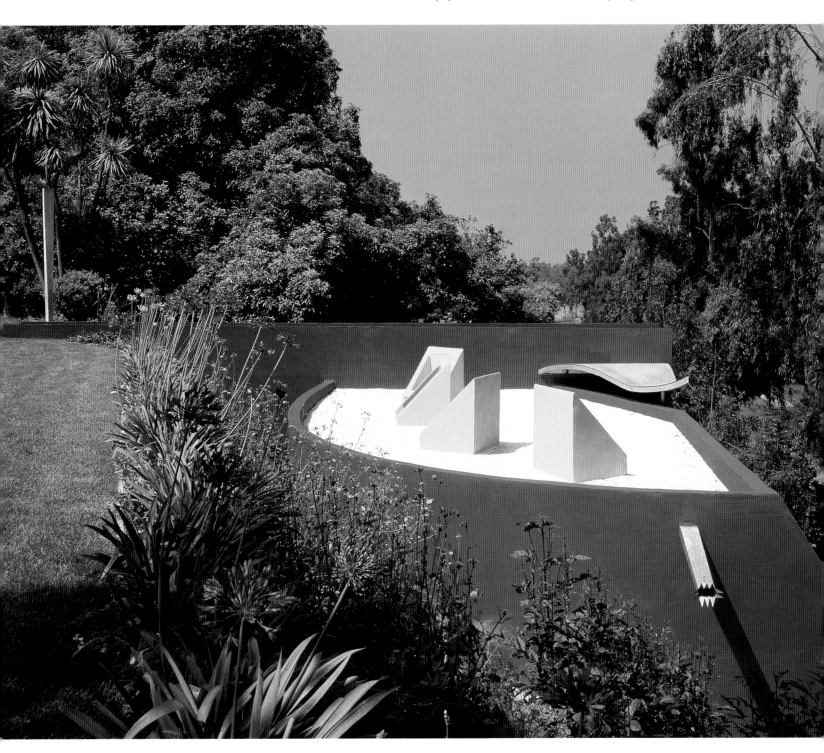

Achva Benzinberg Stein

Achva Benzinberg
Stein

The distinction between indoors and outdoors will disappear . . .
The sense for the perception of architecture is not for eyes—but living.
 —*R. M. Schindler*

GARDEN FOR A FILM PRODUCER, LOS ANGELES, CALIFORNIA

Achva Stein's garden design and plantings for this glass-and-white-walled modernist aerie have enhanced the terraces and garden plots recently added by architects Smith-Miller + Hawkinson, who remodeled the house in 1989–91. The original one-story structure was designed in 1956 by Donald Polsky, who had apprenticed to one of the masters of California modernism, Richard Neutra; Neutra, in turn, had worked with Frank Lloyd Wright, an earlier master at setting a house to best advantage in a landscape.

The Polsky house can be seen as a variation on the famous Case Study Houses that were built between 1945 and 1960 in a program devised by John Entenza, then editor of *Arts & Architecture* magazine. The Case Study House Program's objective was to encourage modernist architects to design elegant and inexpensive housing using the latest technologies. By the end of the program, thirty-six houses had been designed and built; participating architects included Craig Ellwood, Eero Saarinen, Charles and Ray Eames, and Neutra. The style that emerged in these houses was one adapted to the benign climate of southern California, with glass walls for transparency and an open flow between lightly framed interiors and exterior garden spaces for outdoor living.

A rectangle of drought-resistant low blue fescue grass beyond the swimming pool
echoes the rectilinearity of the film producer's house.

Stein planted the four areas of the garden with a modest and astute use of plant material, making the modern, rectilinear house even more dramatic. To add structure on one side of the house and to push the design strongly there, Stein has planted the evergreen pittosporum, a medium-sized tree with a neat habit. All of the seasonal plantings and groundcover Stein has chosen—common and lemon-scented thymes, potentilla, a variety of cotoneaster, and most important, beautiful blue fescue grass—are drought-resistant types from the hot and dry Mediterranean countries. For seasonal interest Stein has interplanted perennial bulbs: narcissus in the late winter and spring and a desert wildflower mix emphasizing poppies during the late spring and summer. In the front yard garden, Stein has used wisteria on the substantial trellis that leads to the front door; other climbers are jasmine, creeping fig, honeysuckle, and mandevilla.

The main vista on the garden side of the house includes the swimming pool, decks, and lawns, all of which are rectilinear and relate to the architecture of the house. The existing cape honeysuckle reinforces these elements of the ground plane and also serves as a wide security barrier, as the ground drops off precipitously at some points of the hilltop site. Blue fescue grass appears again beyond the swimming pool and provides a ground carpet for the splendid pine tree centered on the swimming pool. French lavender and dwarf chaparral broom are also used as groundcover. Fruit trees give some height to the design here, among them peach, pomelo, navel orange, Meyer's lemon, and Santa Rosa plum trees. More fruit trees grow in the kitchen garden, including apricot, loquat, and pear, as well as many herbs and passion fruit vines.

The north garden, with its shady aspect, gives room for the baby's tears groundcover and for perennials of hosta, sweet violets, and chamomile. The upper story of this design has camellias, Japanese maple, podocarpus, and bottlebrush trees.

Wisteria climbs the freestanding pergola at the entrance to the house.
At the approach to the garden, another square of blue fescue grass, this one interplanted with perennials, reinforces the clean lines of the composition.

Ferns
Adiantum (exist, relocate)
Asplenium bulbiferum- Mother Fern
Cyrtomium falcatum - Hollyfern
Polystichum munitum - Native Sword Fern
Polystichum setiferum - Fern
Rumohra adiantiformis - Leatherleaf Fern
Woodwardia radicans - European Chain Fern

Trees
Acer palmatum- Japanese Maple
Callistemon viminalis-Weeping Bottlebrush (exist.)
Podocarpus (exist.)

Vines
Passiflora edulis- Passion Fruit

Shrubs
Camellia (exist.)
Azelia (exist, relocate)

Ground cover
Soleirolia soleirolii - Baby's Tears

Perennials
Hosta
Viola - Sweet Violet (exist.relocate)
Chamaemelum nobile - Chamomile
Hemiaria glabra - Green Carpet

N ▶

North garden

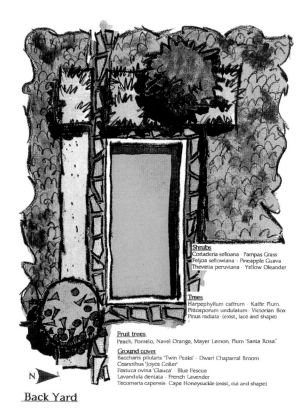

Shrubs
Cortaderia selloana - Pampas Grass
Feijoa sellowiana - Pineapple Guava
Thevetia peruviana - Yellow Oleander

Trees
Harpephyllum caffrum - Kaffir Plum.
Pittosporum undulatum - Victorian Box
Pinus radiata - (exist, lace and shape)

Fruit trees
Peach, Pomelo, Navel Orange, Mayer Lemon, Plum 'Santa Rosa.'

Ground cover
Baccharis pilularis 'Twin Peaks' - Dwarf Chaparral Broom
Ceanothus 'Joyce Colter'
Festuca ovina 'Glauca' - Blue Fescue
Lavandula dentata - French Lavender
Tecomaria capensis- Cape Honeysuckle (exist, cut and shape)

N ▶

Back Yard

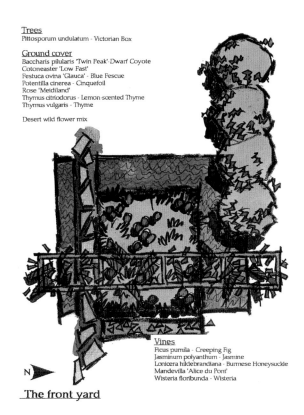

Trees
Pittosporum undulatum - Victorian Box

Ground cover
Baccharis pilularis 'Twin Peak'-Dwarf Coyote
Cotoneaster 'Low Fast'
Festuca ovina 'Glauca' - Blue Fescue
Potentilla cinerea - Cinquefoil
Rose 'Meidiland'
Thymus citriodorus - Lemon-scented Thyme
Thymus vulgaris - Thyme

Desert wild flower mix

Vines
Ficus pumila - Creeping Fig
Jasminum polyanthum - Jasmine
Lonicera hildebrandiana - Burmese Honeysuckle
Mandevilla 'Alice du Pont'
Wisteria floribunda - Wisteria

N ▶

The front yard

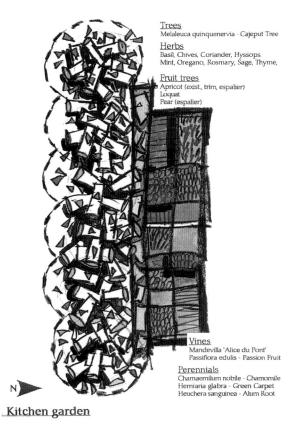

Trees
Melaleuca quinquenervia - Cajeput Tree

Herbs
Basil, Chives, Coriander, Hyssops.
Mint, Oregano, Rosmary, Sage, Thyme,

Fruit trees
Apricot (exist, trim, espalier)
Loquat
Pear (espalier)

Vines
Mandevilla 'Alice du Pont'
Passiflora edulis - Passion Fruit

Perennials
Chamaemilum nobile - Chamomile
Hemiaria glabra - Green Carpet
Heuchera sanguinea - Alum Root

N ▶

Kitchen garden

Plans for front, north, kitchen, and back gardens.

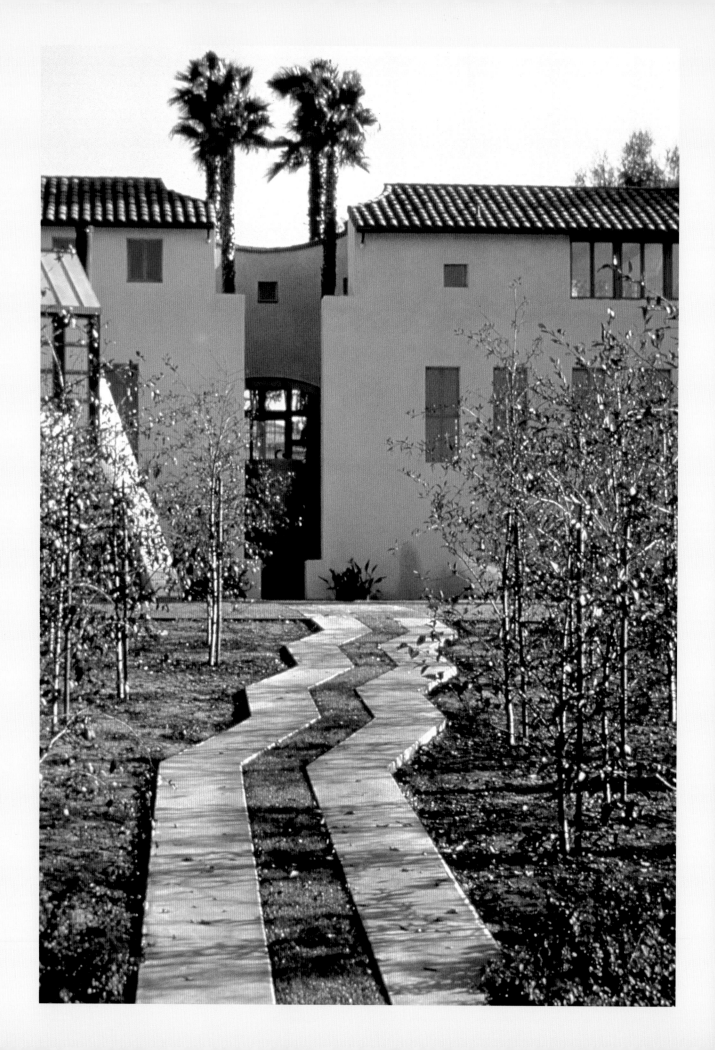

Ron Wigginton & Land Studio

I haven't found a landscape that hasn't affected me. The very center of my work goes back to this awe of the landscape.

The landscape is infinite; it contains the problems of the future, of living together on earth—and the artful part is that, if it's done right, landscape architecture will often be something new.

—*Ron Wigginton*

MIRAFLORES, SAN DIEGO, CALIFORNIA

Before Ron Wigginton became a landscape architect, he worked as a sculptor and as a landscape painter, experiences that were just as related to his awe for the landscape. When Wigginton and his Land Studio team approach their landscape design projects, they consider themselves "site architects," just as there are "building architects." Site architecture includes all aspects of site development: lighting, seating, paving, landscape incidents, as well as planting.

The 1987 design for this house at Fairbanks Ranch, near San Diego, California, presents a geographical description of San Diego's beach-to-mountains ecology. The plantings run from palms to lawn to forest, intentionally composing what Wigginton calls "a scenario which represented Southern California's fascination with its own (constructed) image."

At Miraflores, a path zigzags through alder trees.

The house was placed to the back of the property, pinned there with an allée of tall washingtonia palms that runs right up to the front door and continues on the same path out the back, integrating the house with its immediate surroundings. A dense belt of alder trees was planted in symmetrical form from one edge of the property to the other, but spaced randomly. The distant view from the site is refocused by this forest, in preparation for a dazzling close-up view as one emerges from the house. In the middle of this forest, a grass "stream" leads up to the house. Two long, low walls—tinted salmon pink and pale yellow—run through the forest.

Two huge "clouds" of flowers punctuate the great lawn that sets the house apart. The swimming pool and spa behind the house follow the oblique angle of the library and the porte cochere at the front. According to Land Studio, "this interesting angle and view line allows for a longer pool, and encourages threshold diving from the breakfast room." The house serves as a prototype in a regulated, planned development, indicating the potential for architectural and landscape diversity and innovation in an environment often considered hostile to such things.

STARWALK, PACIFIC BEACH, CALIFORNIA

Another objective in Wigginton's work is to make people think—to make them "more receptive with their minds," as he describes it. One device he uses in this pursuit is the platform or linear deck, raising visitors to a garden above the mundane ground plane. The image of the raised deck recalls the garden tradition of Japan, where raised platforms for viewing the phenomena of nature—the spring blossoms, the moon—sometimes appear.

In his award-winning 1984 project, Starwalk, a narrow deck runs through a field of African lilies with sword-shaped leaves and large yellow flowers. The deck acts as a pedestrian walkway, connecting four condominiums to a grove of trees, and then becomes a platform for sitting and contemplation. At night, the deck is transformed into Starwalk: it is illuminated by Plexiglas rods lit with fiber-optic technology. The points of illumination form a star-chart design, mimicking the constellations of the spring sky. Wigginton, one of the first designers to use this high-tech lighting in the landscape, describes Starwalk as "magic-making" and considers this kind of design to be very important to the human spirit, whose dreams and fantasies are necessary and need expression.

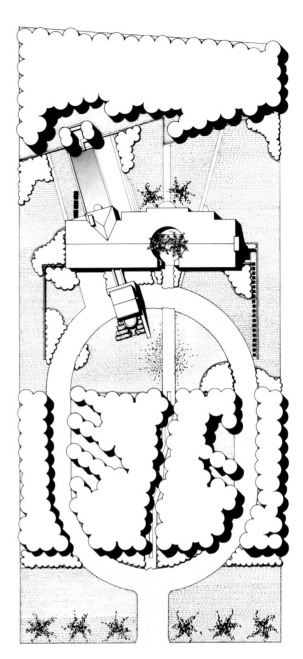

Plan of Miraflores.

The elevated walkway at Starwalk leads through stands of African lilies.

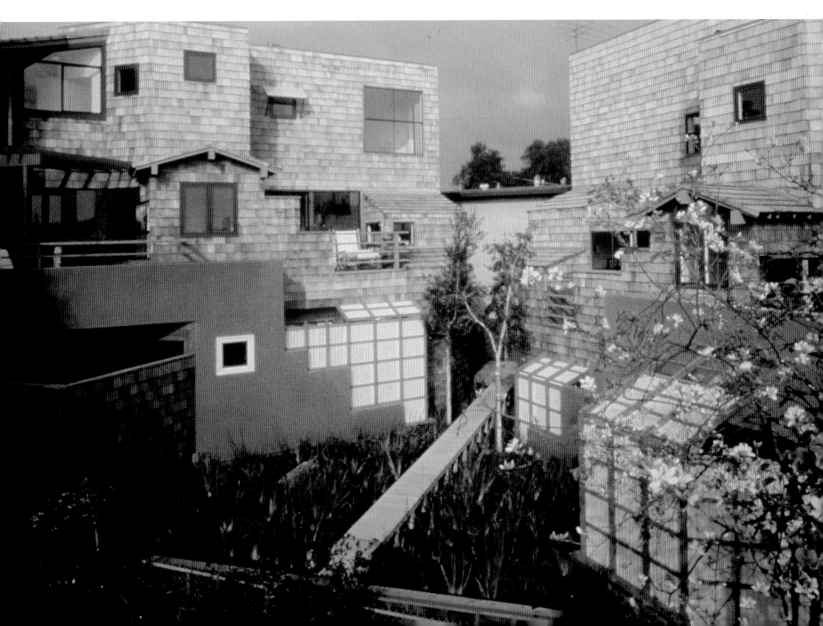

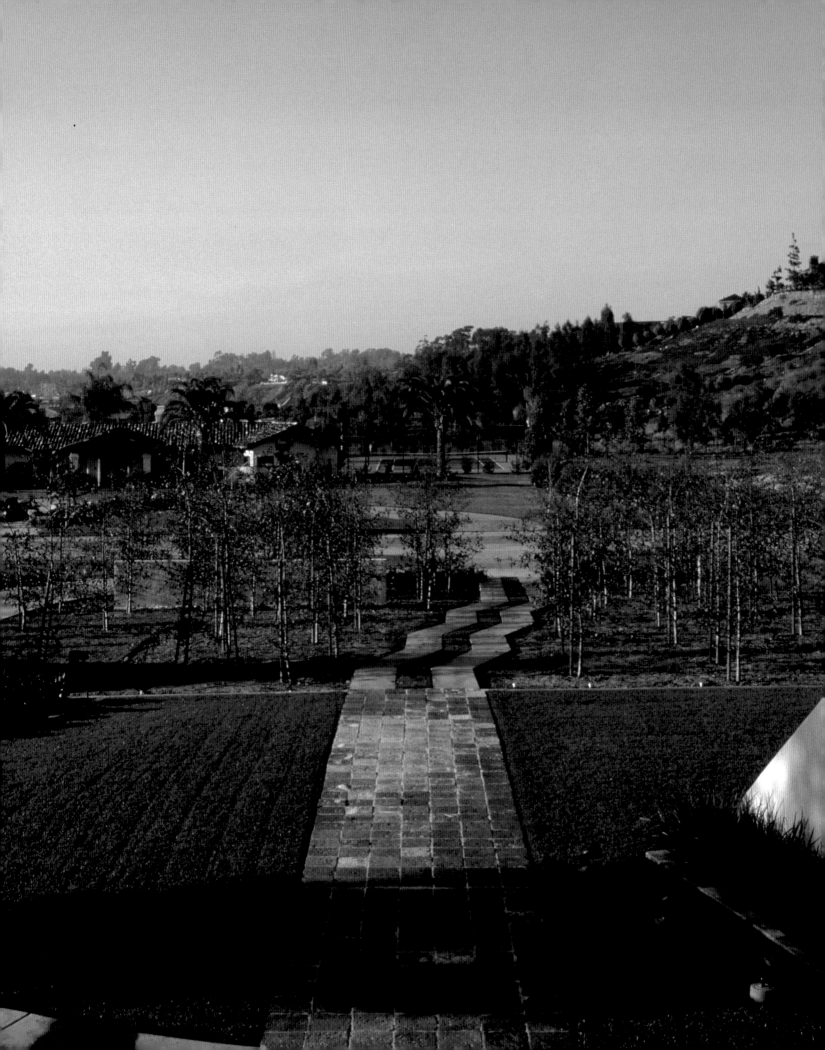

Opposite: The zigzag path at Miraflores divides into two parallel ones as it passes through the grove of trees.
Below: The fiber-optic illumination at Starwalk re-creates the constellations of the spring sky in the deck of the raised walkway.

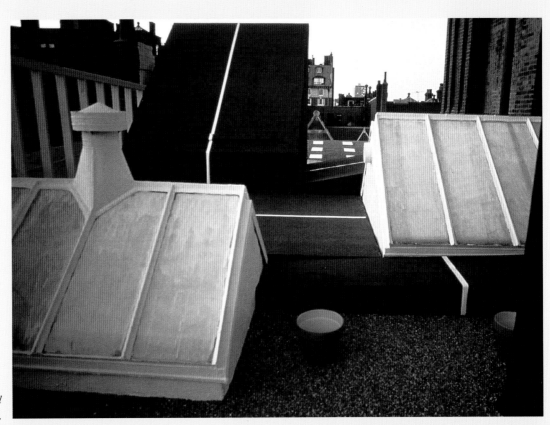

*Astroturf covers flat and
sloped roof structures.*

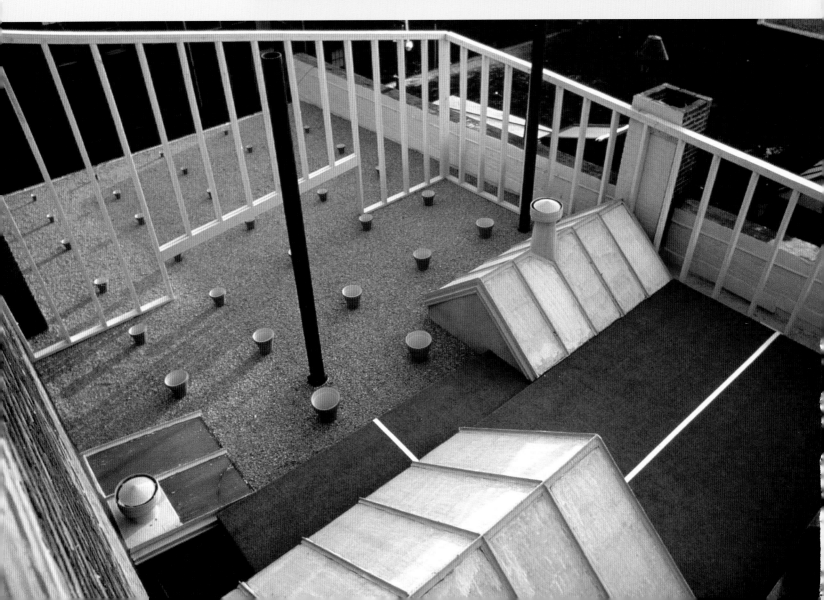

Peter Walker

ROOFTOP GARDEN, BOSTON, MASSACHUSETTS

Peter Walker has had a long and distinguished career as one of the leading landscape architects in the United States. He and his partner, the designer and teacher Hideo Sasaki, founded the highly successful Sasaki Walker Associates in 1957, which later became the SWA Group. In the 1960s and 1970s the firm designed large-scale urban, suburban, and regional projects throughout the United States and abroad, based on the company's multidisciplinary expertise in town and land planning and environmental awareness and management.

During these decades, as SWA became large and corporate (although still creating imaginative and excellent designs), Walker became interested in the minimal in art, mainly in sculpture but also in painting. He began to collect works by such artists as Donald Judd, Sol LeWitt, Frank Stella, and Jake Bertolt. This interest changed his professional life, as his own designs became based on the serial use of a few elements, often governed by a grid plan, in a bid to bring a contemporary minimalism to landscape architecture.

Walker was also influenced by the landscape architecture of Garrett Eckbo, Thomas Church, and Lawrence Halprin and the buildings of the Bauhaus, Ludwig Mies van der Rohe's in particular. Walker commented to J. William Thompson, an editor of *Landscape Architecture*, that "Mies was going to rebuild the whole world according to modernist principles,

Opposite: Terra-cotta pots that diminish in size force a perspective view. Their interiors are painted sky-blue.

but it wasn't until years later that I realized how strong the influence was, because when I got interested in minimalism it was simply a rebirth of late Bauhausian thinking." And Walker will remind critics who contend that modernist design has no historical basis of Le Corbusier's obsession with the Doric architecture of the Parthenon and of Picasso's use of images from Catalonian, Oceanic, and African primitive art.

Walker's revelation that there was a basis for the garden being considered as art came from experiencing the superb formal gardens designed by André Le Nôtre at Sceaux, Vaux-le-Vicomte, and Versailles. (He told Thompson that his ultimate goal "is almost a religious goal, because I will never achieve it: I would like to outdo Le Nôtre. That is the level of seriousness one should aspire to.") The experience of the grand simplicity of these gardens became fundamental to his thinking on landscape design; formalism is integral to his investigation and use of minimalism.

This roof garden, a collaboration in 1988 between his office and Martha Schwartz, on top of a Georgian-style brick townhouse in the Back Bay section of Boston, is not as grand and large as many of Walker's projects, but it is a fine example of his interest in seriality and minimalism. The south-facing area is twenty-two by sixty feet, with a view that includes the John Hancock Tower; to the north are Cambridge, Harvard University, and the Charles River.

The inherent problems of a conventional natural garden—weight and drainage—can become complicated and expensive on a rooftop. Here the human-made environment of the rooftop seemed to call for a design solution using artificial materials—gravel, Astroturf, paint, terra-cotta pots, mirrors, lighting, and wood.

Spatial illusion and perspective tricks were played in the three sections of the space. On one side of the roof, mirrors are set serially in the gravel, opening and stamping holes in the surface. They act as an element of color by reflecting the blue sky and also as barriers, for visitors instinctively adapt to the breakability of the glass mirrors. On the opposite side of the roof, terra-cotta flowerpots play a perspective game and seem to increase the depth of their horizontal plane as they descend in size. The insides of the pots are painted sky-blue; at twilight they glow and become points of light. In the middle section of the roof area, Astroturf covers four boxlike structures that are the entrance to the roof—one on an angle for sun worshippers, a level one for eating, one a ramp leading to the outdoor shower. This artful, minimalist design solution uses inexpensive materials to create a simple, useful, and brilliant "garden."

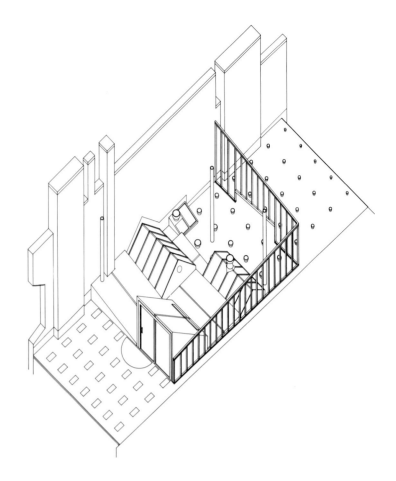

Axonometric drawing showing the three sections of the garden.

Opposite, bottom: Mirrors set into gravel on the rooftop exemplify Walker's interests in minimalism and seriality.

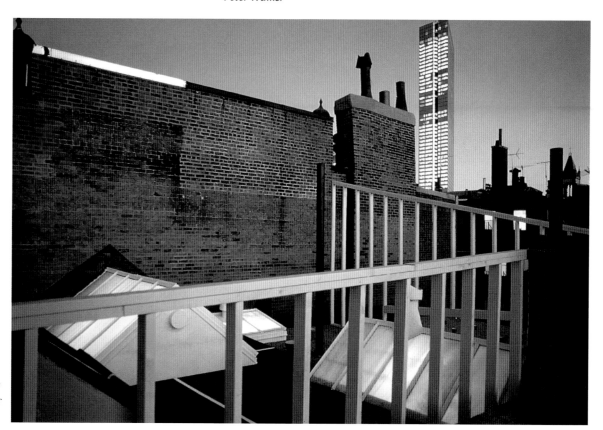

Painted guard rails surround skylights in the central section of the rooftop garden.

Kathryn Gustafson

Abstraction

Kathryn Gustafson

GOLD WALL GARDEN, PARIS, FRANCE

Kathryn Gustafson, one of the most important landscape designers working today, was involved in fashion in the United States in her early working life, but twenty years ago she decided that she really did not want to continue in that line. Taking a year off to think about her future, she spent time in an isolated beach house in the San Juan Islands north of Seattle, Washington. There, a new acquaintance said that if she could do anything with her life, she would become a landscape designer. This struck Gustafson as a great revelation, and she soon enrolled at the Ecole du Supérieure Paysagisme in Versailles to study landscape, completing her studies in 1979.

In addition to her formal education, Gustafson has drawn inspiration from many twentieth-century artists, especially the land artist Dennis Oppenheim and the painter Richard Tuttle. The tremendous achievement of the great sculptor and garden designer Isamu Noguchi is another inspiration. And the Polish sculptor Igor Mitoraj gave her a set of sculptor's tools from Carrara, with which she began to sculpt her models for the landscape.

Gustafson has completed thirty projects in the past fifteen years, including landscapes for the headquarters of major multinational companies such as Shell, Exxon/Esso, and L'Oreal. In the town square of Ivry, near Paris, she has created a grid ground plane, on one side of

A small, simple, two-tiered granite upstand waterfall in the Gold Wall Garden.

197

which runs a raised pool of Brazilian green granite, the Dragon Basin. The pool is 130 meters long and each section is about one cubic meter. The enormous weight of the pieces compresses a single thin rubber strip in the center of the bottom of the pool where the stones meet, making it watertight. Gustafson's splendid design relates to the Mario Botta–designed cathedral on the square and to the town hall.

One of Gustafson's latest projects is in the Dordogne at Terrasson. In a hillside wood of fourteen acres she has created a work called "Fragments of Garden History." Here she has placed the Gold Leaf Ribbon, a 3,200-foot thin aluminum ribbon, sixteen feet above the ground, embellished with gold leaf and running through the canopy of mature trees she calls "the sacred oaks." The names of the five main rivers of the world are carved on large stone slabs as evocative "water incidents." The main purpose of the design is to provoke and teach about gardens and their history—not as a direct narrative but through fragmented elements.

Gustafson has also made a prototype of a very beautiful pair of uprights to support high-voltage electrical wires, an alternative to the ugly metal pylon supports now used all over the world. Power companies are considering the design for use throughout France; it is both more efficient and a simple, stunning sculptural design.

Gustafson sketches the first ideas for a project by modeling clay bas-reliefs of her initial sensations and ideas, which eventually become master-plan models. These ideas in clay, she maintains, are only a direct transposition from fashion—fluid and minimalist and sinuous. She says that this is simply a change of material, that they are the same thing—design ideas in different media.

Gustafson, like some of today's most farsighted landscape architects and designers, thinks that design concepts must come out of the layers of contemporary culture. Here she makes a distinction between ideas and concepts: an *idea* for a garden or landscape would be a rock garden, a boxwood parterre, or a rose garden, but these have no meaning in the late twentieth century; strong *concepts* in landscape design must come from cultural bases—the social, political, and economic—and from the hopes, dreams, and fantasies of the client. And the resulting design must always consider the human being moving through the landscape spaces.

The Gold Wall, installed in 1991, is in a very small Parisian garden above a parking garage. The pure rectangle of the wall is exquisite in its simplicity, but it also serves to screen the top of the metal staircase that descends to the garage. Linear ribbons of bamboo act as a background, below which is another ribbon of cut stone containing a waterfall and its channel. A ribbon of box hedges surrounds a ventilation unit from the garage below.

The granite waterfall and its shallow stone water course.

The Gold Wall blocks the view of the metal garage staircase from the house.

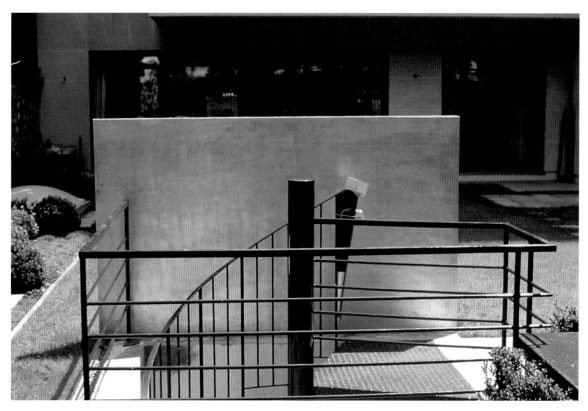

The gold-leafed concrete wall in the Paris garden represents the client's business success.

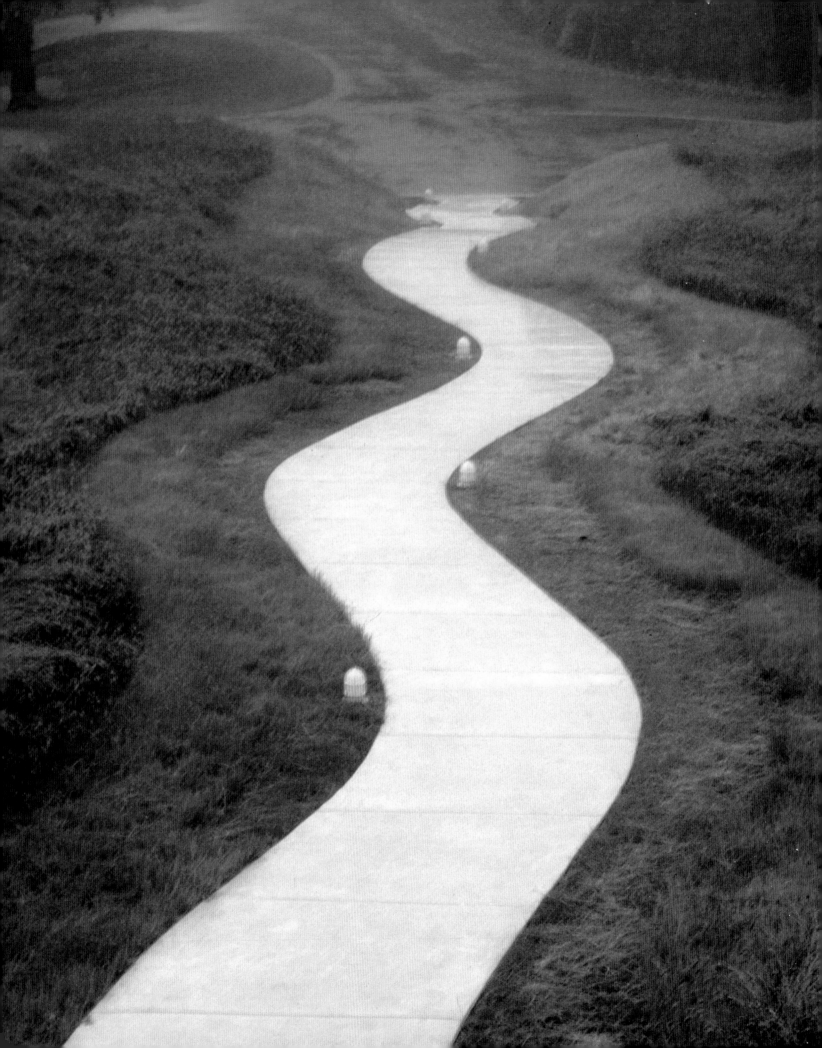

George Hargreaves

VILLA ZAPU, NAPA, CALIFORNIA

Sculptural land and plant forms based on the analysis of ecological processes are a major element of the landscape designs of George Hargreaves and his team, leaders in the profession. In 1986 Hargreaves designed the landscape for this postmodern dream mansion by London architects Powell-Tuck, Connor and Orefelt in the beautiful Napa Valley—he calls it a "twisted" Palladian villa—for a client he had known for a long time.

The house was built at the highest point of a hill from which the ground gently falls away on all sides. The land then rises in various parts, becoming carpets of vineyards surrounded by hills covered with bosquets of native trees such as oaks, firs, and madrones. This house is well known from published images, but the actual experience of it is distinctive. After a drive of many miles along a twisting, hilly road, the unique profile of the villa rises against the sky behind tall wrought-iron gates.

The primitive and elemental serpentine path from the driveway to the house at Villa Zapu is reflected exactly by the waves in two different types of grass.

Overleaf: Two mixes of drought-resistant grasses—the paler rattlesnake grass and blue flax, the darker fescue and bluegrass—surround the villa with spiral and serpentine forms.

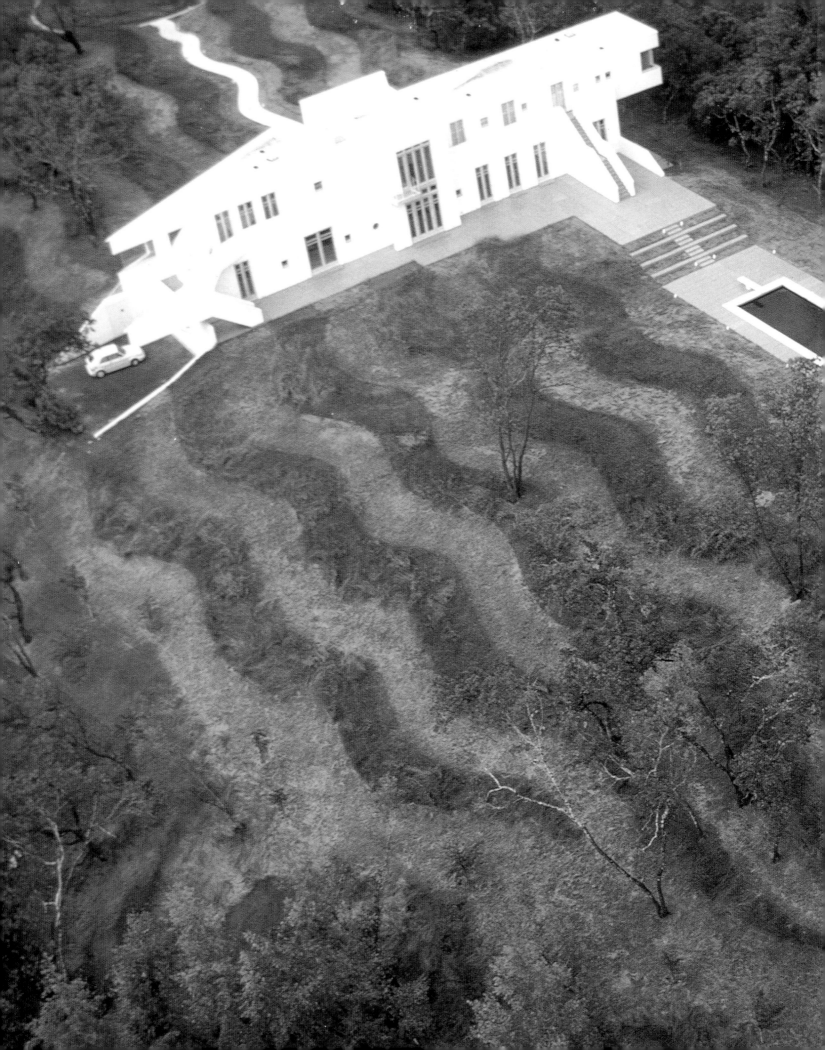

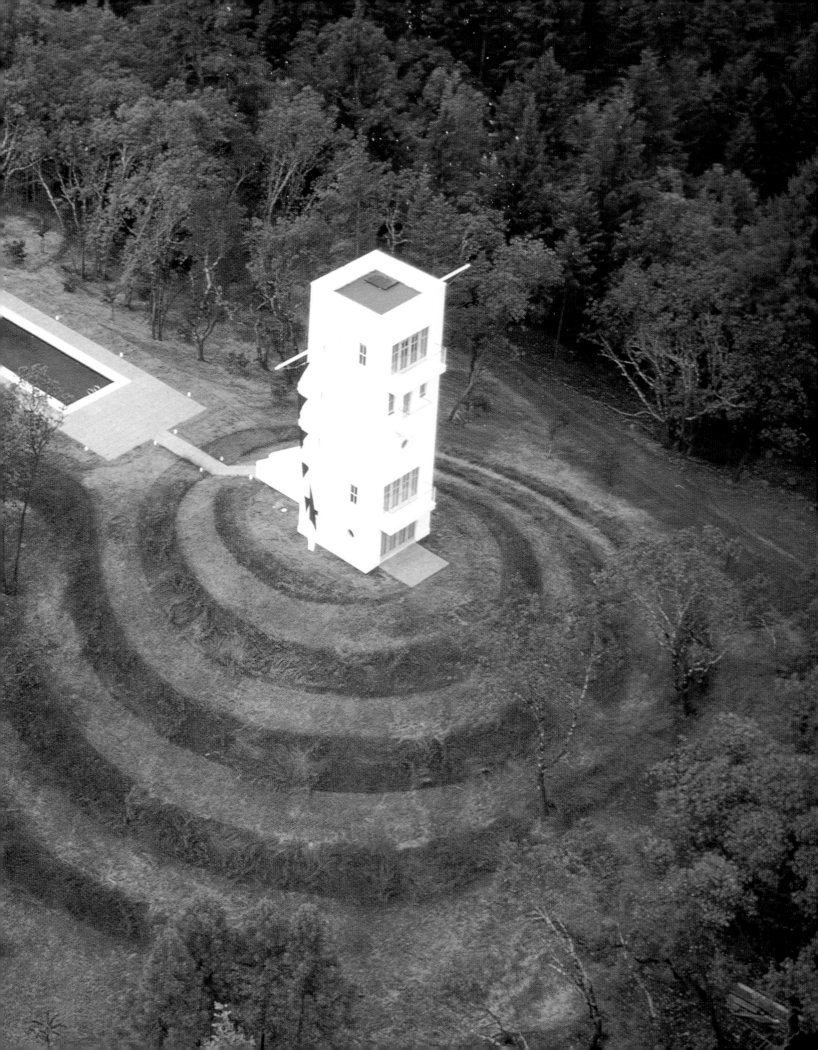

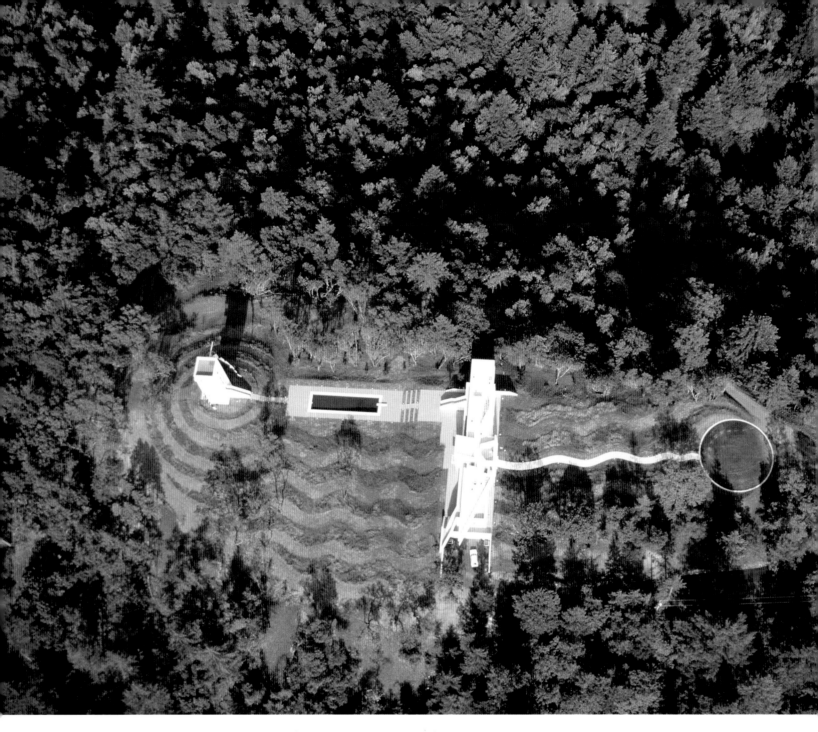

An aerial view of Villa Zapu shows the progression from driveway to turning circle to path to house to pool to guest tower, all set within a clearing atop a hill in the Napa Valley.

From these gates the house appears to be built on an entirely natural site, but it is still half a mile away. The drive curves up an easy grade and takes an oblique approach to the house. A turning circle signals arrival; from here a stepped serpentine path approaches the front door. The modernity of the facade leads unexpectedly into a formal French-inspired entry hall. Beyond it are five sets of double doors connecting the enfilade of main rooms.

The garden terrace is dominated by a long rectangular swimming pool on axis with a five-story guest house tower. From two flagpoles extending from the top of two sides of the guest house hang narrow, thirty-foot-long celebratory pennants. The tower sits on a knoll at the center of concentric circles planted in two different perennial grasses. The circles unfurl into serpentines below the terrace and roll back toward, and past, the house, anchoring it as they resolve themselves by embracing the turning circle beyond the front of the house.

From the air, the two types of native California grasses could be a long carpet patterned with two of the most primitive human marks, the spiral and the serpentine. (The zigzag motif of the pennants on the guest house tower is yet another early decorative motif.) The paler, shorter areas are rattlesnake grass interplanted with blue flax. The taller, darker bands are a combined planting of fescue and bluegrass seeded with California poppy. The flax and poppies give the bands color in the summer. Using these perennial plant materials must inspire gratitude from the owner, making the usual summer lawn chores unnecessary. Besides four containers with oleanders, there are no other ornamental garden plantings.

The guest house tower is a late-twentieth-century version of the lookout that appears in fairy tales. From the tower, the spiral and serpentine grasses are seen clearly, as are the vineyards on which the prosperity of the valley is based, and the encircling mountains forty to fifty miles away.

One of George Hargreaves's favorite landscapes is the splendid formal garden at Château de Courances, south of Paris, a classic design from the time of Louis XIV. The château is a moated manor, with water in a long canal on the central vista, many formalized springs, tall clipped box hedges backed by mature trees, and statues and lawns. The simplicity that characterizes this French design is adapted in all of Hargreaves's projects, and it continues to be beautifully expressive, whether in seventeenth-century France or in the present-day United States.

Selected Bibliography

Abrioux, Yves. *Ian Hamilton Finlay: A Visual Primer.* London: Reaktion Books, 1985.

Ackerman, James. *The Villa.* Princeton, N.J.: Princeton University Press, 1990.

Adams, William Howard, and Stuart Wrede. *Denatured Visions: Landscape and Culture in the Twentieth Century.* New York: Museum of Modern Art, 1991.

Adams, William Howard. *Roberto Burle Marx: The Unnatural Art of the Garden.* Exhibition catalog. New York: Museum of Modern Art, 1991.

Ashton, Dore. *Noguchi: East and West.* New York: Alfred A. Knopf, 1992.

Barragán: Armando Salas Portugal Photographs of the Architecture of Luis Barragán. New York: Rizzoli, 1992.

Beardsley, John. *Earthworks and Beyond: Contemporary Art in the Landscape.* New York: Abbeville, 1989.

Butler, Christopher. *Early Modernism: Literature, Music and Painting, Europe 1900–1916.* London: Oxford University Press, 1992.

Chipp, Herschel B. *Theories of Modern Art.* Berkeley: University of California Press, 1968.

Church, Thomas D. *Gardens are for People.* New York: Reinhold, 1955.

Dillon, David. "On the Edge in Santa Fe." *Garden Design,* May/June 1992.

Eckbo, Garrett. *Landscape for Living.* New York: F.W. Dodge, 1950.

——. *The Landscape We See.* New York: McGraw-Hill, 1969.

——. *Urban Landscape Design.* New York: McGraw-Hill, 1964.

Encyclopedia of World Art. 17 vols. New York: McGraw-Hill, 1959–87.

Farbman, Suzy. "Cool, Calm and Reflective" (Robert Murase). *Landscape Architecture,* September/October 1991.

Fieldhouse, Ken, and Sheilah Harvey. *Landscape Design: An International Survey.* London: Laurence King, 1992.

Fondation pour l'Architecture. *Les Jardins de Jacques Wirtz.* Brussels, 1993.

Francis, Mark, and Randolph T. Hester, Jr., eds. *The Meaning of Gardens.* Cambridge, Mass.: MIT Press, 1990.

Frederick, Kate Carter. "Up on the Roof." *Garden Ideas & Outdoor Living,* Summer 1995.

Frey, Susan Rademacher. "Hargreaves Associates." *Progressive Architecture,* July 1989.

"Garden Against the Grain: Martha Schwartz." *Landscape Architecture,* May/June 1984.

Gothein, Marie Luise. *A History of Garden Art.* 2 vols. London: J. M. Dent, 1928.

Hortus Third: A Concise Dictionary of Plants Cultivated in the United States and Canada. New York: Macmillan Publishing, 1976.

Hughes, Robert. *The Shock of the New.* London: Thames & Hudson, 1991.

Hunt, John Dixon. *Garden and Grove: The Italian Renaissance Garden in the English Imagination, 1600–1750.* London: J. M. Dent, 1986.

Hunt, John Dixon, and Peter Willis, eds. *The Genius of the Place.* London: Elk Press, 1975.

Itoh, Teiji. *Space and Illusion in Japanese Gardens.* New York: Weatherhill/Tankosha, 1973.

Jellicoe, Sir Geoffrey, Susan Jellicoe, Patrick Goode, and Michael Lancaster, eds. *The Oxford Companion to Gardens.* London: Oxford University Press, 1986.

Jencks, Charles. *The Architecture of the Jumping Universe.* London: Academy Editions, 1995.

——. "New Science, New Architecture." *Architecture + Urbanism,* October 1995.

Jewell, Linda L. *Peter Walker: Experiments in Gesture, Seriality and Flatness.* New York: Rizzoli, 1990.

Johnson, Jory, and Felice Frankel. *Modern Landscape Architecture.* New York: Abbeville, 1991.

Kassler, Elizabeth B. *Modern Gardens and the Landscape.* New York: Museum of Modern Art, 1964.

Keswick, Maggie. *The Chinese Garden.* London: Academy Editions, 1978.

Klinkenborg, Verlyn. "Landscape Architecture: Martha Schwartz." *Architectural Digest,* December 1993.

Kuck, Loraine. *The World of the Japanese Garden: From Chinese Origins to Modern Landscape Art.* New York, 1968.

Landscape Design: The Work of Dan Kiley. Tokyo: Process Architecture, 1983.

"The Landscapes of Noguchi." *Landscape Architecture*, 1990.

Lazzarro, Claudia. *The Italian Renaissance Garden.* New Haven: Yale University Press, 1990.

Lewin, Roger. *Complexity.* London: J. M. Dent, 1993.

Lowry, Suzanne. "The Unknown Garden Guru" (Jacques Wirtz). *Telegraph Magazine* (London), Feb. 4, 1995.

Lyall, Sutherland. *Designing the New Landscape.* London: Thames & Hudson, 1991.

McHarg, Ian L. *Design with Nature.* New York: Doubleday, 1969.

Moore, Charles W., William J. Mitchell, and William J. Turnbull, Jr. *The Poetics of Gardens.* Cambridge, Mass.: MIT Press, 1988.

Mosser, Monique, and Georges Teyssot. *The History of Garden Design.* London: Thames & Hudson, 1991.

Miyagi, Shunsaku, and Makoto Yokohari. *Contemporary Landscape Architecture: An International Perspective.* Tokyo: Process Architecture, 1990.

Motoo Yoshimura: Creator of Contemporary Japanese Gardens. Tokyo: Process Architecture, 1990.

Nitschke, Gunter. *Japanese Gardens.* Cologne: Taschen, 1991.

"190 Marlborough Street Roof Garden" (Peter Walker). *Landscape Architecture,* November 1988.

Page, Russell. *The Education of a Gardener.* New York: Random House, 1983.

Pigeat, Jean-Paul. "A Thinking Man's Gardens in Spain" (Fernando Caruncho). *Vogue Décoration* (Paris), June/July 1992.

Rose, James. *Creative Gardens.* New York: Reinhold, 1958.

The Royal Horticultural Dictionary of Gardening. London: Oxford University Press, 1951, 1992.

Sandars, N.K. *Prehistoric Art in Europe.* New Haven: Yale University Press, 1968.

Schwartz, Martha. "Back Bay Bagel Garden." *Landscape Architecture,* January 1980.

Siren, Osvald. *Gardens of China.* New York: Ronald Press, 1949.

Sitta, Vladimir. "A Particular Case: Notes About Design of One Country Garden." *Landscape Australia,* March 1991.

Steele, Fletcher. *Modern Landscape Architecture.* San Francisco: San Francisco Museum of Art, 1937.

Strong, Sir Roy. *A Celebration of Gardens.* London: HarperCollins, 1991.

Shodo Suzuki: Japanese Landscape Design. Tokyo: Process Architecture, 1991.

Thompson, J. William, and Heidi Landecker. *Profiles in Landscape Architecture* (Garrett Eckbo, Richard Haag, Robert Murase, Peter Walker, Ron Wigginton, Ian McHarg). Washington, D.C.: American Society of Landscape Architects, 1992.

Tomkins, Calvin. "The Garden Artist" (Dan Kiley). *New Yorker,* Oct. 16, 1995.

Treib, Marc, ed. *Modern Landscape Architecture: A Critical Review.* Cambridge, Mass.: MIT Press, 1993.

Vandermarliere, Katrin. *Four International Landscape Designers* (George Hargreaves, Adriaan Geuze, Desvigne & Dalnoky, Torres/LaPeña). Antwerp: International Kunstcentrum deSingel, 1995.

Walker, Peter, and Melanie Simo. *Invisible Gardens: The Search for Modernism in the American Landscape.* Cambridge, Mass.: MIT Press, 1994.

Walpole, Horace. *The History of Modern Taste in Gardening.* New York: Ursus Press, 1995.

Whitney, David, and Jeffrey Kipnis, eds. *The Glass House.* New York: Pantheon Books, 1993.

Wines, James. *De-Architecture.* New York: Rizzoli, 1987.

Wölfflin, Heinrich. *Renaissance and Baroque.* London: William Collins & Sons, 1964.

A SMALL LONDON GARDEN FOR A YOUNG EXECUTIVE, ISLINGTON, LONDON, 1995

Guy Cooper and Gordon Taylor, in collaboration with Joseph Kent,
designed their first contemporary garden while working on this book.